OCT 18 2011

CALLOWAY COUNTY PUBLIC LIBRARY
710 Main Street
MURRAY, KY 42071

DISCARD

D1271592

LOOKING BACK mississippi

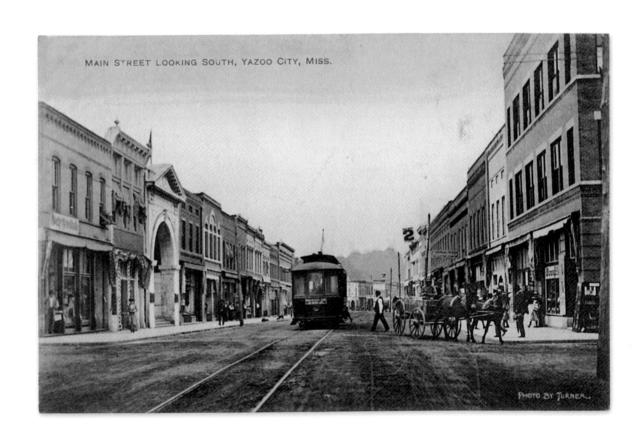

MAIN STREET LOOKING SOUTH, YAZOO CITY, MISS.

PHOTO BY TURNER.

LOOKING BACK mississippi

towns and places FORREST LAMAR COOPER

UNIVERSITY PRESS OF MISSISSIPPI / JACKSON

www.upress.state.ms.us

The University Press of Mississippi
is a member of the Association of
American University Presses.

Designed by Todd Lape

Copyright © 2011 by University Press of
Mississippi
All rights reserved

Printed in China by Everbest through Four
Colour Imports, Ltd., Louisville, Kentucky

First printing 2011
∞

British Library Cataloging-in-Publication
Data available

Library of Congress Cataloging-in-
Publication Data

Cooper, Forrest Lamar.
 Looking back Mississippi : towns and places
/ Forrest Lamar Cooper.
 p. cm.
 ISBN 978-1-61703-148-9 (cloth : alk. paper)
1. Mississippi—History, Local. 2. Missis-
sippi—History, Local—Pictorial works. 3.
Mississippi—Social life and customs. 4. Mis-
sissippi—Social life and customs—Pictorial
works. 5. Cities and towns—Mississippi—
Pictorial works. 6. Postcards—Mississippi.
I. Title.
 F342.C67 2011
 976.2—dc22 2011011629

contents

preface

For the past thirty years, I have been privileged to write the "Looking Back" column for *Mississippi Magazine*. In the course of this time, I have met and interviewed many interesting people and pored over numerous historical documents, military records, newspaper accounts, and literally box after box of photos. In the process, I have also been blessed to have amassed a collection of more than 10,000 pre-1920 picture postcard views of Mississippi towns and places. Most of these cards show a way of life that no longer exists: one-of-a-kind street scenes, long-gone building settings, and rarely seen views of special events. Using some of these views as topics and others as springboards, I have been able to put together more than 150 articles highlighting Mississippi's heritage.

This book contains thirty-nine selected articles. Except to correct minor factual errors, the text is unchanged from the time of original publication. This book, however, adds photographs and postcards to the majority of the pieces, so that most of what's reproduced here is more heavily illustrated than it was when published in the magazine.

Each of the places featured, from Belzoni to Yazoo City, has an intriguing story, a singular identity, and sparks of color. I hope I've made exploring Mississippi as much fun for my readers as it has been for me. Enjoy the read!

LOOKING BACK mississippi

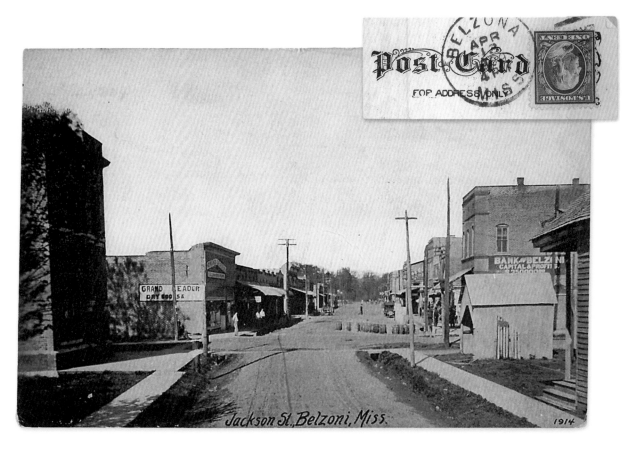

Jackson St., Belzoni, Miss.

1914

This view of Jackson Street looking west shows the main business section of town, including the Bank of Belzoni on the right. Note that the bank used the correct spelling of the town's name, while the post office during this period still used "Belzona." The automobile pictured in the distance on the right side of the street is a good indicator of wealth and prosperity.

the heart of the delta

On March 21, 1918, a reinforced German army stormed the allied trenches of French, British, and Belgian defenders along a cold, slippery, 60-mile western front—the final German push in the Battle of the Somme—in a supreme effort to take the lead in the four-year-long war which had seen little change in real estate since fighting began in 1914. More than one million steel-helmeted invaders charged shoulder to shoulder as fast as a man in soggy leather hobnailed boots can run across a treeless, grassless, lifeless no-man's-land, rechurning 100 kilometers of muddy Belgian earth into a virtual sea of death. The scene was horrific! British losses alone totaled 77,650 men.

One week to the day later, March 28, 1918, back home in the American South, in the heart of the Mississippi Delta, a new county was given life. Humphreys County was named for CSA Brigadier General Benjamin Grubb Humphreys, a native of Claiborne County who gallantly led Mississippi troops at Chickamauga, Knoxville, the Wilderness, Spotsylvania, and Cold Harbor, and who in 1865 was elected as Mississippi's 26th governor. It was Humphreys who before the war bought a small tract of land in Sunflower County and who, according to historian Harold A. Cross in his book *They Sleep Beneath the Mockingbird* (1994), "cleared the land of its virgin timber, built a home and named it 'Itta Bena' from the Choctaw phrase meaning 'Home in the Woods.'" Humphreys, who entered West Point as a classmate of Robert E. Lee, was a natural leader who, long after his death in 1882 on his Leflore County plantation at the age of 74, was a man who attracted many admirers. For instance, when the $4.5 million Greenville, Miss., to Lake Village, Ark., bridge, which at the time was

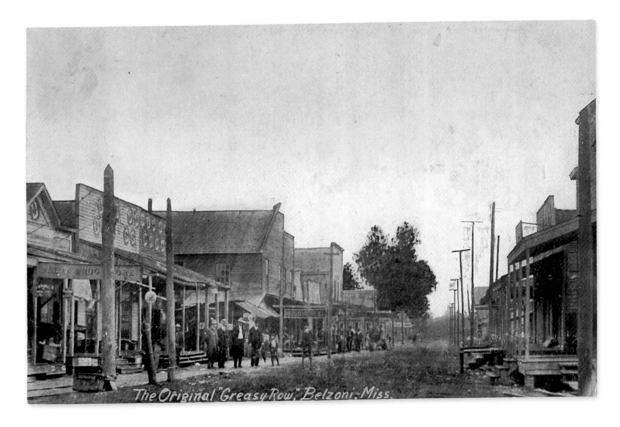

The Original "Greasy Row," Belzoni, Miss.

the final link in the shortest all-paved, all-weather route from New York to Los Angeles, was opened to traffic on October 5, 1940, it was named in his honor—the B. G. Humphreys Bridge.

On December 10, 1917, the state of Mississippi, composed of 81 counties, celebrated its centennial. Twelve weeks later, Humphreys County, number 82, was formed from portions of Washington, Yazoo, Sunflower, Holmes, and Sharkey counties. At 430 square miles of land area, Humphreys ranks 66th in overall size, and with more than 14,000, it ranks 59th in population.

Ninety years before Humphreys County became a reality, Louisianian Alvarez Fisk saw agricultural opportunity and the wealth that was associated with what he surely must have envisioned as a win-win situation. After all, how could anyone go wrong buying the richest farmland on earth?

North Hayden Street, which runs north and south, borders the Humphreys County Courthouse on the west side. It is the town's main entrance for those arriving from Greenwood or Yazoo City. In days of long ago, residents dubbed this area "Greasy Row," as merchants along this street were more often than not quite successful in separating the "just paid" worker from his money.

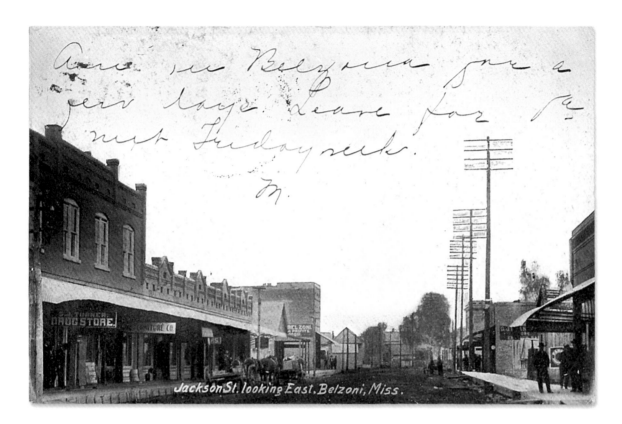

Jackson St. looking East, Belzoni, Miss.

In this 1909 postcard view of Jackson Street looking east, Belzoni is spelled with the letter "i" at the end while both the sender of this card and the post office spelled the town name Belzona. Even though Belzoni is the correct spelling, locals still pronounce the name as "Belzona" ("Bell-zone-nah") and not "Bell-zone-nee." This card was published for (and presumably was sold by) the O. J. Turner Drug Store pictured in left foreground.

Carolyn Newton and Patricia Coggin report in their book, *Meet Mississippi* (1976), that Fisk apparently wasted little time, after purchasing a sizeable tract of land in the then-extreme southwestern corner of Washington County, in laying out streets and measuring off lots. Fisk named his new town, which overlooked the Yazoo River from the west, Fisk's Landing. When the influx of colonists failed to materialize in accord with

his schedule, he decided to change the name of the town. Without question, he gave his struggling enterprise a new lease on life when he renamed the town for a famous person, Giovanni Battista Belzoni. The story goes that Belzoni was actually an acquaintance of his. At any rate, the ploy did work. The town began to grow, at least somewhat, and then a setback came in the form of the four-year-long Civil War. Especially

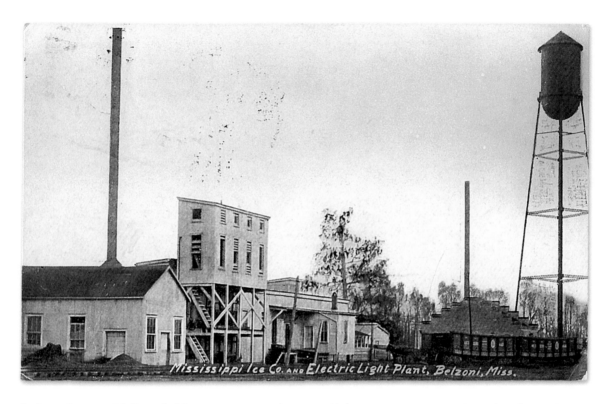

Mississippi Ice Co. and Electric Light Plant, Belzoni, Miss.

bad were the years 1863 through 1865, when the men in blue brought death, pillage, and destruction by fire to the sparsely populated Delta.

Giovanni Battista Belzoni was born in Italy on November 15, 1778. At the age of 25, he immigrated to London, where he joined a traveling circus. At 6'7" tall, the red-haired, red-bearded Italian served the circus for

12 years as a strong man. He became known throughout the world as the "Patagonian Samson" and the "Great Belzoni." He gained worldwide fame for his feat of lifting a specially made iron frame upon which 12 people would sit and then, still holding it, walking across the stage. After leaving the circus, he traveled to Egypt to try his hand at a new line of work,

This postcard view of 1909 features what the town fathers would call bragging rights. Shown are the twon's new electric plant, water tank, and ice company, plus rail cars indicating that the town is served by a rail line.

archeology. Using the knowledge of hydraulics he had acquired before leaving Italy, he attracted the attention of the British Consul General, Sir Henry Salt, when he successfully removed the colossal stone head of Ramses II, which was later transported to the British Museum. In 1817, Belzoni discovered the tombs of Amenhotep III, Ramses I, Merneptah, and Ay, as well as the entrance to the sepulcher of Seti I, Ramses I's son. In 1818, Belzoni became the first person in modern history to enter the pyramid of Khafre at Giza. Three years later, he was honored in London with an extravagant exhibit called Egyptian Hall for being the greatest archaeologist of his era. Quite a legacy for a small town to live up to!

Despite the fact that the town of Belzoni was not blessed with a railroad, English, Irish, and Jewish merchants successfully built businesses that helped the river town grow into the largest trading center between Greenwood and Yazoo City. However, it wasn't until December 29, 1879, that a post office was acquired. Perhaps because of the local pronunciation of the Italian word "Belzoni," the post office spelling became "Belzona," and

it remained that way for 31 years. On January 20, 1910, the spelling was corrected. Even so, 93 years later, Belzoni is still pronounced "Bel-zone-ah."

During the first six years of Belzoni's life as the county seat of Humphreys County, the city hall doubled as the courthouse. But in 1922, the same year British archaeologist Howard Carter discovered the tomb of the young Pharaoh Tutankhamen, Humphreys County's $300,000 courthouse building was completed. Since then, the population of Fisk's dream has more than tripled to 2,663. The city with ties to archeology has in a sense rediscovered its purpose, and in a real way has redirected its mission. Fisk visualized agricultural opportunities, but he had no way of knowing about aquaculture opportunities. Today, with more acres of farm-raised catfish than any other county in the United States, Humphreys County—with Belzoni as its hub—is known across the globe as the "Catfish Capital of the World." Surely if Fisk could see his "Landing" now and taste just a little of its success, he would realize that in more ways than one, Belzoni truly is the "Heart of the Delta." ■

These words of comfort are still sung in English-speaking Christian services around the world. Penned by Edgar P. Stites (1836–1921) in his popular "Beulah Land," this hymn was the favorite of Colonel Frank A. Montgomery, a devout Methodist, who in 1855 moved into the virtually pristine wilderness of western Bolivar County.

Here along the edges of the Mississippi River he began clearing his land by cutting the thick stands of cane and timber to build his vast plantation, Beulah. Only seven years prior to this move, Colonel Montgomery (who attained that military rank later during the Civil War when he led a local cavalry group known as the "Bolivar Troop") married Miss Charlotte "Lottie" Clark from Fayette in Jefferson County. Together they established Beulah as their home, where over the course of fifty difficult, turbulent years, including four long, tragic, destructive, Civil War years followed by several devastating floods, they reared a strong Christian family of ten children. Two other children were lost to disease during infancy following the war.

Beulah is a Hebrew word which means "married." Verses four and five in the sixty-second chapter of the book of Isaiah refer to the Lord being delighted at the prospective marriage of his son, Jesus (the groom), to Jesus's bride (the church). Verse five ends with this assurance: ". . . as a bridegroom rejoices over his bride, so will your God rejoice over you."

Frank and Lottie Montgomery never lost sight of this truth as their plantation grew into a village and then into a town. Within a year following the Civil War, Beulah Plantation was selected to be the county seat of government. Colonel and

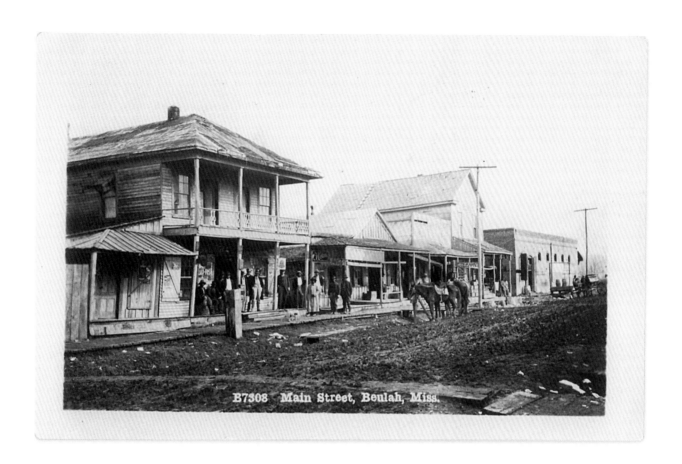

B7308 Main Street, Beulah, Miss.

This century-old photo of Beulah's Main Street speaks loudly as to how difficult life was before there were hard-surfaced roads. The two horses tied up in front of one of the town's grocery stores are facing what looks to be a new "Coca-Cola" sign, suggesting perhaps that their riders may have stopped for some refreshment. The brick building at the end of the street is the General Merchandise Store of J. B. Bond and Company.

Mrs. Montgomery donated land and paid to have a courthouse built, which cost approximately $1,600. This building was accepted by the Board of Police in May 1866. Following the building of the courthouse, a log jail consisting of two rooms was constructed and Beulah was on its way to becoming one of the most important towns in the early development of Bolivar County. In 1870 Colonel Montgomery and C. C. Cummings began publishing *The Bolivar Times* newspaper in an effort to reestablish conservative thinking in the county. Later, in 1872, during the height of the Reconstruction Period, Beulah lost its county seat status to a new location at first named Floreyville but renamed Rosedale in 1876.

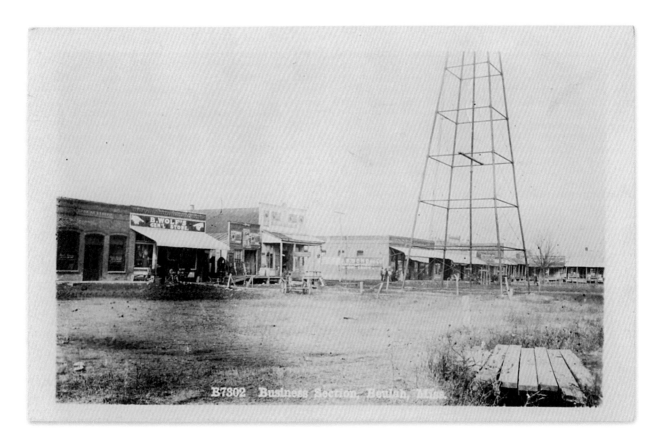

The photograph , showing the bottom framework of the town's water tank, accompanying this article was taken during the winter of 1914 by the M. L. Zercher Postcard Company of Topeka, Kansas.

The first building shown at the extreme left is the Bank of Beulah. This bank was organized and incorporated on March 13, 1907, by W. T. Cassity, W. E. Courson, J. B. Bond, J. B. Walton, F. C. Jones and R. Redline. On January 2, 1971, this bank was remodeled and renamed the First National Bank of Rosedale. The second building from the left is "B Wolf's Gen'l Store." It was a dry goods store where clothing and other essential items for the home could be purchased. To the right of

In 1914 Beulah's Front Street was typical of the times: wooden storefronts for the most part and dirt roads.

this store, just past two small shops, is a building with a porch across the front. This was a grocery known as the "Cash Store."

Beyond this building, near the center of the photo, is the large brick general mercantile store of J. B. Bond and Company. James Banks Bond, like Colonel Montgomery, was one of the leading citizens of the town. Bond moved to Beulah and began his store in 1897. By the time this picture was made, he had established branch stores in the nearby towns of Mound City, Pace and Lobdell. In the book *Brozenes and Doodlum—Private Money in Mississippi* by George P. Chatham, information is given about Bond's stores using trade tokens to encourage business. Bond's store built in the nearby town of Pace in 1908 was the first brick building constructed there. In a *History of Bolivar County, Mississippi* compiled by Mrs. Florence Warfield Sillers, Mr. Bond's accomplishments are well recorded. His success as a businessman in the Delta is legendary. In addition to his mercantile interests he owned a large amount of land for which in 1918 he was offered one million dollars.

By 1900 Beulah's population had grown to 170. Six years later the estimated population had risen to 250. During the 1920s and 1930s the town tripled in size as workers moved in to cut the last of the big trees in the area. After the depression, with the trees and the sawmills gone, the town almost died. In 1908 the population stood at 431 and by the 1990 census the town's number of residents remains roughly the same—460.

During this decade the economy in the area is beginning to pick up again, as farmers are enjoying bountiful harvest seasons. With the world population booming, the agricultural products grown in and around Beulah and, indeed, all of the Mississippi Delta are destined to play a vital role against world hunger. This challenge will be met by the citizens of Beulah and her sister towns; for these people—descendants of Colonel Frank A. Montgomery, James B. Bond and others like them, who rose from pioneers to patriarchs—can proudly claim their heritage of living in a town built on courage and faith. ■

CALLOWAY COUNTY PUBLIC LIBRAR
710 Main Street
MURRAY, KY 42071

last the last spa

"Allison's Wells, a rambling, old-time spa and art center 10 miles north of Canton, burned to the ground shortly after noon Monday, going up in a tremendous pillar of flame and smoke that only a big old frame building can cause." So read the top story on the front page of *The Clarion-Ledger* newspaper on Tuesday, January 15, 1963.

Before, during, and for several years after the War between the States, the property, which later became well-known as a weekend resort, was part of the 960-acre William Lambert Plantation. Surely it must have been with heavy hearts in January of 1876—15 months before the blue-jacketed Federal soldiers who had occupied the state since 1865 would be withdrawn by President Rutherford B. Hayes—that the children of William Lambert were forced by the hard times to default on agriculturally related loans. Their property was sold by the county to Mrs. Mary B. Allison of New Orleans, the high bidder at $3.35 per acre. The deed called the mostly arable acreage, which did include some thickly forested areas, "Way's Bluff, county of Madison." Until then, Way's Bluff had never been much more than a small railroad depot into which was tucked a single-room post office that opened on January 9, 1858, with Elipha White as the first postmaster. But Way's Bluff was destined to play a vital role in the economic livelihood of what eventually became the most popular health resort and mineral springs hotel in central Mississippi.

In 1878, the widow Mrs. Allison had built for herself and her family a spacious home in a heavily wooded area about a mile north of the Way depot. In an effort to make the home more livable, she hired a man named Parson Hargon to dig a well.

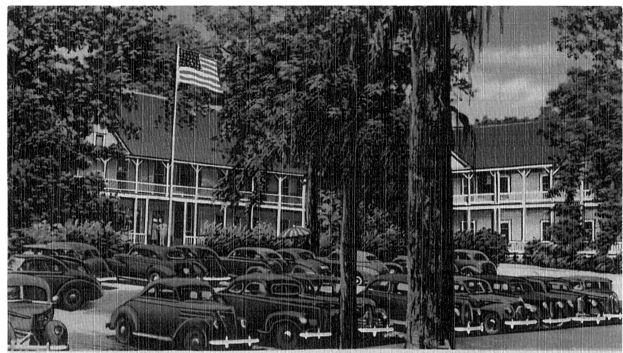

Allison's Wells is in a hill-top grove overlooking a lake and all buildings are air-cooled . . . You'll enjoy famous Allison's meals.

The Allison's Wells resort would have looked very much like this view when John and Hosford Fontaine took over ownership of the famous spa and gathering spot in 1938.

After a great deal of effort, the hand-dug shaft was completed in 1879, and although the water that flowed from deep inside the roan-colored earth was crystal clear, it tasted strange—medicinal. A bright red hand pump was installed over the well opening, from which came "sparkling, bubbling, ice cold water." It was reported "quite palatable at the well, but harder to drink when allowed to settle" because the heavy mineral content induced a slightly oily film to float to the top. Nevertheless, the Allison family learned to like it, and over the next few years, different stories were told as to how the peculiar-tasting water healed first one infirmity and then another. Soon people started to "show up" on the front lawn just to drink the

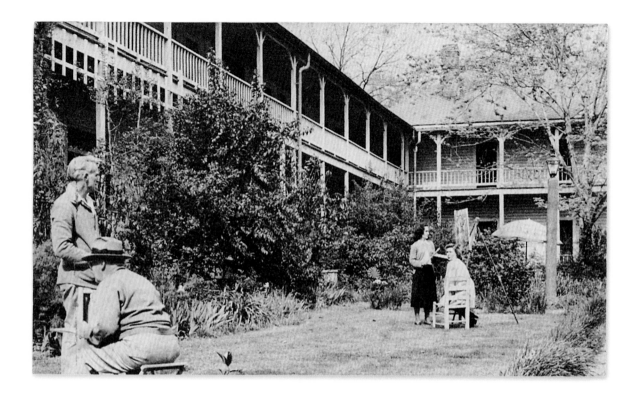

water and buy it. It seems that it "was of some particular value in the treatment of malaria, a purgative as well as a tonic water, with all the minerals." So wrote Mrs. Hosford Latimer Fontaine in her 1981 history/recipe book entitled *Allison's Wells: The Last Mississippi Spa.*

By word of mouth, the healing powers of the Allisons' well water spread quickly and remained popular with the public year after year. On June 30, 1896, state chemist W. L. Hutchinson of the Agricultural and Mechanical College (now Mississippi State University) made an analysis of the water, listing nine different mineral properties, chief among which were calcium sulphate, aluminum sulphate, magnesium sulphate, and sodium chloride. The amount of minerals found totaled an impressive 214,263 grains per gallon of water, and not surprisingly, this information was used as an advertising testimonial for decades.

In this view the celebrated artist Karl Wolfe is shown standing at the far left. He was the first director of the Allison's Art Colony, which was begun at the Wells in 1948, and his artistic goal—"To teach, to explore, to work, to learn, and not to copy"—became their theme.

In 1899, Durant horticulturist Sam Wherry, who reportedly shipped the first railroad carload of strawberries from Mississippi, bought from Mrs. Allison the home, the well, and 96 acres of property. After allowing the Allison family sufficient time to build a new home about a mile away, near the Way depot, Wherry—ever the businessman—set about developing the well and house as a health and pleasure resort. Using lumber taken from the surrounding forest, he transformed the old home into a two-story hotel. Before the project was completed, he made a second effort to locate pure drinking water by having a new well dug on the lawn, and this time the water was permeated with sulphur. The discovery turned out to be another blessing, for when sulphur water is heated the curative powers—as discovered by the Romans—are ideal for relieving tension and curing skin problems.

In 1904, ownership of the property changed hands again when D. C. Latimer, who had partnered with Wherry for perhaps three years, purchased the site, including "all furniture, farming implements, three horses, one mare, two large mare mules, all cattle and hogs, and an omnibus and a surrey." Under Latimer's direction, additional hotel space was constructed near the north end of Wherry's structure, giving the place an elongated L-shaped appearance. The two-story frame buildings were designed in the traditional summer resort style with a double veranda across the front on each floor level, much like the decks on a river steamer. The wide, spacious porches, which hosted a profusion of rocking chairs, proved to be favorite gathering spots for guests young and old.

Latimer was a talented manager who also possessed a keen mind for business. He apparently was the first owner to see real potential in marketing the mineral water. He had special five-gallon crockery jugs made, all bearing the Allison's Wells name along with their address at "Way, Miss." Each business day the double-teamed omnibus, which actually was a 10-passenger hack, transported the demijohn-like jugs of water to the Way railroad station for shipment to customers all over the United States. The water was priced at $1.65 per jug, "F.O.B. Way," or if requested, it would be shipped C.O.D. The income derived from the sale of water was important to

the venture, and Latimer stood solidly behind his product. In 1910, an incident occurred that helps to illustrate Latimer's commitment to the integrity of his business. Mr. Wad Nason, a telegrapher with the railroad based at Ackerman, apparently was a frequent buyer of the Allison's Wells water. By April of 1910, agent Nason had transferred to Sterling City, Texas, a small county seat town located 75 miles west of Abilene, where he continued to order water. On April 24, Latimer sent Nason a handwritten letter on company stationery that read, "Dear Sir, Our express agent at this place tells us that the last jug of water we shipped you got broken at Vicksburg. So we ship you another one today. Hope you will get this one OK and it will do you lots of good. With best wishes I am yours truly, D. C. Latimer."

When the 1938 season opened at the resort, dozens of shiny new automobiles arrived, some from as far away as Memphis, St. Louis, and Chicago. The most frequent guests probably first noticed the signature yearly new coat of white paint on all the buildings. Upon exiting their cars, the alluring fragrance of the rose garden accented by freshly mown grass instantly reminded

them of why they came. They were greeted by new owners John and his wife, Hosford Latimer Fontaine, who had recently bought the spa from the Latimer heirs. The Fontaines were just what the doctor would have ordered for the aging facility. They were energetic and inventive, and their personalities combined both warmth and spontaneity. Always the gracious hosts, they were the kind of people who not only made visitors feel welcome but made them feel good about themselves for having come.

Under their care, a number of new amenities sprang forth. The Fontaines joined the National Spa Association, prompting members of the prestigious Saratoga Springs group to visit from New York. They later hosted the first American Bridge League Tournament in Mississippi, the first art colony, the first continuous exhibition of paintings with a tea . . . and the list goes on. The Fontaines placed an emphasis on "high living and health," two goals in which few were ever disappointed.

The art colony, which was begun in 1948 with revered Jackson artist Karl Wolfe as the first director, introduced the theme "To teach, to explore, to

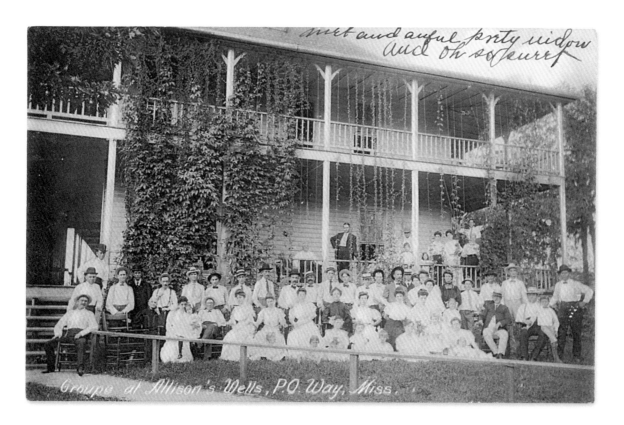

met and awful prity widow and oh so purty

Groupe at Allison's Wells, P.O. Way, Miss.

This view, which dates from the summer of 1907, shows a group of guests posing in front of the Wherry-constructed hotel. Note the willow leaf butterbean runners, which were planted to provide shade from the late afternoon sun.

work, to learn, and not to copy." The names of the students and the visiting instructors who attended during the 15 years of the colony's existence here read like a national who's who of the art world. Their activities were recognized by *The New York Times* in a feature on April 3, 1949, and in numerous other newspapers and magazines as the fame of the colony grew.

The one thing that seems to have overshadowed all the amenities and

activities at Allison's Wells wasn't the art colony, nor the natural beauty, nor the lake in the moonlight. It wasn't even the water. It was the food, served in beautiful antique dishes complemented by crystal and silver. The resort employed the talents of local women who knew how to cook meats, vegetables, breads, and cakes that would melt in the mouth—meals that were highly praised by diners from Duncan Hines on down. To quote Mrs.

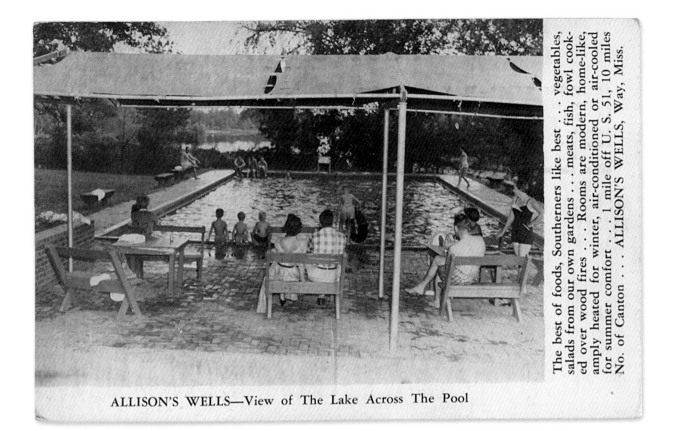

The best of foods, Southerners like best . . . vegetables, salads from our own gardens . . . meats, fish, fowl cooked over wood fires . . . Rooms are modern, home-like, amply heated for winter, air-conditioned or air-cooled for summer comfort . . . 1 mile off U. S. 51, 10 miles No. of Canton . . ALLISON'S WELLS, Way, Miss.

ALLISON'S WELLS—View of The Lake Across The Pool

Fontaine from her memoirs, "Allison's menu was developed from cooking from scratch—home-grown vegetables, fresh fruit from the orchard, wild muscadines brought from the swamp; even quail and wild ducks occasionally; hams, stuffed sausage, bacon cured in our smoke house. A Jersey herd furnished yellow heavy cream, fresh churned butter and buttermilk, and cream of cheese which dripped from a sack."

In a recent column in the *Northside Sun* newspaper, the Fontaines' son John III reminisced about the good country cooking, all of which took place on a "gigantic" old commercial wood-burning stove. He explained that the cooks knew how to regulate the heat even without temperature

The swimming pool pictured here, circa 1950, wasn't your regular pool; every drop of water in the pool was mineral water, pumped directly from their famous mineral well.

gauges, presumably just by looking at the color of the flames that danced on the heap of burning coals. John recalled that Lena Tucker, the chief cook for 40 years, "knew exactly how to make it all come out from the pinch of this to the dash of that." Even former Governor Ross Barnett apparently had fond memories of the resort's food, John said; the governor once stopped him on Capitol Street in Jackson and asked "if I had that great squash casserole recipe he remembered from Allison's."

No one knows what started the fire on that cold January day 42 years ago. It is only known that it started in the upper rear portion of the kitchen. It was discovered by Ellis Lindsey, the beloved handyman and waiter who had served the hotel for 33 years, upon his return from taking Mrs. Fontaine to Canton to board the train for a trip to New Orleans. Railroad personnel got word of the tragedy to Fontaine as her train reached Brookhaven. There she disembarked and was driven back to Way.

I never visited Allison's Wells, although I remember seeing the wooden "Welcome" sign near Highway 51 as I passed on my way to and from Ole Miss during my freshman year.

Neither did I know Mrs. Fontaine. But for more than 40 years, the photograph that appeared on the front page of the *Jackson Daily News* on January 15, 1963, which showed Mrs. Fontaine dressed in what may have been her best suit and hat and accompanied by her loyal collie dog, has stayed in my mind. How could a lady standing amid the ruins of her home and business, amid the ashes of all her earthly possessions—priceless family heirlooms, treasured photographs, and irreplaceable keepsakes—hold her head so high? I don't know the answer, but I like to think that it was because of her strong faith. Maybe she remembered the words of one who lived 4,000 years ago who experienced a similar but even more devastating personal loss. It is my hope that when and if I'm called upon to face a disaster of this magnitude that I, too, will be able to gain strength from the same man, who wrote:

"Naked came I out of my mother's womb, and naked shall I return thither: the LORD gave and the LORD hath taken away, blessed be the name of the LORD" (Job 1:21). ■

in the right place
at the right time

It is no secret that Mississippi College is the oldest institution of higher learning in the state of Mississippi. The origins of this prestigious school date back to 1826 when John Quincy Adams was President of the United States—a union which then consisted of only 24 states. The Great Northwest corner of what is now the continental United States—known then as Oregon Country, an area which now consists of the states of Washington, Oregon, Idaho and a large portion of Montana—was still occupied by Great Britain. In addition the rugged vastness of what is now America's Great Southwest, that area which comprises the states of California and Texas and all the states in between, was claimed and was occupied by Mexico. Stated another way, MC is 11 years older than the state of Michigan and 86 years older than the states of New Mexico and Arizona. What is not so well known is that MC was the first coeducational institution of higher learning in the U.S. to grant degrees to women.

Early in 1826, Dr. Alexander Newton received a charter signed by Governor David Holmes enabling him and a board of directors to organize the first educational institution to be established inside the Choctaw Cession of 1820. By 1827, Hampstead Academy opened, with a two-story brick building, reportedly large enough to accommodate over 150 students, built on a hill overlooking Mt. Salus, the English manor–style home of Governor Walter Leake. A few years earlier, the U.S. Government Land Office had located nearby. The settlement which quickly developed around this site initially became known as Mt. Dexter. However, with the completion of Governor Leake's new home in 1825, the name of the village

KES RESIDANCE « 4

Gov. Walter Leake's home, constructed in 1825 as the first brick house in Hinds County, was named by him Mt. Salus, meaning in Latin "mountain of health." It is shown here in a real photo postcard view that was mailed from Clinton to Raymond on April 21, 1908.

was changed to Mt. Salus in honor of the name of the esteemed governor's home, which in Latin means "mountain of health." On September 25, 1829, the town's name was changed again, this time to honor the popular politician from New York state, Governor Dewitt Clinton. This final name change was the result by local politicians and business leaders in their effort to make

their town sound more attractive as it sought to become the capital city.

Another interesting change occurred during this time. It was the naming of or perhaps the renaming of a street. To this day the first street west of Jefferson Street in Clinton is named Capitol Street. Presumably had Clinton succeeded in being selected as the capital city, then the Capitol building

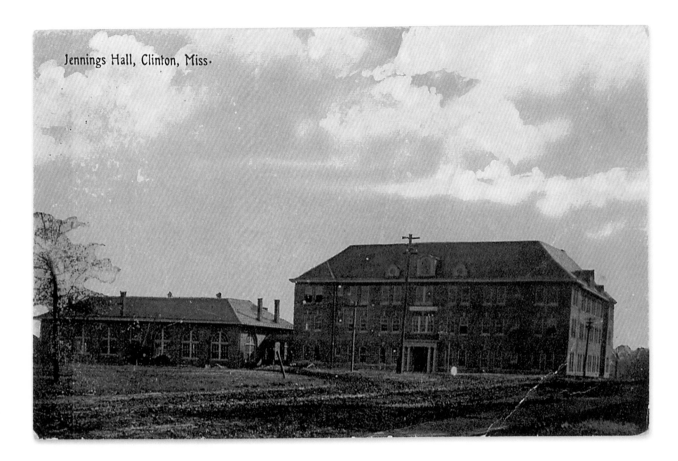

Jennings Hall, Clinton, Miss.

of our state would have been located along this street most likely where it intersects with West Main Street at the top of the hill, where today the city's fire department is headquartered. Although valiant, Clinton's efforts to attract capital city status failed by only one single vote.

On February 5, 1827, the name of Hampstead Academy was changed by the state legislature to Mississippi Academy as requested by the school's board of trustees. Due to the tremendous desire and actual need for an institution of higher learning near the center of the state, the legislature readily approved that the name and academic status of the academy be changed to Mississippi College on December 16, 1830.

Jennings Hall, pictured along with the natatorium (indoor swimming pool) shortly after it was completed in 1908. This building, a gift to the school by the Z. D. Jennings family, originally served as a men's dormitory.

During this same period, Natchez became to the cotton industry what the Silicon Valley in California has become to the computer industry in our day. Since the town of Clinton was located just off the Natchez Trace, the most important roadway connecting Natchez to Nashville (and therefore beyond to Washington and New England), it was strategically placed to take advantage of the rapid new growth of the region.

Clinton was a town to which relatively large numbers of descendants of prominent families from the original colonies were relocating in hopes of capturing a portion of the wealth being produced by King Cotton. The influx of well-to-do families to this area proved a blessing to the struggling new college, and, in the beginning, there were more young women attending Mississippi College than there were young men. In fact, when the very first commencement exercises were held (over a span of four days due to the public examinations in which each of the 17 students were tested) during December 13–16, 1831, the first two graduates—in fact the only two graduates of 1831—were both women: Alice M. Robinson and

Catherine Hall. To quote a newspaper article in the *Advocate and Register* of Vicksburg dated December 30, 1831: "The novelty of the ceremonies excited the warmest interest. In the first place, each [graduate] was presented with a beautiful gold medal, with suitable inscriptions." Following this presentation a diploma was given, followed by an address by the president of the college, Dr. Daniel Comfort.

Mississippi College historians believe that these first two graduates, Misses Robinson and Hall, were the first young women to receive degrees from a coeducational institution of higher learning in the United States. During the college's second commencement exercises, held June 15–20, 1832, there were also only two graduates, and they, too, were both women: Miss Caroline Coulter of Vicksburg and Miss Lucinda F. Bagley of Covington, Louisiana. MC's first male graduate was John M. Mapes, who received his A.B. degree in July 1843. Beginning the next school semester following his graduation, Mapes became a faculty member. He served the college for one year, then became associated with a private school in Copiah County. In addition

to granting that first degree to Mr. Mapes in 1843, MC also granted their first honorary degrees that same year to three men. Among them was Rev. Alexander Newton, the man who first founded Hampstead Academy in 1826. It was he who, after receiving his doctor of divinity degree, led the college in establishing a department of theology. (It should be pointed out that Dr. Newton's son, Rev. Oscar Newton, graduated from MC in the class of 1849, and from 1850–1858 taught school in Jackson at the Jackson Male Academy on North State Street. In 1860 he moved to Copiah County where he founded Newton Institute. This famous private school served young women in and around Crystal Springs for more than 50 years. Unfortunately the historic structure was destroyed by a fire on Thanksgiving night 1912, and was never rebuilt.)

Just as the population in and around Clinton began to expand, so did the student population at Mississippi College. It wasn't long before the board of trustees found itself with an economic dilemma. The growing expenses of the enlarged institution meant the board no longer was able to provide sufficient operating funds, so they were thereby forced to look for a sponsor to take over the management of the college. Three Presbyterian churches in the towns of Clinton, Brandon and Lexington took up the challenge in 1842, and successfully oversaw the running of MC for eight years. By the summer of 1850, they found that financially they could no longer provide the necessary support. These were tough economic times in not only Mississippi, but in all of America due to a series of nationwide bank failures. Because of the money problems of the era, the Presbytery was forced to give up their claim on July 26, 1850. Fortunately for MC the next day (Saturday, July 27), the Baptist Church of Mississippi accepted the responsibility, as they put it, "to share the word of God." The Baptist leaders echoed their fellow Presbyterians by seeing the college as their opportunity to teach Mississippians about Jesus, taking as their scriptural basis from the book of Romans, "For I am not ashamed of the gospel of Christ, for it is the power of God unto salvation to everyone that believeth." In short order, the Baptists expanded the department of theology as part of this charge.

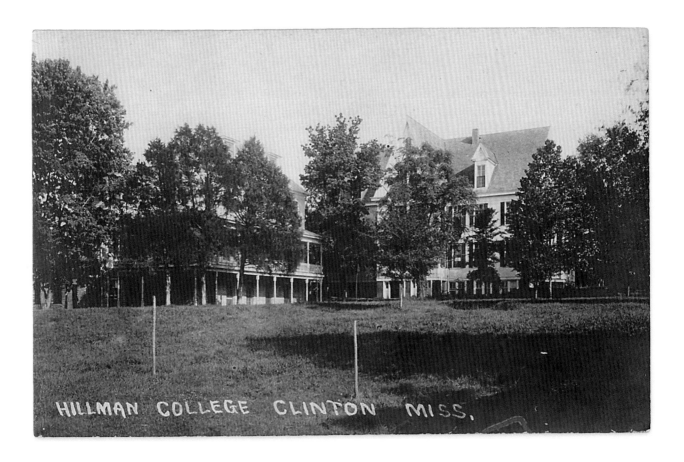

HILLMAN COLLEGE CLINTON MISS.

In 1891 the name of Central Female Institute, a "sister" institution to Mississippi College, was changed to Hillman College in honor of the school's president, Dr. Walter Hillman, and his wife, Adelia M. Hillman.

In an effort to devote the school to educating young men for the ministry, the Central Baptist Association in 1853 founded the Central Female Institute. This school for women a few blocks north of MC's campus became one of the pioneer female colleges in the state. Also in 1853, G. C. Granberry became the first person to graduate from Mississippi College under Baptist patronage. In 1856, five more young men were granted degrees, and, by the time the Civil War started in 1861, a total of 36 men had received diplomas. The war was especially unkind to MC. When the conflict started, 66 of the college's 228 students were organized into a fighting unit known as the Mississippi College Rifles. During the four long years of war they fought in the

Army of Northern Virginia, beginning with the Battle of Manassas and on through most of the other major battles in the Virginia, Carolina and Pennsylvania theaters. The blood, banners and bodies of MC students stained and littered the hills and woods in places that most Mississippians found difficult, if not impossible, to locate on even the best of maps. When the struggle ended in 1865 there were only four members of the company left. Although in dire need of repair, the college opened again in 1868 with most of the buildings still there, and the campus was ever so silent. The entire state was under martial law, the state's economy devastated, and the dreams of many crushed.

In the fall of 1867, MC's board of trustees met and resolved to resume the goal of training young men to serve God. The spring semester of 1868 saw President Walter Hillman, an ordained Baptist minister, along with one assistant, lead 11 young men back to the classroom with the fervent prayer of rebuilding the college. Three years later the board ended their annual report with the following pledge: *"Religion, the basis of all true virtue, will be made, so far as human agency can do it, to throw her healthful restraints and purifying influence over the students. With this view, the public duties of each day are opened by the reading of Scriptures and prayer. On each Wednesday night, a prayer-meeting is held for the special benefit of the students, by the President of the college."*

Over the years, the college continued to grow and prosper. In 1891, the name of Central Female Institute, still a "sister" institution to MC, was changed to Hillman College in honor of the school's president, Dr. Walter Hillman, and Mrs. Adelia M. Hillman, his wife. Hillman College and MC worked together as independent colleges, complementing each other until 1942, when Mississippi College purchased the famous "girls' school" and returned MC officially to a coeducational institution once again.

On January 20, 1949, the then-new administration building located in the center of the campus was formally dedicated and named in honor of the esteemed physics professor and longtime president of the college (1932–1957) Dotson McGinnis Nelson. The handsome clock tower atop the building houses an electric IBM clock which originally had a set of

A Campus View, Mississippi College, Clinton, Miss.

This postcard view of the campus was taken in 1910, the same year that the bell tower was removed from atop the Old Chapel.

electronic chimes. In the years since, it has become the focal point of the campus, and its architectural beauty is readily recognized around the world. A photograph, drawing or engraving of this clock tower is printed on all correspondence and publications mailed or given out by the school. It is the historic symbol which endears the institution to all alumni. For years

the chimes in the clock, Westminster Chimes, alerted and encouraged students as they hurried from one class to another. It provided the right sound that prompted each student to remember the importance of their educational commitment as they set about to prepare themselves for life. Although the clock is now being repaired and the chimes are silent

they are still remembered. Recently, Dr. Charles Martin, vice president emeritus of graduate studies, who is also the much respected resident historian on campus, was asked about the chimes. Did he remember them? "Oh, yes," he said, "they not only chimed each hour, but chimed at the beginning and ending of each class period." Some students don't remember them at all. Perhaps they became used to the chimes, and didn't have an ear for them anymore. However, there are others who did have an ear and who not only appreciated the reminder of the time, but who more importantly may have been comforted by the precious old English verse which accompanies the Westminster tune:

> Lord through this hour
> Be Thou our guide
> For by Thy power
> No foot shall slide.

During the past 173 years Mississippi College has continued to develop and build on its rich heritage to the point where the school is admired by all of its peer institutions. Through the efforts of MC's numerous alumni, Mississippi's premiere college—just as in the days when cotton drove the economy—is once again poised at the right place at the right time in history. ■

streetcars in columbus

Soon after the turn of the 20th century, the enterprising city of Columbus became one of at least 14 Mississippi cities in which trolley car service became a reality. For Columbus, this service began on May 22, 1906. The photo shows a happy crowd gathered around three open-air streetcars. Ceremonies for the opening-day run were held on Main Street where it intersects with Market Street. In the foreground of the picture, one can see a 12-piece band and its director, Louis B. Divelbiss. This picture was reproduced from an old postcard which was published and sold by the L. B. Divelbiss Book Exchange, which was situated near the center of Main Street and which can be seen above the crowd over the top of the first streetcar.

These electric-powered streetcars were operated as the Columbus Railway Company, a partnership of Leopold Marx of Columbus and G. T. Heard, president of the Bank of Brooksville. The car line began at the M&O Railway Station and ran uptown, dividing into the Military Road line and the Lake Park line.

At Lake Park (now Propst Park), the owners of the car lines had a dance pavilion built. The pavilion, constructed by Arthur Stansel of Columbus, was a circular building with a dance floor 45 feet in diameter. Benches around the floor accommodated onlookers, and an open-air porch surrounded the pavilion. There was no charge for admission to the pavilion, which was built as an investment in the streetcar business. The winter of 1907 saw the pavilion covered with a fireproof canvas and enclosed to make a skating rink. Admission for an evening of skating was 25 cents, with an additional charge for renting skates.

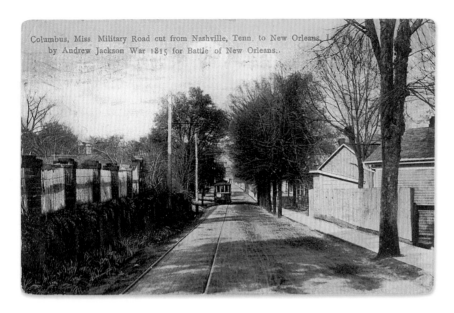

At the corner of Main and 5th streets trolley passengers could transfer to another line which utilized smaller, enclosed cars for a trip out the Old Military Road to North 7th Avenue, the corporate limits of the city.

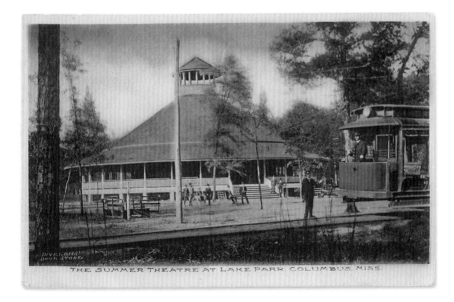

The Summer Theatre, or "Dancing Pavilion" as it was most commonly referred to, was built by the Columbus Railway Company as an investment in the streetcar business. To encourage ridership, admission to the pavilion was free of charge.

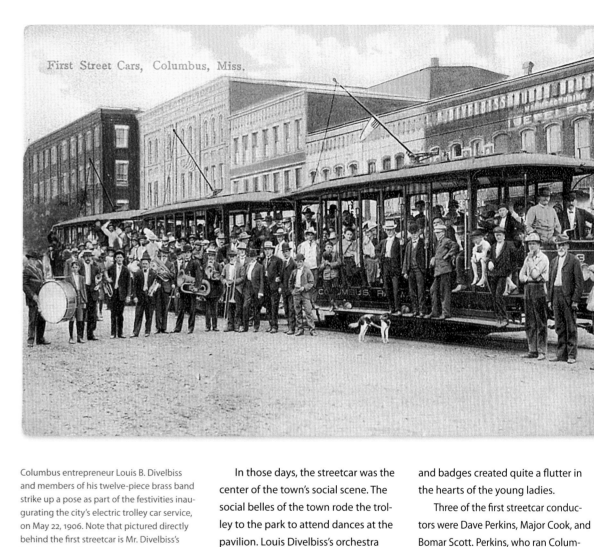

First Street Cars, Columbus, Miss.

Columbus entrepreneur Louis B. Divelbiss and members of his twelve-piece brass band strike up a pose as part of the festivities inaugurating the city's electric trolley car service, on May 22, 1906. Note that pictured directly behind the first streetcar is Mr. Divelbiss's book and novelty store.

In those days, the streetcar was the center of the town's social scene. The social belles of the town rode the trolley to the park to attend dances at the pavilion. Louis Divelbiss's orchestra played at least three nights a week. The pavilion also served as a social center during the encampments of the "State Guards," whose uniforms

and badges created quite a flutter in the hearts of the young ladies.

Three of the first streetcar conductors were Dave Perkins, Major Cook, and Bomar Scott. Perkins, who ran Columbus's first streetcar, moved to the town from Greenville, where he had been a streetcar motorman. He was paid 15 cents an hour for running the streetcar

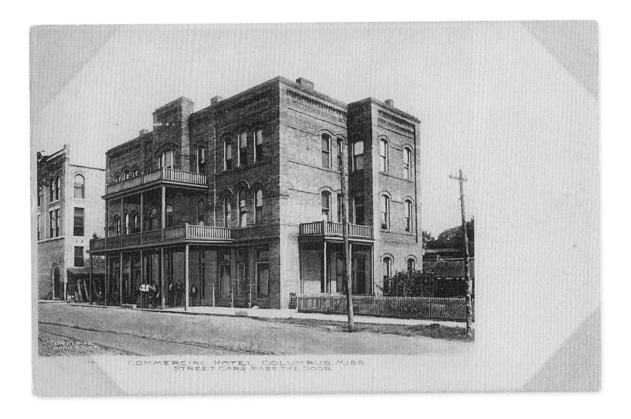

COMMERCIAL HOTEL COLUMBUS MISS
STREET CARS PASS THE DOOR

and five dollars extra per month for training the other motormen.

By 1910, the ownership of the streetcar line changed hands. The business was bought by a Colonel Greenlee, who had also obtained possession of the light and power companies in neighboring towns.

The coming of the automobile spelled the death of streetcars. Early in 1917, the cars and rails were sold as junk to a Mr. Gritzman. But, for an era, streetcars served the people of Columbus as the chief mode of transportation, giving the breath of life to business and social affairs of the town.

For further reading, see the booklet *I Remember When: Recollections of Earlier Columbus,* collected and edited by Pauline Rouse Brandon. The booklet, published by the Columbus and Lowndes County Historical Society, was the source of much of this information. ∎

The Commercial Hotel, popular with businessmen and sales representatives, wisely advertised the convenience of their location on Main Street by making their clientele aware of the fact that "streetcars pass the door."

the coldest city in the state

During January of 1909 Corinth epitomized the definition of winter. Heavy gray skies hung over sleet-covered wires, slushy streets, and citizens bundled in cumbersome clothing. Lack of vegetation created a winter barrenness not common to Mississippi. An example of the misery accompanying this uncommon cold snap is described by the caption that was added to a postcard by J. M. Lowry, the sender. It reads: "This is the day the troublemen got busy at Corinth, Miss. Jan. 11, 1908." "Troublemen" must refer to repairmen who were kept busy by broken telephone and telegraph wires. Apparently Mr. Lowry made a mistake when he wrote the date 1908. A recent check with the U.S. Weather Service has revealed that the actual date of the pictured ice storm was January 11, 1909, not 1908.

Corinth, located in the northeast corner of the state, is actually situated in the foothills of the Appalachian Mountains. Founded in 1853 in an area that was considered a probable railroad junction, Corinth originally bore the name Cross City. Less than two years later, the crossing of the Mobile and Ohio Railroad and the Memphis and Charleston Railroad became a reality. With the railroads came prosperity, and as the town began to grow, so did the desire for a new, more impressive-sounding town name. The editor of the weekly newspaper, W. E. Gibson, suggested that the name be changed to Corinth—reminiscent of the Grecian crossroads city. The suggestion was accepted, and in 1855, Cross City officially became Corinth.

In 1891, the United States Weather Bureau, now known as the U.S. Weather Service, began keeping day-by-day weather records in Mississippi. However, incomplete sketches of Mississippi weather records exist from as far back as 1849.

Because of its high elevation, Corinth has seen longer and colder winters than other Mississippi cities. In all the years of record keeping, there has never been a colder temperature registered in the state of Mississippi than that recorded in Corinth on January 30, 1966—nineteen degrees below zero. ■

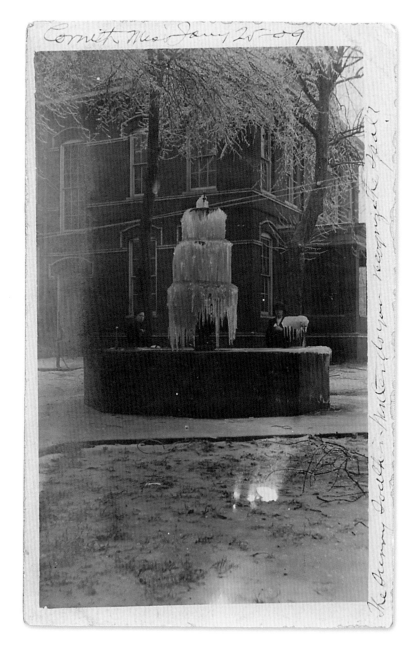

This view of the 1909 ice storm pictures the frozen three-tiered fountain on the grounds of the Alcorn County Courthouse. With the temperature at 19 degrees the two ladies posing on the other side of the fountain probably didn't stay outside very long.

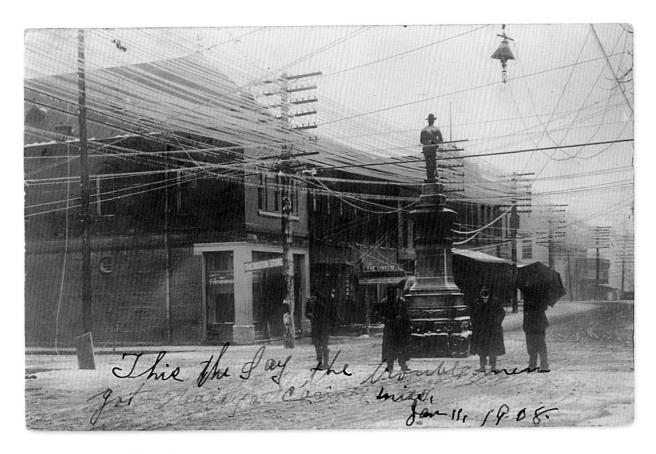

This old real photo postcard depicts inclement winter weather not normally seen in Mississippi. The sender, who mailed this card on February 7, 1909, wrote his own caption across the front of the card: "This [is] the day the troublemen got busy at Corinth, Miss. Jan. 11, 1908." Note: a recent check with the U.S. Weather Service has revealed that the actual date of the pictured ice storm was January 11, 1909, not 1908.

chautauqua

assembly

Few Americans give much serious thought to entertainment. After all, radio, television, and films make it possible for anyone to be entertained at any time. News is relayed to the public almost as soon as it happens.

But before the evolution of a sophisticated communication network, entertainment and news had to be sought. The hardship fell not only on the public but also on those who wished to communicate with the populace. The candidate could not reach voters across the country with a thirty-second commercial. The social reformer did not have television cameras covering the demonstration for the six o'clock news.

Two independent movements developed to fill the information void. The mid-1800s witnessed the development of the lyceum circuit, which provided public lectures, concerts, and entertainment. The Lyceum Building at the University of Mississippi, built 1845–48, attests to the strength and importance of this movement.

During the same period, camp meetings flourished in this country. Similar to modern revivals, camp meetings were primarily for the study of the Bible.

The chautauqua movement was a blending of the traditional camp meeting and the lyceum concept. These two American institutions were merged in 1874 through the planning of the Reverend John Vincent. In August of that year, a gathering was held at Fair Point, N.Y., on the banks of Lake Chautauqua.

The lake's name had come from a tale of pre-colonial days, when a young Iroquois boy was seen leading a blind man by a leather cord tied around the man's waist. The Indian word for the concept was "chau-tau-qua." Vincent caught the vision and adopted the name chautauqua for his idea of an institution that would

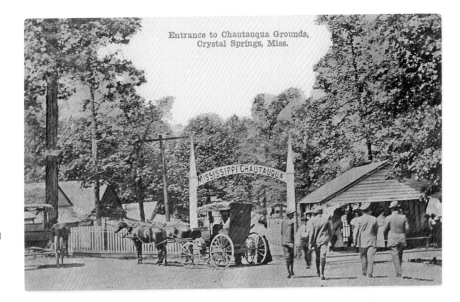

Entrance to Chautauqua Grounds, Crystal Springs, Miss.

Thousands of visitors crowded the grounds of the popular Mississippi Chautauqua Assembly every summer. To help meet the demand, 10 trains made daily stops in Crystal Springs, where for the modest charge of 15 cents a visitor could enjoy a leisurely carriage ride from the depot to the assembly grounds, a distance of 1½ miles away.

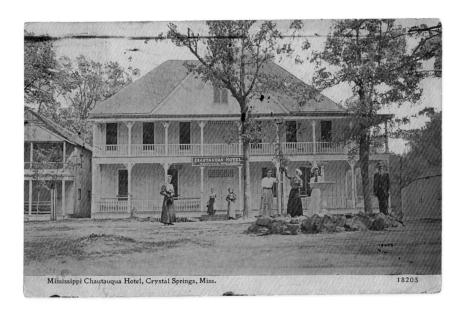

Mississippi Chautauqua Hotel, Crystal Springs, Miss. 18203

The big two-story Chautauqua Hotel, completed before 1900, "contained 44 well furnished rooms with new furniture, lace curtains, a number of baths, a large parlor complete with two pianos, and a telephone."

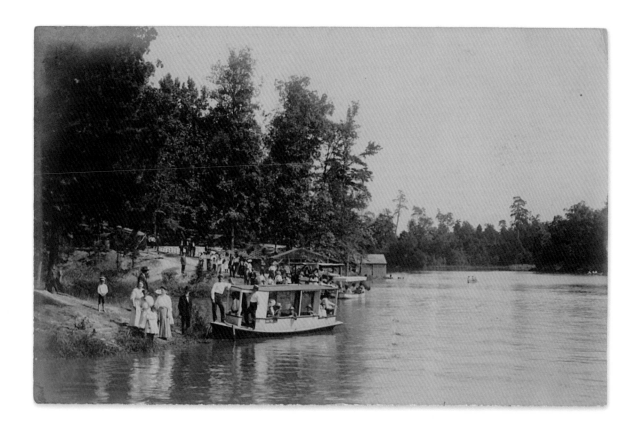

lead the spiritually blind. Thus, the word chautauqua came to refer to an institution that was distinctly religious at its foundation, but which offered the best for the moral, mental, and physical growth of its patrons.

Soon, regular chautauquas were taking place blending religion, education, and recreation. Word traveled, and requests for chautauquas came from all over the country.

Here in Mississippi Dr. Inman W. Cooper, president of Whitworth College at Brookhaven, is credited with organizing the Mississippi Chautauqua Assembly in 1892. Many of the state's religious and political leaders believed in the idea so strongly that Mississippi became the only state in the union to charter such an institution.

The chautauqua was located near the progressive little town of Crystal

At Lake Chautauqua, brightly painted canvas-topped excursion boats were traditionally a popular summertime attraction. In this circa 1908 view, two of the boats, the *Maybell* in the front and an unidentified craft in the rear, appear to be ready for castoff.

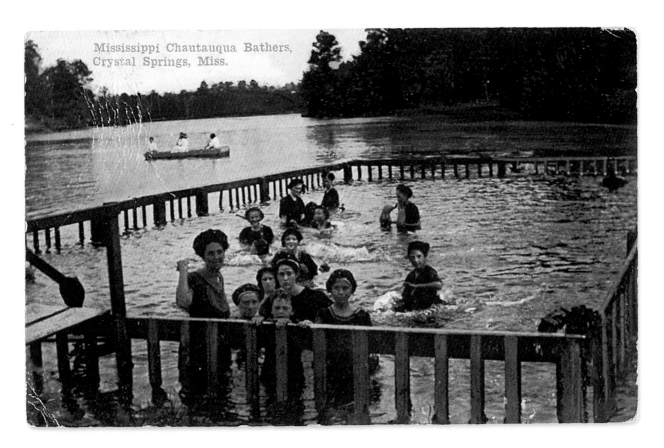

Mississippi Chautauqua Bathers,
Crystal Springs, Miss.

A group of supervised youngsters are shown having fun inside the fenced "safe area" in this postcard view postmarked July 30, 1912.

Springs on the old Hennington Camp Meeting site. This picturesque location dated to 1872, when the leading Methodist ministers of the Brookhaven district decided to establish a camp meeting and build a tabernacle in the wilderness where people could gather in the groves and under the shade of trees to worship peacefully. In 1895 a lake was built and named Lake Chautauqua. It measured about 30 acres and was generously stocked with native fish—bream, perch, crappie, and black bass from the famous Private John Allen fish farm in Tupelo.

Soon after the Chautauqua Assembly was organized, a large southern-style two-story hotel was built. It contained 44 well-furnished rooms with new furniture and lace curtains, a number of baths, a large parlor complete with two pianos,

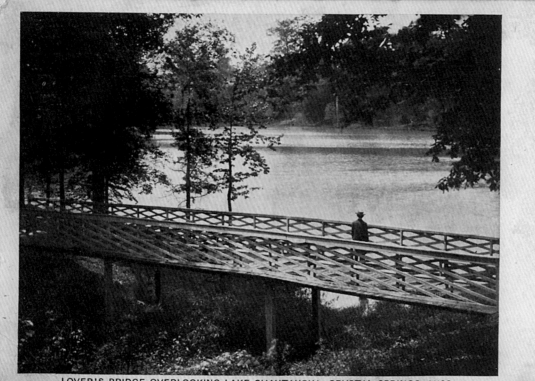

LOVER'S BRIDGE OVERLOOKING LAKE CHAUTAUQUA, CRYSTAL SPRINGS, MISS.
PUB. BY DAMPEER & DAMPEER.

and a telephone. A pavilion restaurant which could seat 150 people was added later. There were several public boardinghouses, as well as a grocery store. An electric light plant carried 300 lights and furnished illumination for the tabernacle, auditorium, and cottages. Water was supplied from a 10,000-gallon elevated tank that contained pure spring water and was located on the highest point on the grounds. The number of cottages grew from 8 in the beginning to 88 in 1916.

On the assembly grounds were a large auditorium and a natural amphitheater, capable of accommodating 3,000 to 5,000 people. A boathouse with 12 dressing rooms was located on the north side of the lake, as well

The 50-foot-long latticed footbridge, commonly referred to by everyone as "Lovers Bridge," offered spectacular views of the lake—especially at night when the moon was reflected on the water.

as a large fenced swimming area. The assembly attracted people from all over the country to its programs. Ten trains made daily stops in Crystal Springs, bringing scores of visitors. Hacks met every train, and for the modest charge of 15 cents, a visitor could enjoy the leisurely ride from the train depot to the assembly grounds, a distance of 1½ miles.

The highlight of the chautauqua was the opportunity to see and hear famous local, regional, and national personalities including speakers, politicians, preachers, singers, magicians, band concerts, and musical competitions. Some of the more famous personalities who spoke at the Mississippi Chautauqua Assembly were William Jennings Bryan, Governor James K. Vardaman, H. L. Whitfield (who later became governor), Dr. Franklin L. Riley, Bishop Charles B. Galloway, Colonel George Soule, Senator James Gordon, Senator John Sharp Williams, and Luther Manship.

For more than two decades, thousands of people enjoyed the education, entertainment, and recreation provided by the chautauqua. The assembly was the birthplace of the Mississippi Parent Teacher Association in 1909. The group was organized by delegates from five Mississippi cities, with Mrs. R. V. Stapleton of Hattiesburg the first president.

The popularity of the chautauquas began to fade in the late teens, due to the growing popularity of the automobile and the advent of the radio. Radio swept the country in the early 1920s, with sales surpassing the 2,000,000 mark in 1927. Mississippi, along with all Americans, thus had a ready source of news and entertainment, and the demand for chautauquas dwindled. Today the city of Crystal Springs operates the Mississippi Chautauqua site as a municipal park. ■

In 1850 Green T. Blythe, who, along with his brother Captain Andrew K. Blythe of Columbus, organized and led the once famous Blythe's Battalion during the Civil War, purchased a large tract of land from the Chickasaw Indians about fifteen miles northwest of Hernando near the western edge of DeSoto County. Located on a slight rise, this area was the ancient home of the Chickasaws for generations. Proof of this was revealed during the early part of this century when two nearby Indian mounds were excavated, yielding a valuable archeological find of pottery, tomahawks, and human skeletons.

In 1856 Blythe's community was hard hit by malaria. His own family was devastated by the loss of three children. But, knowing that life isn't easy and that even roses have thorns, Blythe and his wife stayed on as did other pioneers.

For the next thirty years the population of this area grew rather slowly, due to the fact that it was located in an area consisting mainly of cotton plantations of large acreage. In the 1880s there was talk of the railroads wanting to open up this section to loggers. As interest grew, more people moved into the area, where on December 23, 1883, a post office was granted.

Mr. Green Blythe was appointed as postmaster, a position he held for almost twenty years. He named his settlement Blytheville. Within a few months after securing the post office Blythe granted the right-of-way to the New Orleans and Baton Rouge Railroad. With the completion of this rail line Blytheville was put on the map, giving it connections to markets in New Orleans to the south and Memphis to the north. In 1890 the U.S. Post Office Department shortened the town's name

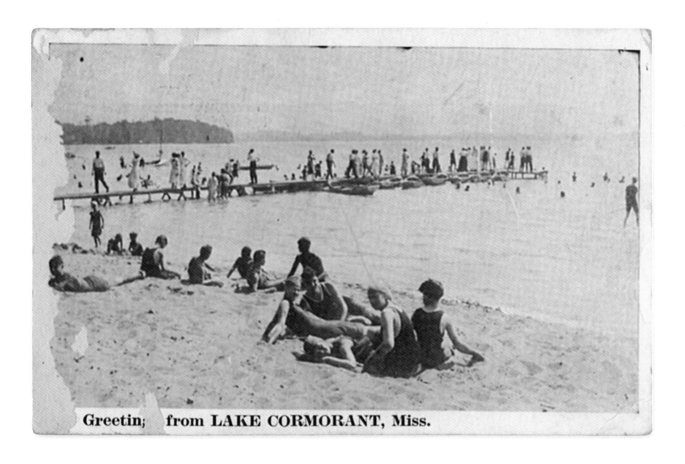

Greetin; from LAKE CORMORANT, Miss.

Each summer Lake Cormorant became a destination for many of the young people who lived in nearby Memphis, Tennessee, as well as, of course, other places. This particular postcard view was mailed from Lake Cormorant on August 5, 1929, to West Allis, Wisconsin, with the following message: "Hi Mom!—Just taking a little jaunt down here in the land of cotton. A Ford can travel long distances—Elaine."

to Blythe, and by 1900 the population of this rural cotton community had grown to 52 residents.

On November 2, 1903, the post office changed its name again. This time it was changed to Lake Cormorant for an ancient lake that was formed by the Mississippi River. This lake gained its name from the immense number of cormorants that

once lived in and around its shore. A cormorant is actually a sea bird that pursues and catches fish under water. A large cormorant is about 30 inches long, has a long neck, a wedge-shaped tail, and a slender hooked beak. They commonly weigh up to four pounds, and have wing spans as wide as four feet. It is a dark-colored bird with a patch of bare

skin around the throat. When the cormorant catches sight of its prey, it dives swiftly into the water. The bird uses its webbed feet and strong wings to propel itself beneath the surface. These large, very active birds are capable of diving to depths of about 75 feet, and can eat from ¾ to 1½ pounds of fish a day. For centuries Chinese fishermen have trained cormorants to catch fish for them. A band fitted around the bird's neck prevented it from swallowing a whole fish, but did allow it to consume small pieces tossed to it by the fisherman.

Five of the world's 25 species of cormorants are found in the United States. And, according to a field check list published by the Mississippi Ornithological Society in 1981, only three species of cormorants have been sighted in Mississippi: the great cormorant, the olivaceous cormorant and the double-crested cormorant. Of these three, only the double-crested cormorant has confirmed breeding records in this state. These somewhat unusual birds are now seldom seen in or around Lake Cormorant although according to state wildlife officials there are an estimated 100,000 of them living in the Mississippi Delta.

By 1906 Lake Cormorant's population had risen to 100. Apparently the new town name was chosen to help identify the town with the lake in an effort to not only help outsiders to locate the town, but perhaps more importantly to utilize the lake as a summer tourist's destination. This was especially true in regard to gaining the interest of the growing number of young people from nearby Memphis who were looking for a spot for fun and relaxation. It didn't matter that the old-time residents still preferred to call the town Blytheville or that some even used the name Blythedale; Lake Cormorant was on the map and new faces steadily became a common sight in town.

In 1915 Mr. William M. Mink was attracted to the area because of its large stands of hardwood timber. He built a sprawling lumber mill there that specialized in the manufacturing of staves, which were used in the barrel making industry. This mill also produced white oak rungs which were sold to ladder and chair making companies nationwide. As the Mink Lumber Mill grew, so did the population of the town. By 1920, just five years after the mill came to town, the

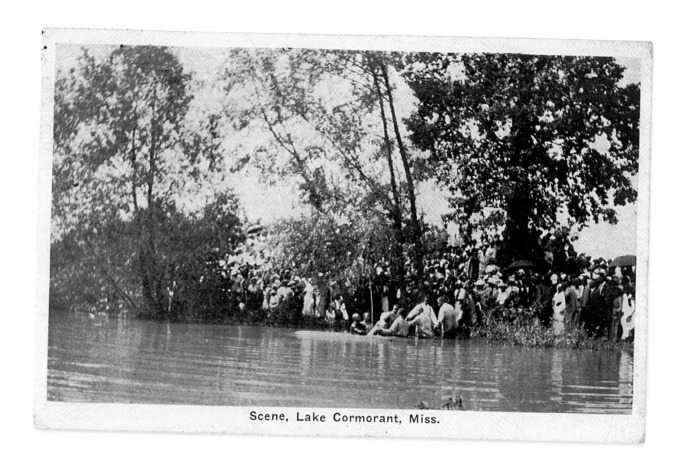

Scene, Lake Cormorant, Miss.

As may be deducted from this baptizing scene—which was mailed from Lake Cormorant on September 24, 1934, to Abington, Pennsylvania—the big lake was used for more than just swimming.

population doubled to 200. And like most large employers of the period the W. M. Mink Company owned and operated its own commissary or company store. Consequently workers received tokens that were good for trade in the store as part of their regular salary. These round brass trade tokens, "Good For / $1.00, 50 cents, 25 cents or 10 cents / In Trade," were a common item around the town of Lake Cormorant as late as the early 1940s.

The lumber mill provided work, and the lake, with its long wooden pier and man-made sandy beach, became the summer favorite for hundreds of people from miles around. During the exciting decade of the 1920s the big oxbow-shaped lake became a mecca for boaters and

bathers alike as can be seen in the accompanying postcard view entitled "Greetings from Lake Cormorant, Miss." This particular postcard view was mailed from Lake Cormorant on August 5, 1929, to a lady in West Allis, Wisconsin, with the following message: "Hi Mom!—Just taking a little jaunt down here in the land of cotton. A Ford can travel long distances.—Elaine."

Mr. Green Blythe moved to this part of what is now DeSoto County to take advantage of the rich soil, some of the most desirable farmland in the entire world. And Mr. William Mink moved to the area to reap the harvests of the virgin hardwoods. Once the big oaks were gone the land was cleared to make way for more farmland. After all, the world has learned to depend on the agricultural crops grown in the unique delta land of Mississippi. The arable earth of western Mississippi takes precedence over timber, towns and even lakes. With the timber gone in the 1930s, a decision was made to drain Lake Cormorant in an effort to make more farmland available. The lake was dredged, and in essence a ditch was dug for almost 12 miles from the bank of Lake Cormorant to the Coldwater River. The drain took place over a period of months as the lake and the surrounding sloughs slowly yielded up their beds to the plows of the farmer.

The body of water once known as Lake Cormorant is no more. The mill isn't there anymore either. It has been gone for more than fifty years. It ceased operation when all the timber was cut. And the town itself is not nearly so large as it once was. With only two stores and a population of approximately 75–80 residents, it is more like it was when it went by the name of Blytheville. However, indications are strong that the old town is destined to grow as a residential community of greater DeSoto County. Even as you read this new homes are being built not only inside the town limits, but throughout the surrounding countryside. It is quite likely that within a few years homes may even stand where once boaters and bathers splashed across Lake Cormorant. ■

influential florence

Positioned at the southwestern corner of Rankin County, Florence is the historical entrance into what is today the third-fastest-growing county in Mississippi. The longtime village is rapidly developing into a town with a population of 2,500-plus. It is a bud beginning to blossom. It is my hometown.

Mississippi, the seventh state formed following the American Revolution, is our nation's 20th oldest state and is unique in that it was settled for the most part from west to east. Like a multilane highway, the Mississippi River played an enormous role in this development. Because there were no interior roadways, the majority of people who chose to relocate from New England, Virginia, Kentucky, Tennessee, and even the Carolinas came by way of the Mississippi River.

When statehood was achieved in 1817, the city of Natchez became sort of an Ellis Island, as thousands of new settlers eventually entered the state at this port. Almost immediately, many began to migrate to the center of the state in anticipation of the state capital being moved from Washington, near Natchez. Consequently, the town of Monticello, the seat of government for Lawrence County, became a boomtown as families, merchants, and professionals moved inland. It was largely from Lawrence County and Covington County that the Steens, Enochses, Butlers, Coopers, Williamses, and Smiths, to name only a few, moved northward to settle into the southwest corner of what became Rankin County in 1828.

The most favorable homesteading site selected by these pioneers was at the juncture of an ancient Indian crossroads near the confluence of Indian Creek, Butler

Creek, and Steen's Creek. This coveted spot was still occupied by scattered families of Choctaws, who would continue to call this area home for several more years, even after the land-ceding Treaty of Doak's Stand was signed in October of 1820. Of the newcomers, the family who had the greatest impact was the Protestant Irish-American family of William and Nancy Lusk Steen. The exact date of their arrival from the Carolinas by way of Tennessee isn't recorded, but it is known that members of the Steen, Enochs, Neely, Cooper, and Williams families fought together to defeat the British at the Battle of Kings Mountain during the American Revolution, and that after the war they traveled in ox-wagon caravans westward in search of more arable soil.

The family of John Romily and Mary Steen Enochs arrived in south-west Rankin County in the second decade of the 19th century, according to a Steen family history written by Captain Isaac V. Enochs in 1893. The family history records that when they built their home near Steen's Creek (now Florence), "he carved on the mantel of the best room 'John R. Enochs—His Home 1817.'" Soon,

several other members of the large William Steen family began to build their own homes nearby. Realizing that the teachings of Jesus are a whetstone to the heart and essential to developing Christian character, the family of Silas and Hannah Myers Steen led the way in establishing the First Baptist Church. This church, which dates from 1824, is the oldest church of any denomination in the county.

Primitive flint points, petrified wood, and other fossils are being discovered in Florence as land is cleared to make way for modern development.

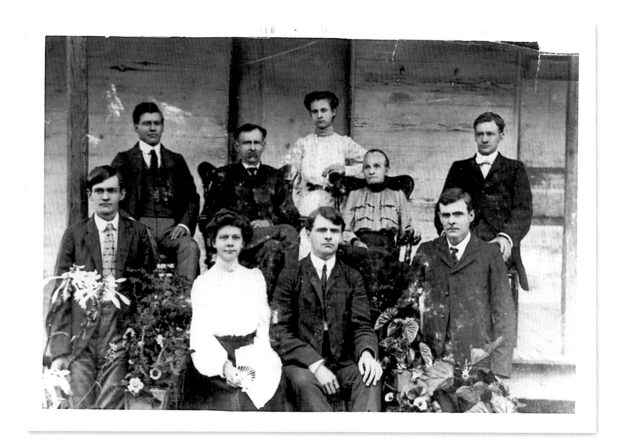

This 19th-century photo features descendants of the William and Nancy Lusk Steen family, who settled in the southwestern corner of Rankin County in the 1820s. The village of Steen's Creek was named for them.

The present building, the fifth to house the Baptist congregation here, is a six-year-old Colonial-style brick structure with seating for 1,200. The cross-topped steeple stretches skyward for 120 feet and can be seen a mile or more away in almost every direction. The sanctuary houses the second-largest Allen digital organ in the state (the largest is at Christ United Methodist Church in Jackson). However, more important than the sacred music is the Word preached from the pulpit; here, pastor Dr. Dwight L. Smith preaches what many other pastors have lost the ability to say or have never felt. Like the Steens of 10 generations ago, he pleads by example the teaching of Jesus found in the Gospel of Matthew (6:33), "Seek ye first the

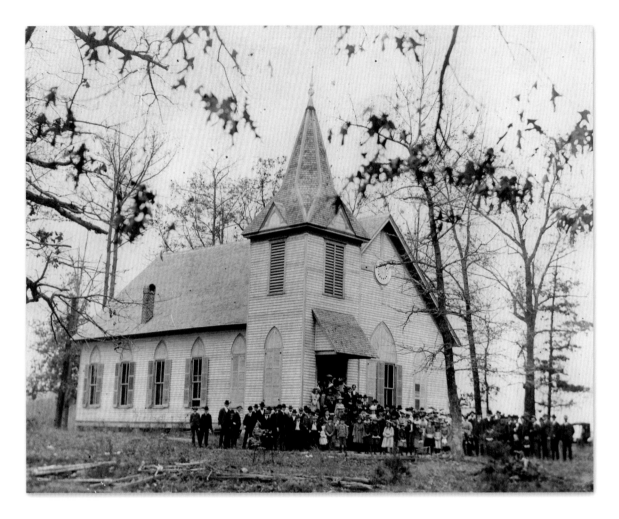

kingdom of God." This is the theme for which the town of Florence has been known for more than 180 years.

Up until the time of the Civil War, the small community of Steen's Creek was on the map largely due to its post office, which dated from March 16, 1829, and which was located in a small store owned and operated by Orin C. Dow. During these years, the village was not much more than a cluster of shops around the Baptist church.

All that changed in 1858 when a merchant-minded family named Ellis

Members of Steen's Creek Baptist Church, now First Baptist Church of Florence, pose for the camera on a winter day around 1885. The church is the oldest in Rankin County.

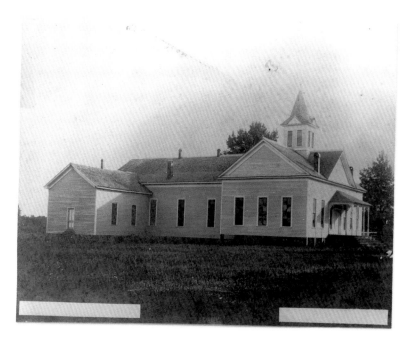

Steen's Creek High School, new at the time this photo was taken in 1908, stood at Main and College streets, where the Florence Middle School auditorium stands today.

moved here from North Carolina by way of Kemper County. After the war, which almost destroyed the settlement's economy, Gray Ellis gave the reins of his general store to his son William Cofield Ellis, known as "W. C." in the business world and "Cofe" to his friends. During the late 1870s and early 1880s, Ellis applied the knowledge he had gained at the University of Kentucky to become one of the premier businessmen in the state. Although Steen's Creek was his home and his

general merchandise store here was the largest in town, he owned similar stores, sawmills, gins, and warehouses in Magee, Crystal Springs, Terry, Hamburg (in Franklin County), New Hebron, and Jackson, along with 2,140 acres of farmland.

In 1881, "Cofe" Ellis married Florence Norrell, daughter of the Honorable Thomas N. Norrell of nearby Richland. Both were of strong Christian character, and together they strove to follow the path inspired by the Steens

two generations before. Once while a student at Whitworth College in Brookhaven, Florence—known to her family and friends as "Fonnie"—wrote a term paper on "character." The following quote from the paper gives us an insight into the beliefs of this enlightened college senior of 1879:

What constitutes true loveliness? Not the polished brow, the gaudy dress, nor the show and parade of fashionable life. A woman may have all the outward marks of beauty, and yet not possess a lovely character.

It is the benevolent disposition, the kind acts, and the Christian deportment.

It is in the heart, where meekness, truth, affection, [and] humility are found, where we look for loveliness, nor do we look in vain.

The woman who can sooth the aching heart, smooth the wrinkled brow, alleviate the anguish of the mind, and pour the balm of consolation in the wounded breast possesses in an eminent degree true loveliness of character.

It is such a character that blesses with warmth and sunshine, and maketh earth to resemble the paradise of God.

In 1852, the citizens of Steen's Creek built a school, which likely was the first to serve the county as its origins dated to the 1820s. It was in the Baptist church that the Steens and others first started to teach both young and old citizens to read. Their textbook was the Holy Bible. The school, a boarding school, was the only high school in the county well into the 1890s.

In 1893, officials hired native Rankin Countian Henry L. Whitfield to serve as headmaster. Under Whitfield's tutorship, the school drew students from as far away as Yazoo City. In his book, *The Life of Henry L. Whitfield of Mississippi*, Bill R. Baker wrote, "The religious character and interest of Henry Whitfield was very obvious to the students at Steen's Creek School inasmuch as he wanted them to develop in spirit as well as in mind and body." On the front page of the February 23, 1894, *Steen's Creek Record* newspaper, Whitfield made a plea to the local citizens to help build a school library. He asked that people donate books of "pure moral tone—histories,

This is the 1881 wedding picture of William Cofield Ellis and Florence Norrell Ellis, for whom the town of Florence was named.

biographies, etc." The school, Whitfield said, "should be a mental gymnasium where the thinking subject should have every faculty of his mind developed just enough." Whitfield's philosophy of education, wrote Baker, "could

not be separated from the ideals of Christian faith."

From that time until now, Florence High School has been ranked in the top echelon of high schools in the state, thanks to Whitfield's early standard. From Steen's Creek, he left to become the state superintendent of education, then president of what is now Mississippi University for Women, and finally Mississippi's 42nd governor in 1924.

Even though Florence has had several mills over the years, it has never really been known as a mill town, nor has it gained a reputation for being a gin town even though the W. C. Ellis gin and later the J. H. Alford gin brought scores of farmers to town every harvest season. It also never made a name for itself as a rail town, though the Gulf and Ship Island Railroad, which linked Gulfport to Jackson, played an important role. The last spike driven to complete the rail line was hammered into place at Steen's Creek on July 4, 1900, in a gala celebration complete with speeches, soft drinks, and a fireworks display.

The rail line not only brought the world to the doorsteps of southwest Rankin County, but also brought

Steen's Creek—or "Steen Creek," as it had been known officially since January 7, 1892—a new name. How this came about has never been recorded; some locals will tell you that Florence was named for Mrs. Florence Norrell Ellis by railroad officials when the right-of-way through the town was "given" to them by her husband. Others claim that Mr. Ellis specifically asked the railroad men to name the town in honor of his wife in exchange for the right-of-way. Whoever is right, there is no denying that the post office officially changed the name to Florence on February 19, 1901.

On May 30, 1905, the village of Florence, with a population of 300, was elevated to town status in a document signed by Governor James K. Vardaman. Because of this, some think the community of seven Christian churches, including 102-year-old Marvin United Methodist Church, plus the only four-year accredited college in the county (Wesley College, operated by the Congregational Methodist Church) is only about a century old. Nothing could be further from the truth.

New construction of businesses and homes, including eight subdivisions in or near the town limits, is alerting everyone's attention to the future. Even those who have lived here for a lifetime are beginning to see real change. Florence is no longer the sleepy little town it used to be—the high school, middle school, and elementary schools are all being enlarged; a new bank (the town's third) and several other new businesses, including a third strip mall, are in the process of being built.

Land is being cleared to make way for the building boom, and in the process the past is being uncovered. During the last 18 months, I have found several ancient flint points and tools. The oldest point, commonly referred to as an arrowhead, is actually a small spear point. In archeological language, it is a "Cache River point" and is thought to date to around 8000 B.C. The largest point is a "Pickwick point," which likely served as a knife. It was made from Tallahatta quartzite (sugar quartz), possibly quarried from the Meridian area, and is dated to the late Archaic period, 3000–1500 B.C.

Another knife blade, almost opaque, is made from novaculite, which is found in the Ouachita National Forest area of Arkansas. It is a classic "Gary point" and dates from

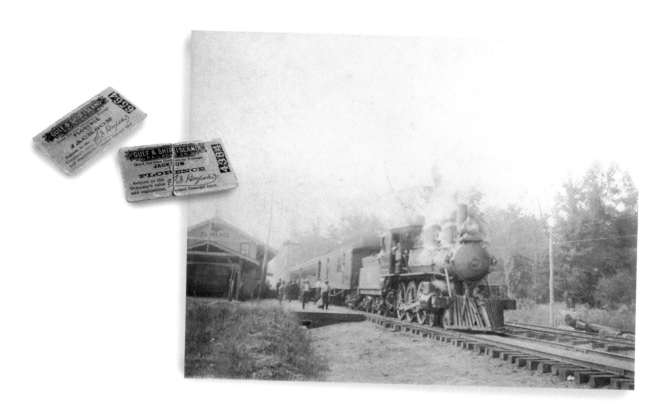

The Gulf & Ship Island Railroad was completed at Steen's Creek on July 4, 1900, and the first train arrived the next day. Since the depot was named Florence by railroad officials, the official name of the town and post office was also changed to Florence on February 19, 1901.

2000–500 B.C. It has been suggested that this little blade may have originally been 6 to 8 inches long and was resharpened so many times that it is now only 1¾ inches in length. The second-largest point is a "Pontchartrain point," the edges of which are serrated, indicating use as a spear point or knife. It was made from local gravel and dates from 1500–500 B.C.

The newest point, which dates from 500 B.C.–800 A.D., may actually have been an arrowhead. The bow wasn't

introduced to the Americas from Europe until around 500 A.D., so this point may have been made to fit an arrow shaft, but, more likely, it too was used as a spear point. It was made from local gravel and was lightly heated to improve flaking during the process of chipping the stone into shape.

The final two artifacts in this group are not arrowheads or points at all. They are tools, which are perhaps more exciting because they conjure up images of settled people. One,

which has an arched blade, is actually an Archaic biface fragment. This was made sometime between 6000–500 B.C. It was never finished, perhaps because of a stone flaw, but is believed to have been used as a spokeshave, to shape handles and such. The last item is an Archaic "adze." It is an early specimen dating between 9000–6000 B.C. It obviously has been extensively resharpened, and the edges have been ground smooth to facilitate hafting. When the last resharpening was done, the maker put a graver spur on one edge, making this a multipurpose tool.

In addition to these ancient tools and points, I have also found in the same area a couple dozen small pieces of petrified wood, including palm, cypress, and oak. I have also found more than 100 chunks of seashell-encrusted coral, most of which are rounded smooth, apparently from being tossed about by water. All of these items I have found lying on top of red clay hills near the eastern town limits of the town of Florence.

Some people to whom I have shown these artifacts do not seem to be very amazed. They simply say, Oh, didn't you know much of Mississippi was under water thousands of years ago? My answer is of course it was, every state in America was under water about 5,000 years ago, as was every nation on earth. Not only that, but the water was 20 feet deeper than the world's tallest mountains (Genesis 7:20) and it covered the earth for more than a year. As far as I am concerned, these artifacts are visual proof of the written truth. The variety of these prehistoric projectile points and tools, which were found in a one-square-mile area and which are from different stair-stepped eras of time, strongly suggests a permanent habitation by people who lived here long before the Choctaws.

From early man to Choctaws and from pioneers to modern-day citizens, the mantle is about to be passed to the hundreds or perhaps thousands of newcomers who will move to Florence during the next few years. We can hope that they will continue the heritage of striving to inspire character as left to us by the Steens and Ellises and the many, many others . . . only time will tell. ■

an early look
at downtown greenwood

In 1911 few cities in the state enjoyed as much daily activity as did the energetic city of Greenwood. With a population of 9,000 and growing, it had a well-established reputation as one of the leading trade and cultural centers of the Delta.

On April 5, 1837, Titus Howard and Samuel B. Marsh purchased a large tract of land on both sides of the Yazoo River in what is now Leflore County. They bought the land from Coleman Cole, a Chakchiuma Indian, with the understanding it would be used as a town site. This area, which had previously been referred to by some as Williams Landing, was at first slow to develop. But seven years later, on February 16, 1844, the small town was incorporated under the name Greenwood, in honor of the great Choctaw Chief Greenwood Leflore.

Once incorporated, the town began to grow and prosper. Two weeks before Christmas in 1897, the town became a city, and by the turn of the century Greenwood was known throughout the state as "The Queen City of the Delta."

The accompanying postcard offers a view looking northeast up Howard Street. Ten years before this photograph, a fire destroyed most of the buildings in this heart of the business section.

Although the city's streets weren't paved at the time of this view, they were oiled with a crude black oil spread over the most heavily traveled streets in an effort to keep down the dust. The two white horses at left appear not to be too concerned with the automobile or any dust, perhaps because a city ordinance regulated the speed of autos to six miles per hour or four miles per hour around curves. On the opposite side of the street, however, the young cyclist pausing at the intersection

HOWARD STREET, LOOKING NORTH,
GREENWOOD, MISS.

of Howard and Washington streets seems to be totally captivated by the new machine.

In the distance trees grow on the bank of the Yazoo River, just two blocks away. The large building on the left is the Greenwood Furniture Company, whose slogan reads "everything for the home." Next to it stands the Electric Theater, which only a few years earlier was the Opera House. The first building on the right is a dry goods and clothing store. Beyond it, the tall building with the yellow front is the Bank of Leflore County; farther down the street can be seen a sign reading "SHOES," advertising the Crull Shoe Store. In 1913 this store sponsored the city's first youth baseball team. This business interest in youth reflects the spirit of this postcard view; Greenwood depicted small town America in the early part of this century at its best. ■

In this hand-colored circa 1910 postcard view, Greenwood depicts small town America at its very best. Note the boy to the right, leaning on his bicycle seat, who appears to be totally captivated by the busy scene in general and the new auto in particular.

mississippi citrus

For over half a century oranges grew profusely along the Mississippi Gulf Coast. Because of the warmth resulting from the water frontage, the entire coastal area was, for an era, especially adapted to orchard fruits in general and orange culture in particular. At the turn of the 20th century, the Mississippi Coast area was known as the Satsuma Belt, with thousands of trees bearing their golden fruit in groves stretching from Bay St. Louis to Pascagoula.

According to Mr. John H. Lang, a lifelong resident and historian of Harrison County, orange trees which he referred to as the "Louisiana Sweets" not only grew in abundance, but were quite large as well. He states in his book, *History of Harrison County, Mississippi*, published in 1936, that "These trees were as much as 12–15 inches in diameter." He implied that a large number of these trees grew wild, and were found in small groves in every county along the coast. In the 1870s these small groves were certainly not an uncommon sight, and were, I presume, no more of an oddity than are wild plum thickets today.

As early as 1876 the small town of Orange Grove, Mississippi, located 12 miles northeast of Pascagoula, had a post office, indicating a substantial population of permanent inhabitants. This town was named for a grove of orange trees that history tells us were planted in the mid-1700s by two French settlers. These early Frenchmen were also responsible for introducing pecan trees as well as fig trees to this area.

In April of 1882 two brothers, James and Woods Thomas, moved to Long Beach, Mississippi, from Wilson County, Tennessee. These men purchased 40 acres of land

At the turn of the 20th century, the Mississippi Coast area was known as the Satsuma Belt, with thousands of trees bearing their golden fruit in groves stretching from Bay St. Louis to Pascagoula.

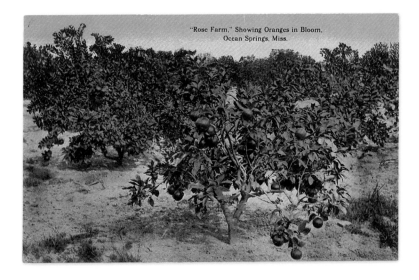

Before 1910 E. W. Halstead, the former assistant horticulturist for the island of Cuba, established a large citrus nursery including several orange groves near Ocean Springs.

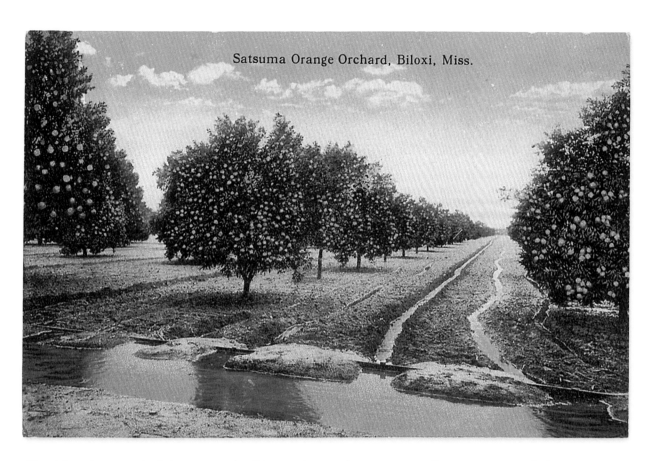

Satsuma Orange Orchard, Biloxi, Miss.

Although the Washington navel and other varieties of oranges were grown in Mississippi, it was the satsuma that was by far the most profitable.

and on this property opened a nursery of fruit trees specializing in satsumas, peaches, pears, and pecans. So successful was their nursery business that soon a third brother, Caesar Thomas, joined them as a partner in what became a booming enterprise. They soon employed several travelling salesmen who sold thousands of satsuma trees all along the coast from New Orleans to Mobile.

Many growers were enjoying varying degrees of prosperity when, on March 5, 1885, the first known freeze occurred on the Mississippi Gulf Coast. Up until this time freezes were never known to have occurred in this region. The sheer size of the trees as referred to earlier by Mr. Lang certainly adds credit to the fact that the year 1885 marked the beginning of a climate change. The next freeze occurred

on March 16, 1892, but the coldest weather ever experienced in this area was during the morning of February 13, 1899, when the thermometer dropped to 4 degrees above zero. These freezes, coming as they did in late February and early March, dealt a very severe blow to most of Mississippi's citrus orchards.

After the turn of the century a concentrated effort was made to reestablish citrus fruit culture. Dozens of nurseries sprang up all along Mississippi's coastline. Mr. E. W. Halstead and his sons established a large nursery with several orchards near Ocean Springs. Mr. Halstead, before coming to Mississippi, was the assistant horticulturist for the island of Cuba, where he attained great successes in the management of satsuma and grapefruit trees. While in Cuba, he managed one of the largest citrus orchards on the islands, over 3,000 acres, giving him valuable experience in successful orchard development. With this knowledge, Mr. Halstead and his sons built one of the largest nurseries on the Gulf Coast.

While the Washington navel and other varieties of oranges were grown, in Mississippi the satsuma was by far the most profitable orange. Unlike any other orange, the satsuma is almost free of seeds, peels perfectly, contains very little acid and has no equal in juice, flavor, and rich appearance. In December of 1904 several boxcars of satsuma oranges were shipped to New York City and Scranton, Pennsylvania, by Mr. Frank H. Lewis of Pascagoula. These oranges were grown in Mr. Lewis's groves on the banks of the Pascagoula River. In 1915, Jackson County produced 10,000 straps, or 12 railroad boxcars of satsuma oranges, worth $20,000. These oranges sold for $4.00 and up per box (or strap), the highest priced citrus produced in the United States. This Mississippi-grown orange was the earliest variety on the market and was also reported to be the best tasting. When asked in 1915 about Mississippi's citrus, Mr. G. A. Park, General Immigration and Industrial Agent for the Louisville and Nashville Railroad, stated, "Ocean Springs, Mississippi, is in the lead of any other section on our road of citrus fruit."

During the second decade of the century many Mississippi citrus growers were enjoying a fairly high degree of success with all their citrus crops: satsumas, grapefruits, lemons, and

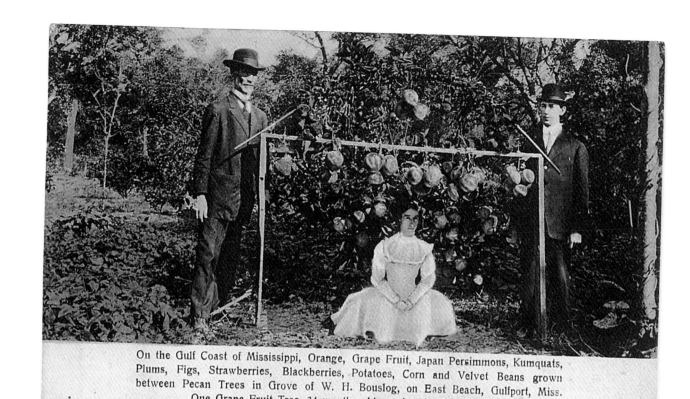

On the Gulf Coast of Mississippi, Orange, Grape Fruit, Japan Persimmons, Kumquats, Plums, Figs, Strawberries, Blackberries, Potatoes, Corn and Velvet Beans grown between Pecan Trees in Grove of W. H. Bouslog, on East Beach, Gulfport, Miss. One Grape Fruit Tree, 34 months old, produced 90 Grape Fruit.

Before 1920 many Mississippi citrus growers were enjoying a high degree of success with all their citrus crops: satsumas, grapefruits, lemons, and kumquats.

kumquats. The 1915 citrus harvest was the most abundant ever, and dozens of growers, nurserymen, and scores of land owners and investors looked forward to even greater years. But, this was not to be. Another hard freeze came in the late teens, killing almost all of the citrus trees to the ground.

The groves were so completely destroyed that most growers were bankrupted. Those who were not

began to look elsewhere for an investment. Some planted their entire land area in pecan trees. Others began planting large acreages in tung nut trees. Still others invested in forest management. However, there were a few growers who managed to maintain their citrus groves through the 1920s and into the 1930s. One of these was state senator George Smith who had a satsuma grove of 3,500 trees,

located 9 miles north of De Lisle, in Harrison County. Another was state senator Frank Pittman who had a large satsuma grove in Hancock County, 7 miles east of Picayune—along the banks of the Pearl River. During the depression years, Senator Pittman marketed his oranges by trucking them to the Mississippi Delta, where he sold them to the local merchants. The late 1930s saw another hard freeze, completely wiping out the once famous Mississippi orange groves.

Today, the few trees that can be found are located in residential areas and are grown more for novelty than for the fruit they may bear. The Mississippi orange groves are but a fading memory, preserved for us only on the faces of postcards proudly sent in earlier days. ■

where the lights live

Nestled along Mississippi's 75-mile shoreline, high atop cone-, pyramid-, and even cottage-shaped lighthouses, is where the lights live, or—more correctly—lived. All but one are gone. No longer do the lights actually exist as live flame like they once did, providing guidance to safe harbors for sailors, fishermen, or weary travelers. Once, more than 10 lighthouses guarded the Gulf waters from the Alabama state line to the Louisiana border. Today, those lights have faded almost completely away.

Throughout the expanse of the Mississippi Sound, the only original lighthouse still in place is the Biloxi lighthouse. Built in 1848—the same year that the foundation for the Washington Monument was laid and the University of Mississippi was established—it stands today as the most distinctive symbol of the Mississippi Gulf Coast. No other man-made structure so identifies the area. The still-illuminated 155-year-old tower is an image indelibly etched into the minds of perhaps millions of people from around the world.

The 48-foot-tall conical brick structure is sheathed in a strong cast-iron armor-like skin that has enabled it to withstand every hurricane, gale, and squall Mother Nature has sent her way over the past century and a half. Time-tested, she stands like the proud sentinel she is, gleaming under her pristine coat of beach-white paint. She looks nothing like her age. She doesn't act it, either. Now under the management of the Biloxi City Department of Museums, her light shines 365 nights a year. Controlled by an electrical timer, the beam of light comes from her original Fresnel lens and is visible from 13 miles away.

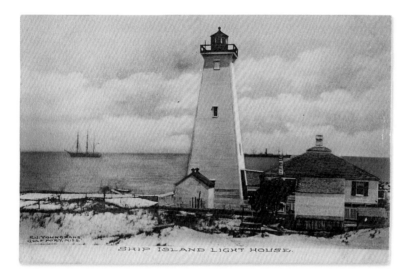

SHIP ISLAND LIGHT HOUSE.

The Ship Island lighthouse, shown in this 1906 view, was the second lighthouse built on the west end of the island. The original 48-foot-tall brick lighthouse, constructed in 1858, was disabled by Confederate troops in 1861 and rebuilt by Union forces the following year. Time and storm damage caused it to be condemned in 1885. This second tower, described as a "square wooden pyramid," was a popular tourist landmark for more than a century. It was accidentally burned by campers on June 27, 1972.

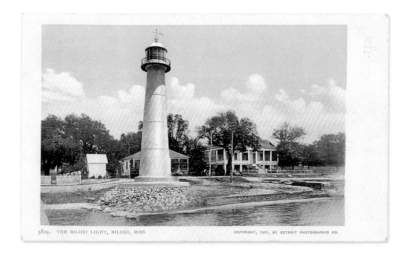

5824. THE BILOXI LIGHT, BILOXI, MISS COPYRIGHT, 1901, BY DETROIT PHOTOGRAPHIC CO.

Biloxi's lighthouse, the pride of the Gulf, is shown in this 1901 view sporting a fresh coat of white paint after its foundation was shored up with ballast stones. The stones, which came from sailing and steamships from all over the world, initially were cast overboard at Ship Island as large seagoing vessels were loaded with Mississippi timber for export.

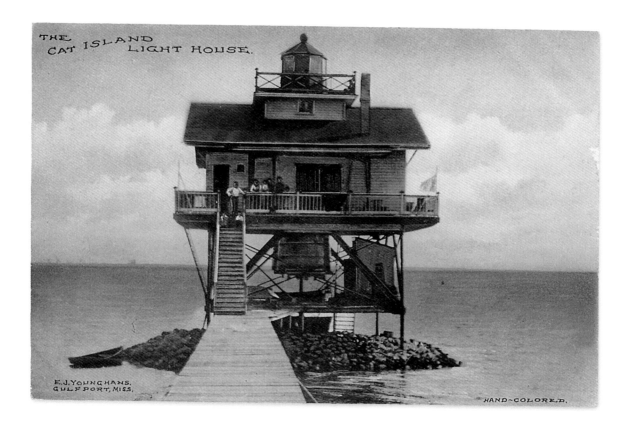

THE CAT ISLAND LIGHT HOUSE.

E.J.YOUNGHANS.
GULFPORT, MISS.

HAND-COLORED.

This hand-colored view pictures the Cat Island lighthouse and presumably its keeper and family circa 1907, not long after five feet of rock riprap was placed around and underneath the structure in an effort to stabilize the foundation.

It hasn't always been that way. During the Civil War, her light went out. Actually, the boys in gray buried the French-designed brass lamp and reflectors in the sand in a successful effort to keep the lighthouse from being useful to the Federal navy. After the war, the lens was recovered and placed back into what was by then a somewhat run-down tower. During the war, the annual (and sometimes more frequent) whitewashing of the

iron sheathing had not taken place. It doesn't take wind-driven sand and sea salt long to strip paint from iron. By the middle of 1865, the tower was encrusted in rust from top to bottom. There was a rumor several years ago that during this period, the lighthouse was painted black in sympathy for the death of Abraham Lincoln. It is highly unlikely that in the shadow of Beauvoir, Lincoln would have been so honored by those who had only recently

buried their dead. What is likely is that some caretaker of the lighthouse, perhaps the keeper himself, swabbed the rusting sides of the structure with an oil-based, tar-like substance in a desperate attempt to preserve the metal until funds could be acquired for its proper repainting.

The iron lady on the beach had another problem during this same period. Her foundation started to wash away. A retaining wall that had been neglected during the war failed. An 1867 engineer's report indicated that the tower had "inclined at least two feet from perpendicular" and was "in danger of toppling into [the] Mississippi sound." The problem was solved when workers carefully excavated just enough from under the northeast side of the structure to allow it "to ease itself to upright under its own massive weight."

Again in the early 1900s, the tower was plagued by erosion. This time, hundreds of stones were brought in from Ship Island and placed as riprap around the base of the tower. These stones were retrieved from near the 310-foot-wide channel that ran from the end of the Gulfport pier to Ship Island's harbor. At the time, the seven-mile channel wasn't deep enough for the large ocean-going vessels, so timber and other cargo were floated via smaller craft out to Ship Island for loading onto the big ships. Captains of tall-masted ships and steamships from Europe and Asia, and from the Baltic to the southernmost nations of South America, ordered their sailors to toss overboard stones, which served as ballasts during their incoming voyages. Now, a full century later, the Biloxi lighthouse is no longer in danger from erosion. It is secured by stones from Wales and Newcastle, by portions of boulders from the Pyrenees to the Andes, and by rock from the Holy Land.

In the waning years of the 17th century, when French mariners first sailed into what is now the Mississippi Sound, they initially focused their attention on the small islands that act as sentries, guarding our state's shoreline. The deep water at Ship Island made the tiny isle a perfect port for ships of the sea. Some 150 years later, under the leadership of U.S. Secretary of War Jefferson Davis, Ship Island was selected as a coastal defense site. A brick cone-shaped lighthouse, almost identical to the Biloxi tower, was

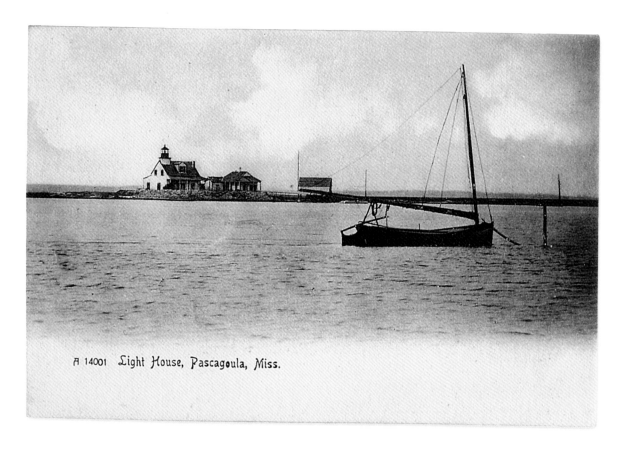

A 14001 Light House, Pascagoula, Miss.

This Rotograph postcard view of the Pascagoula River lighthouse, shown to the left of the light keeper's home and boathouse, predates the Great September Storm of 1906.

completed in 1853. Disabled during the war but quickly repaired by Union militia, it stood until 1886, when it was replaced by what has been described as a "square wooden pyramid." The beacon atop this station was first lighted in September 1886, a month before the Statue of Liberty was dedicated in New York Harbor by President Grover Cleveland. (The Statue of Liberty was the nation's first lighthouse powered by electricity.) Constructed much like a forest fire tower with the sides enclosed with planks of pine lumber, the Ship Island lighthouse was a popular tourist attraction. So well-known and admired was this "wooden pyramid" that it became the logo for the Coast's largest banking institution, Hancock Bank. Unfortunately, during the night of June 27, 1972, two young campers who had started a small fire

failed to extinguish the blaze, and after their departure, it grew into an inferno that could be seen for miles. By morning, all that was left of the lighthouse was the concrete foundation. A replica now stands in its place, and although it is a nice look-alike, it isn't used for navigation.

The two oldest of the Mississippi Sound's lighthouses were the Cat Island lighthouse and the Pass Christian city tower, both of which dated from 1831. The tower on Cat Island was constructed of brick and stood 34 feet tall. Apparently it was wrecked by a hurricane in 1860 and destroyed one year later by Confederate forces. In July 1871, a prefabricated cottage-like structure on screw piles arrived via ship from New England and was installed as Cat Island's second and last lighthouse. By 1900, the island had so shifted from storms and sand erosion that the lighthouse no longer stood on the land but was surrounded by shallow water some 100 yards to the southwest.

The Pass Christian lighthouse is described in the booklet *Lighthouses and Lightships of the Northern Gulf of Mexico* by David L. Cipra as a "stubby white brick tower." The lens and lighting apparatus were confiscated by the Confederacy during the war and hidden, and the light was not made operational again until August 15, 1865. However, by the late 1800s, trees between the light and the beach had grown so tall that the beacon was no longer effective. The owner of the trees reportedly did not want to cut them, and the government refused to spend additional funds to build the tower taller, so the lighthouse and its small acreage was sold to a private citizen in 1882, and the tower was dismantled for salvage. The Pass Christian Lighthouse Society now hopes to eventually reconstruct the city's lighthouse.

The Pascagoula River lighthouse was originally erected in 1854 on the west bank of the East Pascagoula River on a slice of land known as Spanish Point that jutted out near the mouth of the clear water stream. Like the other coastal lighthouses, during the war, its light from a fifth-order lens, visible for 10 miles, was extinguished by the Confederates as a defensive measure. Its flame, supplied by kerosene, was not rekindled until April 20, 1868. The logging industry—the bootstrap by which the state of Mississippi was able to pull itself up after the

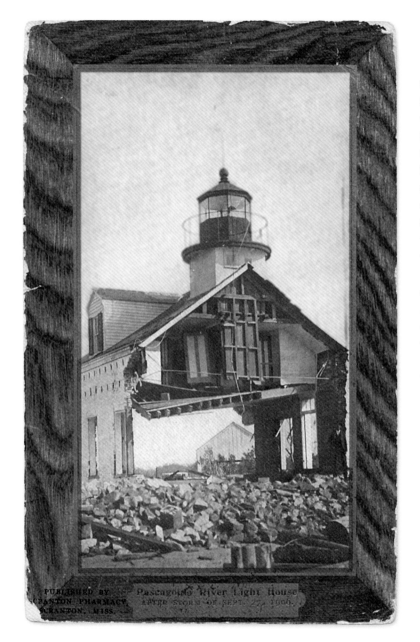

PUBLISHED BY
SCRANTON PHARMACY,
SCRANTON, MISS.

Pascagoula River Light House
AFTER STORM OF SEPT. 27, 1906.

war—jumped into high gear along the coast in the 1880s, when the vast virgin yellow pine forests were beginning to be cut. This harvest, which resulted in almost constant river traffic, made the Pascagoula lighthouse a critical player in the economic development of Jackson, George, Greene, and Perry counties. Unfortunately, at the very height of this boom, disaster struck. On September 27, 1906, a powerful hurricane, remembered for generations as the "Great September Storm," brought death and destruction over a 175-mile area from Pascagoula to McComb. The lighthouse was all but flattened. Although the light itself withstood the winds and rain, the structure was so dangerously weakened that it had to be dismantled. (The light keeper's home, a modest cottage that stood nearby, survived almost intact and was used for the next 50 years as a minor light attendant station.)

In the aftermath of the 1906 hurricane the Pascagoula River lighthouse was all but flattened. The light however, survived intact and was transferred (only a few feet away) to the roof of the light keeper's home where it served as a minor light attendant station until the mid-1950s.

That same night, three miles out into the sound, the Round Island lighthouse also took a beating from the wind, waves, and rain, but it held strong. The original 40-foot-tall Round Island lighthouse had been constructed in 1833, but in 1855, it was determined by government officials that it had been built too close to the shoreline, according to the Round Island Lighthouse Preservation Society in Pascagoula. So $8,000 was appropriated for a new lighthouse and keeper's dwelling, which was completed in 1859. This lighthouse was decommissioned in 1949, and on September 28, 1998, Hurricane Georges smashed the old tower at Round Island to pieces. Only its 170-year-old foundation can be seen today, but members of the lighthouse preservation group hope to change that vista soon. The remains of the lighthouse were recovered and stored after the 1998 storm, and plans are under way to erect a permanent foundation for the lighthouse and eventually rebuild it on the island.

The most tragic victim of that "Great September Storm" was the lighthouse on Horn Island. The hurricane-driven 50-foot waves crashed through the lantern, sweeping away lighthouse keeper Charles A. Johnson and his wife and daughter, never to be seen again. By first morning light, rescuers found the once-picturesque light cottage completely gone and one full mile of the east end of the island washed away. Gone too are the St. Joseph's island lighthouse, the Merrill Shell Bank Light, the Proctorville Beacon that was located near Fort Proctor on the southwest shore of Lake Borgne, and the postcard-perfect Lake Borgne Light Station. They have all bowed to storms, fire, erosion, or time.

Lighthouses like the beautifully proportioned Biloxi tower will likely always be looked upon as symbols of hope and safety. In fact, thousands of people across the globe take comfort daily in these trusted navigational landmarks. Ever since a 400-foot-tall Egyptian lighthouse was erected at Alexandria's Pharos island in 280 B.C., people have admired these man-made symbols of refuge. The ever-inviting warm glow of the beacon offers assurance in the bleakest darkness. It is written, however, that one day, "There will be no more night. They will not need the light of a lamp or the light of the sun, for the Lord God will give them light." ■

high cotton in gulfport

Most people think that the city of Gulfport and its harbor share a history reaching far back into the last century. But unlike her sister cities of Biloxi, Ocean Springs, and Mississippi City, Gulfport is a relative newcomer.

The city was founded on May 3, 1887, by a former C.S.A. captain, William Harris Hardy, and the first stake marking the new city's boundaries was driven that same year on August 27. Gulfport was conceived and built as the terminus of the Gulf and Ship Island Railroad, a company of which Hardy was named president in 1887. Epitomized as the Southern gentleman, Hardy was a big man at six foot two, 220 pounds. He poured his money and energy into the task of completing his railroad from a low-lying, sandy marsh area crowded with tall yellow pines, underbrush, and briars that grew almost to the water's edge. The railroad crossed an uninhabited stretch of land strategically situated almost due south of the new railroad hub of Hattiesburg, a town which Hardy had founded in 1884 and named in honor of his wife, Hattie.

Hardy's dream of building a north-south railroad terminating on the Gulf Coast—where a new city would be built that would emulate both Mobile and New Orleans—began to fade as the difficulty in overcoming the topography quickly consumed his capital. He went bankrupt.

An oil tycoon from Philadelphia, Pennsylvania, Joseph Thomas Jones, came to Hardy's rescue. Like Hardy, Jones had served in the Civil War and had always dreamed of owning a railroad.

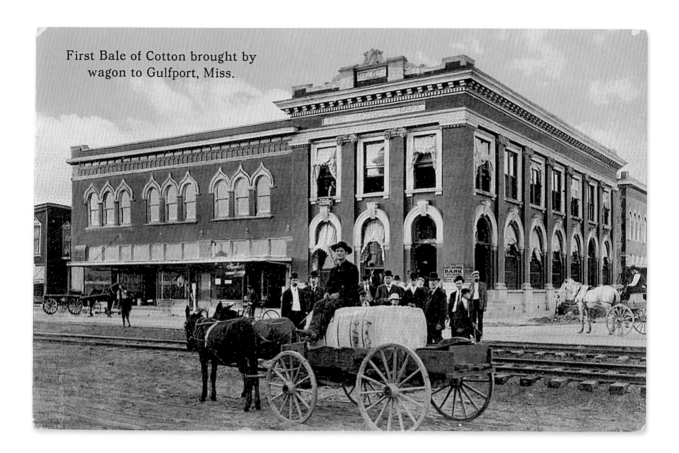

First Bale of Cotton brought by
wagon to Gulfport, Miss.

In 1895 Captain Jones moved to Mississippi, and over the next few years he invested millions of his dollars into building Hardy's dream of a port on the Gulf. The city was given the name of Gulfport by R. H. Henry, the editor of Jackson's *The Daily Clarion-Ledger*.

Jones built the city, the harbor, and paid for the dredging of the channel all the way from the pierhead to the Ship Island anchorage, a distance of some twelve miles.

Finally on January 25, 1902, the first large ship, the Italian schooner *Trojan*, docked at the port of Gulfport in nineteen feet of water. Within months, the word of Gulfport's new deep-water harbor spread worldwide. Over the next few years the great tall ships and

Farmer Campbell (first name unknown), of the Woolmarket community, is shown sitting proudly atop his cotton bale in this view from 1908. Campbell's bale represented the first Harrison County–grown cotton to be exported from Gulfport's new deep-water port.

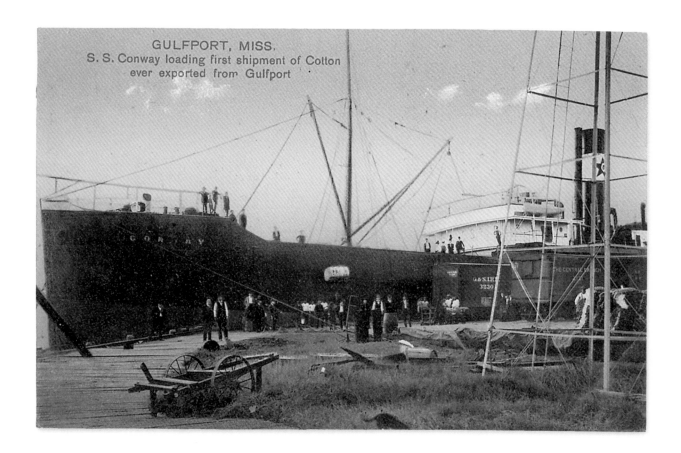

GULFPORT, MISS.
S. S. Conway loading first shipment of Cotton
ever exported from Gulfport

The first of 9,520 bales of cotton is shown being hoisted aboard the SS *Conway* in December 1908. After almost four weeks of loading, the British ship steamed away from Gulfport to Liverpool with "the first cargo of cotton ever to leave a Mississippi port."

steamships from almost every nation on earth jammed Gulfport's harbor for timber as Mississippi's vast pine forests were sold to the world.

A message written on a postcard and mailed to a school professor in Poplarville during this era stated: "Ships are anchored in channel as much as six weeks waiting for a place at the pier." This same postcard

pictures the steamship *Tugelia,* loaded with a cargo of 2½ million feet of lumber. The ship's cargo equalled 150 railroad carloads.

During the first decade of this century, more timber was exported from Gulfport's harbor than from any other harbor in the world. Many of the fine homes and hotels of New York, London, Paris, and Frankfurt were built

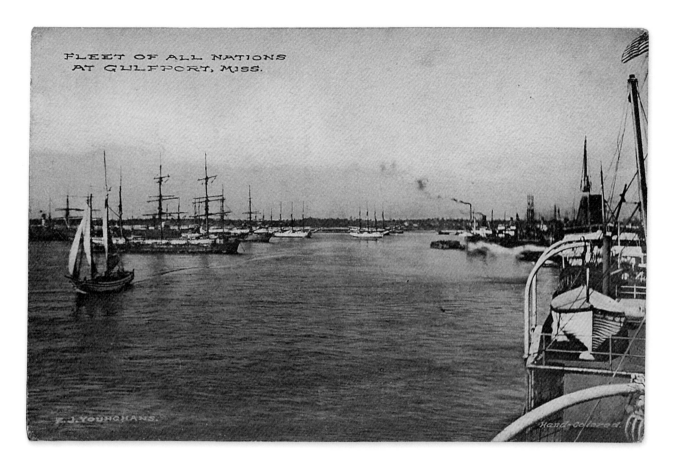

FLEET OF ALL NATIONS
AT GULFPORT, MISS.

F. J. YOUNGHANS.

Hand-Colored

from Mississippi pine, as were the concrete forms for the Panama Canal.

The great September storm of 1906 destroyed one-fourth of the pine trees in south Mississippi. It was at this time that the Gulfport Harbor Commission sought from the Mississippi Railroad Commission competitive rates for the shipping of cotton. Understandably, the railroads were reluctant to give

up their monopoly on the transporting of cotton. However, in 1908 after a lengthy court battle, they granted Gulfport the same freight rates for cotton as were charged to the other ports along the Gulf Coast.

On December 4, 1908, the first shipment of cotton arrived in Gulfport for export to Liverpool on the British steamship *Conway*. The shipment was

Pictured are some of the great tall ships and steamers from almost every nation anchored in Gulfport's new harbor, waiting for their turn at the pier.

from E. L. and E. H. Carter of Meridian and consisted of 8,000 bales with 2,000 more to follow. It took nearly four weeks to load the big steamer as more cotton arrived almost daily by rail. The event caused a great deal of excitement in the press as it marked a distinct era in the progressive history of the port. The first bale of Harrison County cotton grown for export was brought in by wagon by a farmer named Campbell from the Woolmarket community. *The Biloxi Daily Herald* reported that farmer Campbell was photographed in his wagon in front of the First National Bank in Gulfport and that his single bale of cotton would be included in the first export cargo on board the SS *Conway*.

The December 22, 1908, edition of *The Daily Clarion-Ledger* reported that the steamship *Conway* "set sail from Gulfport to Liverpool yesterday" and that surely all of Mississippi was with her in spirit. However, *The Biloxi Daily Herald* reported on Monday, December 28, 1908, that the British steamer *Conway*, with its cargo of "9,520 bales of cotton and 200 tons of cotton seed meal," set sail "yesterday evening for Havre and Liverpool." Although the exact departure date is somewhat confusing, it is a fact that this was the first cargo of cotton ever to leave a Mississippi port, marking the beginning of the importance of Gulfport's deep-water harbor.

The significance of the Gulfport harbor has grown over the years. Today it enjoys the distinction of being "the banana port of America," since more bananas are shipped through Gulfport annually than through any other port in the nation. ◼

This year marks Forrest County's centennial. Shaped like a large numeral "1," the 469-square-mile county was formed by the state legislature on January 6, 1908, and was named for famed Confederate Lt. Gen. Nathan Bedford Forrest. Forrest was revered by many as the greatest cavalry commander of the Civil War. This opinion was shared by his two foremost adversaries: Gen. Ulysses S. Grant and Gen. William T. Sherman. Grant wrote in his personal memoirs that Forrest was "the ablest cavalry general in the South," and according to the official war records, Sherman believed "that devil Forrest must be hunted down and killed if it costs ten thousand lives and bankrupts the Federal treasury." Forrest was never hunted down, nor was he killed, despite having 29 horses shot from under him. Today, his genius for military strategy and decision making is still studied by military tacticians.

Twenty-five years before Forrest County was formed from the most western half of Perry County, Hattiesburg was founded by former Confederate Capt. William Harris Hardy, a railroad entrepreneur. His rail line, the New Orleans and Northeastern Railroad, erected a depot that also became a post office. He named the town "Hattiesburgh" for his wife, Hattie Lott Hardy, on December 26, 1883. The letter "h" used at the end of the name was officially dropped by the post office, after almost nine full years of use, on December 11, 1892.

Hardy is an important figure in the history of our state. He is remembered as the founder of Hattiesburg and Gulfport. The six-foot-two-inch Hardy walked through the pages and chapters of his life projecting confidence and commanding respect

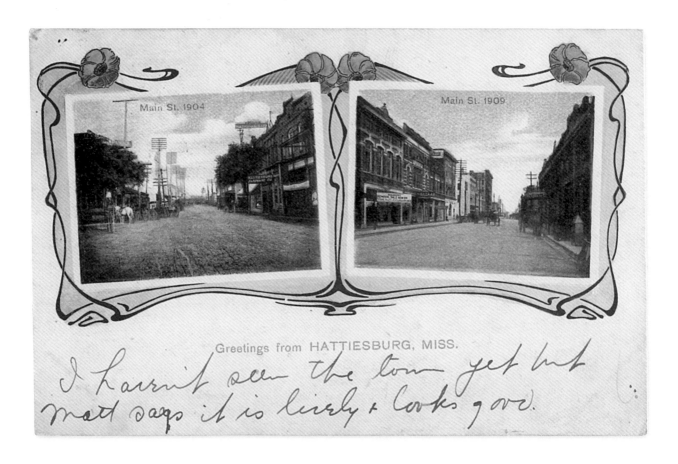

Main St. 1904

Main St. 1909

Greetings from HATTIESBURG, MISS.

I haven't seen the town yet but Matt says it is lively & looks good.

In most instances it takes decades for a town to grow large enough to become a city. As can be seen in this postcard view, Hattiesburg accomplished this feat practically overnight. The sender of this particular card wrote to a friend in 1911: "We arrived safely last night, but 'Hatty' was not at the depot—I haven't seen the town yet, but Matt says it is lively and looks good."

from everyone with whom he came in contact. On April 27, 1861, the tall, slender attorney with grey-blue eyes, dark hair, and ruddy complexion entered the service of the Confederate States of America. He was made a captain of the company of men known as the "Defenders," whom he raised from his hometown, Raleigh in Smith County. Throughout the first two years of

the war, he fought mostly in Virginia under Gen. Stonewall Jackson, and in the second half of the war, he fought in the Carolinas under Gen. James Argyle Smith.

After the war, he moved his family and his law practice from Raleigh to Paulding in Jasper County. Following his first wife's death from malaria in 1872, he moved his family of six

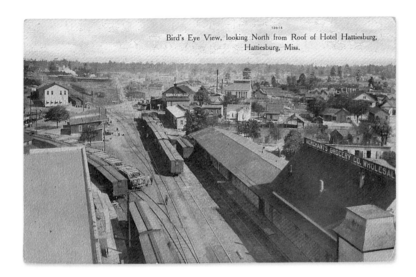

The Gulf and Ship Island Railroad is shown in the center of this circa 1908 postcard view. It was the completion of this railroad in 1900 that propelled Hattiesburg from town to city status.

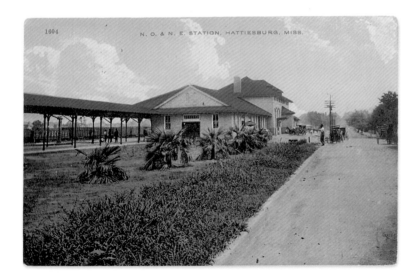

Upon completion of Capt. William Hardy's New Orleans and Northeastern Railroad, the depot, containing a post office, was constructed. It was the post office that Capt. Hardy named for his wife, Hattie, on the day after Christmas in 1883, from which the town, now long a city, gained its name.

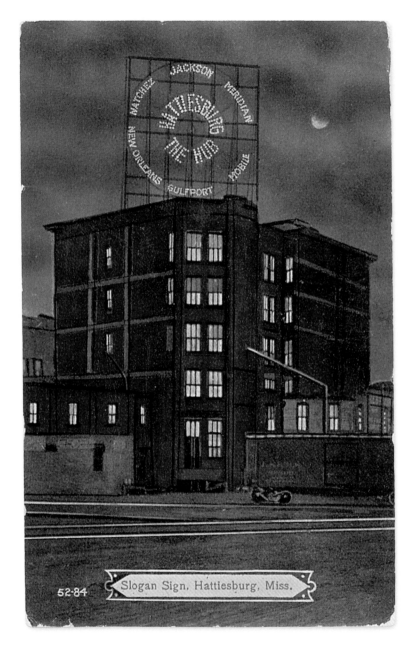

Slogan Sign. Hattiesburg, Miss.

52-84

children to Meridian. Two years later, while visiting Mobile as a delegate to the Southern Baptist Convention, the 37-year-old widower was introduced to a lady who captured his heart— Hattie Lott, the 24-year-old daughter of the Hon. E. B. Lott of Mobile. She was petite, vivacious, and, in Hardy's own words, "a blonde of the most beautiful type."

On December 1, 1874, Hardy married Hattie. At their new home in Meridian, she gave him three sons and a daughter. His six children from his previous marriage adopted Hattie as their new mother. According to the book *No Compromise With Principle*, written by Toney A. Hardy, Capt. Hardy's son, the children loved her "keen sense of humor" and her trait of being "forever optimistic." She taught the children "diplomacy, tact, and ingratiating manners." Hattie complemented her husband well. But on

The big electrified "HATTIESBURG THE HUB" slogan sign, containing some 1,100 lights, stood atop the Ross Building for the best part of 30 years. Even though it was dismantled decades ago, possibly sacrificed during one of the many "scrap metal" drives during World War II, the city is still well known by the nickname "Hub City."

May 18, 1895, 45-year-old Hattie woke feeling nauseated. She went back to bed, and Hardy called a doctor. Before the doctor arrived, one of the children rushed into the library where Hardy was seated to report that "mama was having convulsions." He immediately called two more doctors, and within an hour, all three physicians put their knowledge and skills to work. The desperate captain knelt in prayer by the side of the bed. In spite of their efforts, Hattie passed away.

Toney wrote that his father never got over his mother's death. Nevertheless, Hardy married again five years later to a widow, Ida V. May of Jackson. In seeking a new place to start their lives together, they moved to Hattiesburg. In 1900, they built a new home and named it Pinehurst, and they surrounded it with a profusion of flower beds. Soon thereafter, Hardy's second rail line, the Gulf and Ship Island Railroad, was completed. This new rail line connected Jackson with Gulfport and brought to fruition Hardy's grand scheme of turning Hattiesburg into a railroad center. In fact, no city in Mississippi has enjoyed the benefits of being a rail hub more than Hardy's

dream town. Even today, it is known as the "Hub City."

Hattiesburg began as a woodland clearing delineated by a few unpainted wooden stakes. Some called Hardy's vision a fantasy. Others called it a pipe dream. But the county seat of Forrest County has blossomed. With two nationally recognized universities, several award-winning health facilities, and a plethora of commercial businesses, Hattiesburg continues to grow and reinvent itself, while remembering its founding father.

Captain Hardy and his beloved Hattie would be pleased. ■

the gentleman
from rock rose

On May 13, 1539, the stillness of a Florida morning was shattered when 80 iron-shod Spanish horses clambered out of the hold of Hernando Mendez de Soto's 800-ton flagship, *San Christobal*. Nearby, 157 other horses neighed and snorted as they, too, gained freedom from inside the dark and dank bellies of the other six ships anchored in pristine Tampa Bay, tucked within the western shoreline of central Florida.

De Soto, who descended from a noble family in the Province of Badajoz (the Kingdom of Estemandura) in southwestern Spain, was born in the year 1500 at Jerez (Rock Rose) de los Caballeros. Situated on the crests of two hills, and commanding a breathtaking view of a picturesque pastoral plain, this city is reported by historian John R. Swanton in his definitive volume, *The Final Report of the United States De Soto Expedition Commission,* as De Soto's hometown. Few small cities in the world own even a portion of the historical heritage of Jerez de los Caballeros, the city heralded around the world also as the birthplace of Vasco Núñez de Balboa, the discoverer of the Pacific Ocean. Still, for centuries the chief feature of this seat of government city has been its basilica, San Bartholomew de Jara.

Apparently the original name of the town was Jerez de los Badajoz; however, following the crusades, King Alonzo X gave as a recompense for services rendered the hermitage of St. Bartholomew to a group of knights who utilized the fort-like structure as their headquarters. In 1251 the secret order of the Knights Templars was founded and based inside the temple. Thus, the name was changed to Caballeros, meaning "knights" or "gentlemen."

The rock rose is common to the Mediterranean area and is believed to be the fragrant plant from which myrrh is made. Myrrh, a perfume used during embalming, was one of the three treasures brought by the Magi and given as a gift to the baby Jesus. History records that it was here, Jerez de los Caballeros, that at least three of De Soto's descendants who hailed from or near the Valley of Soto were made Knights of the Order of the Ribbon. During the Crusades (1096–1291) the victorious Knights achieved for themselves a respect which cannot be overstated; therefore the locality name of "Soto" was proudly adopted as a surname and was used like a title and badge of honor.

Hernando, whose full name was Hernando Mendez de Soto y Gutierrez Cardenosa, became the most famous De Soto of all. As the second-born son of the prominent Francisco Mendez de Soto, he, under Spanish law, could not inherit the family fortune, so he sought to forge his own through the military. Spain, at the time, was the most powerful nation in the world; consequently its highest ranking military officers were handsomely paid. He began his career as a soldier under Francisco Pizarro during the Spanish conquest of South America. Accounts by historians as well as personal letters written by men who served under him bear witness to his ability as a natural leader who looked after his charges. As a warrior he was known for his loyalty to Spain, for his invincible bravery, and for his much envied horsemanship. His men, who held him in high esteem during the spring of 1539, respectfully referred to him as the "adelantado" (governor), because before they sailed, King Charles V granted to him the title of governor of Florida.

De Soto came to North America with the blessings of his nation and with the full backing of his king to conquer, and he arrived fully prepared to do just that. Although the numbers vary among the four different Spanish historians who recorded the expedition, most agree his army consisted of some 700-plus men, 500 of whom were highly trained and motivated soldiers, or conquistadors (conquerors), and about 200 support personnel. Among the support staff were carpenters, tailors, cobblers, cooks, sword makers, blacksmiths, shipwrights, clergymen, etc. The conquistadors arrived dressed in mail

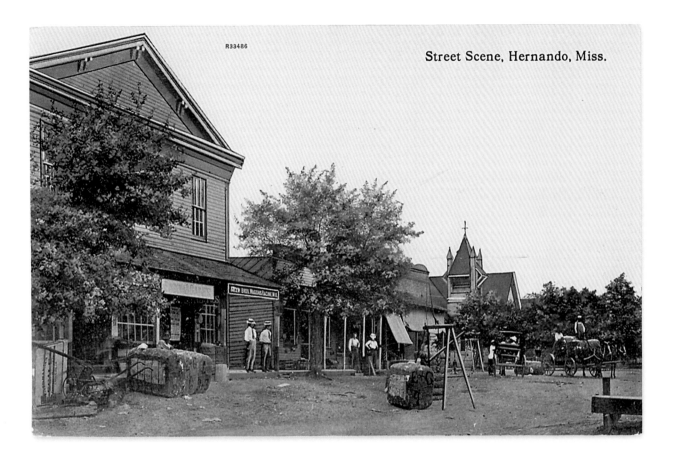

R33486

Street Scene, Hernando, Miss.

This view of a portion of Hernando's historic town square, reported to be the only square in the South built on a 12-street Spanish plan, is circa 1908 when cotton was still king.

and brightly polished metal armor bearing razor-edged swords, lances, halberds, and their weapon of choice, the unforgiving crossbow. Many of them also proudly shouldered shiny new muskets, and each wore an intimidating morion (a high crested steel helmet) telling viewers at first glance that their path would not be crossed unscathed.

Before reaching what is now the state of Mississippi, De Soto and his men trekked north from Tampa, through the swamps and grasslands of west central Florida into and through central Georgia. By the time they reached northwest Georgia, or perhaps the southeast corner of Tennessee, the fruitless conquest had long ceased to be an expedition. With

their quest for gold and other treasures unrealized, the Spaniards found themselves in a much more densely populated hostile land than they first thought. Perhaps stories of the brutal cruelties performed by other conquistadors on the people of the West Indies, tales of which continue to haunt their name even to this day, preceded De Soto. Be that as it may, each travel day brought the weary conquerors to a different village, but unlike the tribal systems of South and Central America where each village was actually part of a type of national government, here each village was more like an independent city-state. Often these villages, poor and lacking any tangible items of value, were at war with each other, but at the same time they seemed to have a common desire to rid their territory of the newly arrived Spanish.

From Tennessee the conquistadors moved cautiously, more together as a military unit than before, into south-central Alabama where they violently clashed with the fierce Mabilas. In the ensuing melee De Soto lost a great deal of his property: foodstuffs (salt, flour), tools, clothing, the vessels used in celebrating mass, etc., plus

twenty of his men. Two killed were of the seven men in the expedition who bore the surname of De Soto. Both of these men, Francisco De Soto and Diego De Soto (Hernando's nephew), described as possessing the "most worth and honor in the army," were slain by the militant Chief Tascaluca's warriors on October 18 (St. Luke's Day), 1540.

Following the burial of his men, and allowing some extra time of healing for the wounded, De Soto, fearing a plot of desertion by a demoralized segment of his officers, changed the course of the expedition away from the Gulf of Mexico toward the northwest. After some difficulty (having to build a large barge and scavenging for abandoned Indian canoes, etc.), the determined Spaniards crossed the Tombigbee River and entered Mississippi. The recorded date of this river crossing, by De Soto's personal recorder, Ranjel, is December 16, 1540.

The winter of 1540–1541 was inhospitable with ice, snow, and temperatures below freezing for several weeks. Neither De Soto nor his men were prepared for this type of weather, and their problems were compounded by a lack of food and

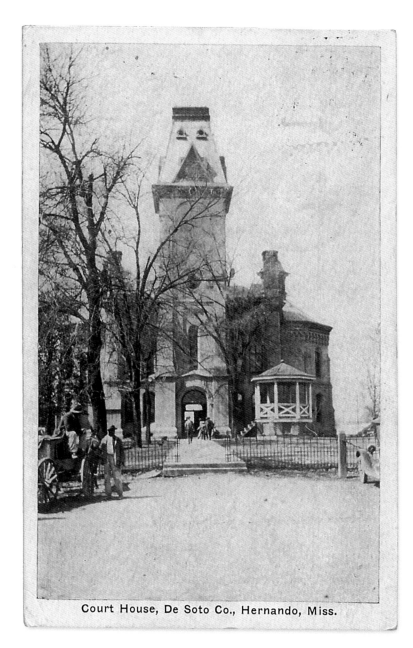

Court House, De Soto Co., Hernando, Miss.

the absence of their extra clothing, which was lost in Alabama during the battle with the Mabilas. Perhaps no one was more surprised than De Soto himself when he learned that the chief of the Chickasaw Nation had agreed to allow him and his soldiers to winter with them. The Spaniards ate the Chickasaws' corn, and the Chickasaws ate quite a number of the hogs that the conquistadors had herded along with them. Spanish historians have noted that the Chickasaws, who had never seen swine before, were quick in developing a taste for pork. There were incidences of numerous raids on the makeshift pigpens, and before De Soto could put an end to them it had cost the Chickasaws the lives of two of their braves. Other than this, the friction between the two armies was minimal, to the extent that by the time warm spring weather returned the Spaniards had unfortunately relaxed their guard. The Chickasaws

Hernando's third courthouse, built in 1871 from a plan for a French château given by local citizen Col. Felix LaBauve, is shown in this postcard view postmarked 1929. Widely acclaimed for years as being the most handsome building in north Mississippi, it unfortunately was destroyed by fire in 1940.

showed that their presumed accommodating posture was simply a ruse. Very cunningly they took advantage of the time in which the Spanish lived in their midst to gain an understanding of their strengths and weaknesses. Suddenly, just before daybreak on March 4, 1541, the antagonistic, shaven-headed Chickasaws lived up to their rebellious name with a well-organized surprise attack. The planned assault, whereby "the Indians brought burning wood with them concealed in little pots with which they set fire to the fragile materials of the houses," taking the lives of a dozen of De Soto's men, took the normally cautious Europeans totally by surprise. Amid the smoke and confusion and before the conquistadors could forge themselves into a fighting unit, the ferocious Chickasaws, utilizing a guerrilla style hit-and-run tactic, inflicted upon the sleeping soldiers the most serious damage of the expedition. In fact Spanish historians have recorded that the north Mississippi surprise attack was more disastrous to the expedition than all the other

Hernando Mendez de Soto y Gutierrez Cardenosa, as illustrated by L. F. Bjorklund.

battles and skirmishes combined. For example, in addition to those killed and including an even larger number wounded, De Soto lost 59 horses and 300 hogs, which escaped in all directions. The Indians, who did not understand the horse, looked upon the animal as a flesh-eating beast and were therefore terrified to the point that they aimed to kill them at every opportunity. On the other hand, the Spanish revered the magnificent warhorse, and in battle considered one horse to be worth twenty soldiers.

On Saturday, May 21, 1541, De Soto became the first Caucasian to see the mighty Mississippi River, and the thought of having to cross it, spread out such as it was in the spring, with his hundreds of soldiers, their weapons and gear, plus some 175 horses, must have at first seemed insurmountable. But, his shipwrights and woodworkers were up to the task, and on June 18, 1541, everyone associated with the expedition including the support team and all the horses was safely across, standing on what is now Arkansas soil.

For twelve months De Soto led his resolute band of adventurers hundreds of miles throughout a large portion of the great southwest. They fought and eluded numerous unfriendly Indian tribes in Arkansas, Louisiana, Texas, and possibly even Oklahoma. The mythical kingdom of El Dorado they sought, they never found. Dejected and disheartened and wearing much less armor, the battle-weary conquistadors skirmished their way back east to the Mississippi River. One full year to the day from when De Soto first looked upon the wide expanse of the mighty river, he succumbed to a fever and was buried, May 21, 1542, in a most solemn military manner. It is believed that his body, dressed in his full uniform including his trademark white ostrich plume attached to his glistening morion, was placed inside a large hollow log which had been weighted with metal, and quietly slipped into the swirling currents of the "Father of Waters."

In the 1700s the French arrived only to be murdered and driven deep into south Mississippi by the merciless Chickasaws. It wasn't until one hundred years later that the warring Chickasaws finally had to give in to the descendants of the British who tenaciously formed the territory of

Mississippi around the Chickasaw Nation. Later they carved counties out of the blood-soaked land with and sometimes without the Chickasaws' permission. In 1836 Mississippi's most northwestern county, comprising some 483 square miles of land, was formed and named for one of Spain's bravest, Hernando de Soto. A small Indian trading post named Jefferson located near the center of the county was renamed in honor of this same brave conquistador, Hernando. Today Hernando and all of DeSoto county is a veritable gold mine of possibility as its citizens enjoy the positive reputation of being not only the fastest-growing county in the state, but one of the premier sites for business and residential opportunities in the nation. If Hernando Mendez de Soto, the "bearded gentleman from Rock Rose," could somehow see Mississippi and America now he would probably be pleasantly surprised at the influence he and his group and the other Spanish leaders like him have had on the quality of life that we Mississippians enjoy. He would notice that not only are horses loved and live in abundance throughout our land and pork is a common feature of our diets, but groups of all nationalities and creeds have come together to live in peace and harmony. ■

famous houston

Sam Houston, the first great Texan, a legendary giant who walked at the right time on Texas soil, was the man for whom the first judicial district county seat town of Chickasaw County was named. Initially founded as a settlement during the winter months of 1836 preceding the organization of the county on February 9 of that year, Houston, located only two miles east of the Natchez Trace, rapidly became popular with merchants, farmers, and lumbermen alike. On December 5, 1837, merchant Henry B. Carter became the first postmaster, and before the year was out, the status of the thriving community was raised to that of a town. Set just a little southwest of the geographical center of the county, the 163-year-old city now boasts a population of almost 4,000 citizens who share a historical heritage that surely is the envy of many cities ten times its size.

Unquestionably Samuel (Sam) Houston is known to history as a Texan. However, he was actually a native of Virginia, born near the small town of Lexington on March 2, 1793. In his youth he was not keen on formal schooling; in fact, he spent many of his formative years living among various Indian tribes. When he turned fifteen he ran away from home and lived with a Cherokee tribe for three years. Later, in 1814 at the age of 21, he studied for and was admitted to the bar in Nashville, Tennessee, where in 1821 he was chosen as a major general of the state militia. In 1823 he was elected to Congress from that state, and then at the age of thirty he was elected governor of Tennessee. He was reelected to the governorship in 1829, but resigned in April of that year and went west again to live among the Cherokee. Six months after his arrival he was officially adopted into their tribe. During the

next few years he spent his time traveling back and forth to Washington in an effort to secure better treatment for the Indians.

In 1832 he was sent by his friend President Andrew Jackson to negotiate with several tribes in the Texas Territory. Once there, he was quickly caught up in local politics. He had a hand in drawing up a constitution and a petition to the Mexican government for statehood. Following the fall of the Alamo, General Houston commanded a small army of some 740 men to victory over Mexican General Santa Anna's 1,600 veterans. The next day, April 22, 1836, he and his men captured Santa Anna, ensuring independence for Texas and securing for himself a permanent place in history.

While General Houston is unquestionably remembered as the father figure of Texas, Colonel Joel Pinson is regarded as having been the founder of Mississippi's Houston. He not only gave the lot where the courthouse is built; he also donated other lots for schools and churches.

The origin of the naming of the city has been told and retold so many times that it now has become the stuff of romantic legend. Writer James F. Brieger has recorded in his book, *Hometown Mississippi,* the legend of General Houston and his long-time friend Colonel Joel Pinson. The account began in the late 1820s in Tennessee where they both fell in love with the same girl, Eliza Allen. Apparently, Eliza loved Pinson, a fact which brought about a quarrel between the two men. Houston challenged Pinson to a duel. With their mettle put to the test, their friendship proved to be as true as David's and Jonathan's, for when on the field of honor, each, in the words of Brieger, "rather than fire on his friend, fired [his pistol] into the air." In January 1829, 18-year-old Eliza and 35-year-old Sam Houston were married. The marriage, however, was short lived. In fact, before the first blossoms of spring, Mrs. Houston returned to the home of her parents. Sam, depressed, embarrassed, and somewhat despondent, resigned his governorship—he was governor of Tennessee at the time—and moved west into the land of the Cherokees (now Oklahoma). Pinson left too and traveled south into Mississippi, down the Natchez Trace into what was then the heart of the Chickasaw Nation.

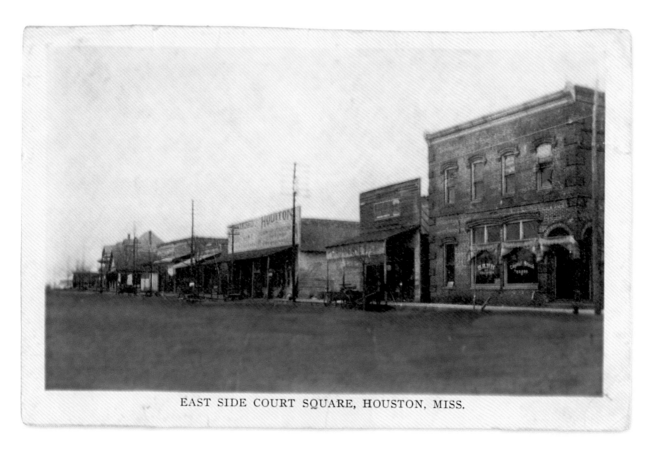

EAST SIDE COURT SQUARE, HOUSTON, MISS.

The east side of Court Square in Houston is pictured in 1906 showing one of the town's two banks, the Bank of Houston, built in 1903.

There he purchased a large piece of land in the wilderness.

His benevolence played no small part in producing a business-friendly atmosphere, encouraging an unusually large number of prominent men to make Houston their home. By the time the Civil War began, Pinson's town, which he insisted from day one be named for his friend Sam, had grown to be one of the leading trade towns in northeast Mississippi. In fact, the Union Army recognized its trade and manufacturing importance by selecting it as one of the cities to be visited and razed by one of the most daring cavalry commanders in the United States Army, Brig. General Benjamin H. Grierson. On April 21, 1863, a detachment of 1,700 invading, blue-jacketed marauders, known as Grierson's Raiders, ravaged Houston,

destroying homes, businesses, strategic sections of the Mobile and Ohio Railroad, and a great deal of property. The raiders were in so much of a hurry to stay ahead of the pursuing Southern defenders by the time they reached Houston that they didn't have much time to pillage. However, during the melee, all the county's records were destroyed by fire.

On July 26, 1863, three months and five days after the destructive raid, the town's namesake died from pneumonia at his home near Huntsville, Texas. He was 70 years old. His biographer Marquis James, in his book *The Raven*, recorded the sober scene, including his last words there in the bedroom of his simple ranch-style home. "In the morning he stirred, reached for his wife's hand and said, 'Texas! Texas! Margaret.'" A union prisoner of war made his coffin, and in a driving rainstorm they buried him in a little cemetery near the house.

General Sam Houston is shown smartly dressed and wearing a Cherokee Indian blanket over his left shoulder. While he served in the U.S. Senate, his tailored suits and brightly colored blankets were his trademarks. It is said that he wore a different blanket each day that the Senate was in session.

GEN. SAM HOUSTON
THE HERO OF SAN JACINTO THE LIBERATOR OF TEXAS

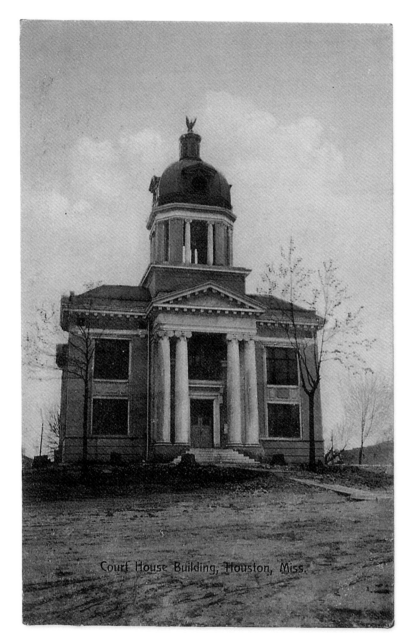

Court House Building, Houston, Miss.

The War Between the States was not kind to north Mississippi and the town of Houston especially suffered. The four long years of sacrifice and war came to an end in the spring of 1865, only to be followed by more sacrifice in the form of an economic depression, which lasted some ten-plus years. Most of the state did well just to exist. The towns of Chickasaw County were no exception. It wasn't until the late 1870s, when a worldwide demand for lumber arose, that a ray of hope began to lift the spirits of those living in the thick timber-rich sections of the state. As the lumbermen and their families began to move into the area, the town leaders began to think about education. In 1888 an unusually gifted teacher, Hosea B. Abernathy, and his wife, Sallie Garrett Abernathy, moved from nearby Pontotoc County and founded the Mississippi Normal College, the first "normal" school (a

The Chickasaw County Courthouse, the third building to serve the southwestern area of the county, is shown soon after its completion in 1910. Chickasaw County is one of ten counties in the state with two seats of government. The other courthouse, which serves the northeastern section of the county, is located in Okolona.

Library Building, Houston, Miss.

school which included a two-year advanced program designed to train teachers) in the state. A large frame building was erected by the couple that served as a dormitory for girls and included classrooms. The success of the college continued to stimulate growth in the town until the Abernathys were apparently lured away by the equally education-minded citizens of Paris, Texas. The concepts initiated by the normal did not go unnoticed, however, as state education leaders were quick to pick up on the revolutionary idea. Emulating and building upon the success begun in Houston, the state department of education constructed a grouping of brick and frame dormitories in Hattiesburg under the name of Mississippi Normal and State Teachers College in 1910. This school grew into what is now the University of Southern Mississippi.

Houston is home to the oldest Carnegie Library in the state, shown in this view taken shortly after it was completed in 1909.

The population of Houston had grown to 677 by 1900; within six years the town was once again experiencing rapid growth as sawmills, planing mills, handle factories, woodworking plants, stave mills, a heading factory, a spoke factory, along with a number of other business enterprises including two banks and a weekly newspaper (*The Houston Post)* helped to raise the town's status back to that of a city, with a population of just over 1,600. In 1908 the city, with its eye again on education, began to seek funds to build a library. Leland B. Reid, superintendent of the city's school system, contacted and received funds from Scottish native Andrew Carnegie, and in 1909 the Houston Carnegie Library became the first Carnegie library to be constructed in the state. Listed on the National Register of Historic Places on December 22, 1978, the library, complete with a modern computer media center, is one of only three in the state that still functions as a library.

Over the years the city's business leaders have continued to build on their strengths. Blessed with a strong heritage in woodworking combined with a masterful understanding of the art of furniture manufacturing, the Franklin Corporation of Houston, founded by Hassell H. Franklin, has become a national leader in producing reclining chairs and motion furniture. It is recognized as one of the nation's largest independently owned furniture-manufacturing companies. Today, within a 75-mile radius of Houston, there are over 200 companies employing over 50,000 Mississippi workers who are producing about 70 percent of the nation's upholstered furniture, says Franklin, a former president of the American Furniture Manufacturers' Association.

The old adage that history repeats itself is highlighted as Houston continues to furnish the area, the state, and even the nation with business leaders. The words "Houston, Mississippi," stamped on thousands of quality-made chairs, couches, and numerous other furniture items, are famous around the world. Perhaps the epitaph cut in stone over General Sam Houston's grave, words that were spoken about him by his friend Andrew Jackson, are a fitting tribute to Chickasaw County's leading city: "The World will take care of Houston's fame." ■

jackson:
175 years of history

Dec-ember marks the 175th anniversary of the birth of the city of Jackson. As Mississippi's capital city, Jackson is rich in history and steeped in Southern traditions. It is envied for its cultural activities. Because of business decisions made in the last decade or so, it is well positioned economically to enter the 21st century.

Jackson provides leadership in many different areas: politics, medicine, and religion, as well as in the fields of communication, distribution, transportation, storage, lodging, and, of course, education.

The site on which the city is situated was designated as the state capital by the legislature on November 28, 1821. The post office began its operation in the then-frontier town on October 21, 1822, and the state legislature (22 representatives and 10 senators) began meeting inside Mississippi's first capitol building on December 23, 1822. It is this latter date that is most often quoted as being the birthdate of the city.

Near the geographical center of the state, Jackson has welcomed legislators and senators from each of the state's counties for close to two centuries. Since 1918 our counties have numbered 82. Consequently, almost all of the laws under which every citizen of this great state live and work have been enacted in this city. In fact, since 1903, all laws have been made inside the New Capitol Building. The absolutely magnificent beaux arts–style capitol building is still, after some 94 years, proudly called the "New" Capitol Building. It is called this simply because the city still has the "Old" Capitol Building, which dates from 1839 and houses Mississippi's

Eyrich & Co., Jackson, Miss.
Copyright 1905 by the Rotograph Co
G 14156 Governors Mansion, Jackson, Miss.

This 1905 view of the Governor's Mansion shows the then 64-year-old building as it appeared during the term of Gov. James K. Vardaman. The wrought-iron fence, which had been erected in 1855 to discourage pedestrians and even riders from taking shortcuts across the Mansion lawn, was removed during the refurbishing of the Mansion and grounds in 1908.

award-winning state museum. This museum, inside what many believe to be the most historic building in the state, has recently been recognized as being in the top 5 percent of museums in America based on authenticity of items displayed. In addition, the Old Capitol Museum has gained national recognition for displaying this country's first permanent civil

rights exhibit. The New Capitol Building, valued at between $700 million and $800 million, is complemented by the beautiful state Governor's Mansion. This mansion, which dates from 1842, is America's second oldest continually occupied Governor's Mansion, second only to the mansion in Virginia. It is also one of only two Governor's Mansions on the National

Register of Historic Places. The other historic mansion, dating from 1852, is in Austin, Texas.

In the area of medicine, the University of Mississippi Medical Center, situated in the northern part of the city, gained world headlines in June 1963 when the world's first lung transplant was performed there. Six months later, in February 1964, UMC again made headlines when Dr. James Hardy, heading a team of eight doctors, performed the world's first heart transplant. Later that same year UMC's Dr. Arthur C. Guyton discovered that the heart does not regulate blood flow. Using the medical center's computer, Dr. Guyton proved that it is not the heart that regulates blood flow, but the capillaries. Actually, the capillaries sense the need for blood, then send a signal to the brain which, in turn, tells the heart to pump the blood. This revolutionary medical discovery has drastically changed the way that the

This is a view of the second building to house the city's First Methodist Church. Constructed in 1883 in the late Victorian style commonly referred to as Second Empire, it served the Methodists until their present house of worship was constructed on the same site in 1915.

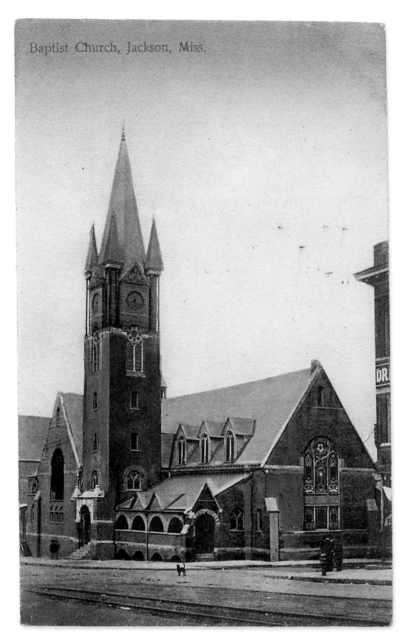

Baptist Church, Jackson, Miss.

cardiovascular system is studied and taught. Dr. Guyton is now considered to be the world's leading physiologist and his textbooks are used in schools and colleges around the world.

There are many different things that have influenced life in the capital city over the decades, but perhaps nothing has had such a positive influence on the city as have the teachings of the Christian churches. In all the long history of Jackson, historians point to the church as the most prominent influence for good. Early figures prove that during the town's initial development, it failed to grow beyond only a few families until the preachers brought the teachings of God. Wives had discouraged their husbands from moving into the frontier town because they saw it as an unfit place to raise their children. This was changed in 1836 when the Methodists

The second building to house Jackson's First Baptist congregation is pictured circa 1909 at the northwest corner of North President Street at East Capitol Street. Built in 1894, this house of worship served the church until 1925. Notice along the extreme right edge of this photo is the southwest corner of the Richard J. Harding Building, which at the time this scene was captured on film was home to Draughon's Business College.

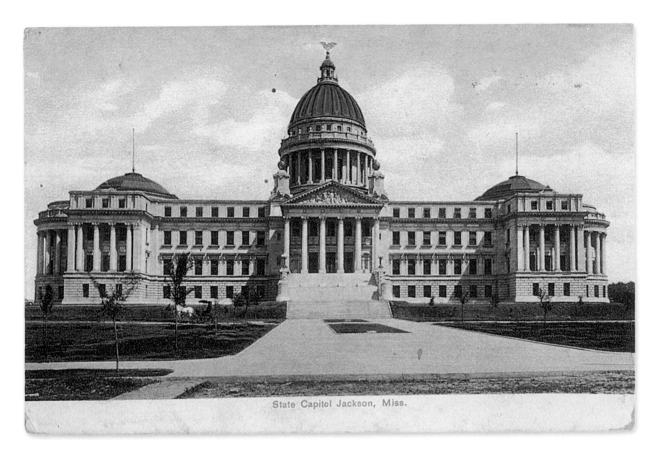

State Capitol Jackson, Miss.

organized the first church in the city. They were followed by the Presbyterians in 1837 and the Baptists in 1838. It is interesting to note that all three of these churches were actually organized inside the original state capitol building situated at the corner of North President Street and East Capitol Street. The Baptists used the state capitol building for some six years, from 1838 until their church building could be completed in 1844.

The original First Baptist Church building, which historians tell us survived the Civil War because it was used as a hospital, now comprises part of the full city block of buildings that house Galloway Memorial United Methodist Church. This church was initially known as First Methodist Church,

Mississippi's most regal building, the New Capitol, is shown here soon after it was completed in 1903. The horse and carriage, pictured at left center, are believed to be the property of the photographer. Professional photographers often utilized people or animals in their photos—particularly of large buildings—as a way to show scale.

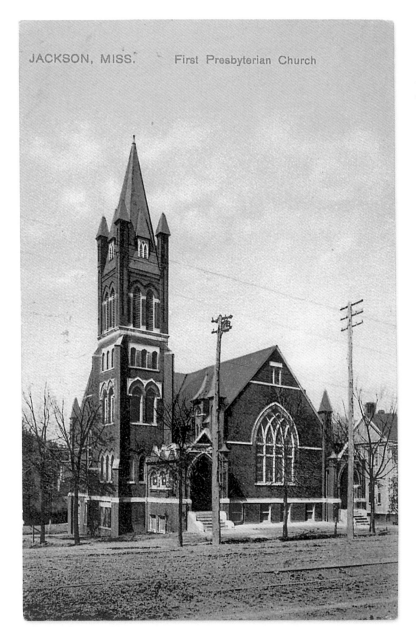

JACKSON, MISS. First Presbyterian Church

and was, as previously stated, the first church organized in the city. Galloway is now a very large church, as is the First Presbyterian Church located somewhat north of the downtown area on North State Street. The First Baptist Church, now in its third location, has grown to become the largest church in the state with more than 9,000 members. It is listed among the 100 largest churches in America. The churches of Jackson continue to have a tremendous influence on the quality of life in the city and the state, and their missionary work is felt around the world.

More than 200,000 people call Jackson home. It is a city in which people love to live. In the following case, it is also a city in which people live to love. George Lemon and his wife, Sarah Ann Kirkpatrick Lemon,

Jackson's First Presbyterian Church was the second church to organize in the city, and, like the Methodists and the Baptists, they too were founded in the original state Capitol Building; and also just like their sister denominations they utilized the Capitol Building for preaching and Sunday school for several months while their church building was being constructed. This view is of the Presbyterians' second church, which was used from 1893 to 1951.

were two of the city's pioneer citizens. Mr. Lemon was born in Belfast, Ireland, on March 29, 1830, and Sarah Ann was born in nearby Castlewellan, Ireland, on February 22, 1841. According to family history, they met aboard the ship that brought them to America in 1846, when he was 16 and she was 5. In America he worked as a rope maker in factories on Long Island and in New York City. In 1853 he moved to New Orleans, where he began work for the Opelousas Railroad as baggage master. His work took him north to St. Louis. At Olney, Illinois, in 1855 he married pretty Sarah Ann. Four years later they made their home in New Orleans. When the Civil War broke out, he enlisted in a Louisiana regiment. In 1862 he received orders to come to Jackson and serve as military yard master. He served in this capacity until the war ended in 1865. He and Sarah Ann saw Jackson as a place of opportunity, so they stayed and made it their home. They entered the mercantile business, where they worked together for

This monument in Greenwood Cemetery memorializes one of Jackson's pioneering couples.

more than 25 years. Mr. Lemon was the builder of the Poindexter School, the first public school erected west of Town Creek, and the street on which it was situated was named in his honor. On March 28, 1907, the couple opened a 58-room hotel at 108 North Mill Street directly across from the Union Depot. The Lemon Hotel, of modern design, was operated on the European plan. It featured a first-class "ladies' restaurant" and an all-night café. The city was experiencing a tremendous growth in population at the time and the hotel became an overnight success. Life was good to the Lemon family and they were good to Jackson. They were the type people who helped make the city what it is today. On August 12, 1909, Sarah Ann died. Devastated, George sold the hotel to a group of investors who continued to operate it under the name of the Nobel Hotel. Three years later, on February 5, 1912, George—former rope maker, railroad worker, Confederate soldier, grocery store owner, director of the Jackson Bank, president of the Bullard Brick Company, founder (along with Sarah Ann) of the Central Presbyterian Church and builder and owner of the Lemon Hotel, joined his wife in death. Before he died he memorialized his beloved Sarah Ann in marble. He sent a photograph of her to Italy and had a life-sized sculpture of her made. This beautiful monument complements her grave marker in Greenwood Cemetery where their earthly remains lie side by side.

George and Sarah Ann loved Jackson. They made it their home, they gave it their very best, and they loved each other. On Sarah Ann's grave marker George had these words engraved: "With heavy heart I bow, O God beneath Thy Chastening rod, In love Thou gavest her to me, In love I give her back to thee." ■

the mississippi state fair:
merriment and memories on the midway:

The Mississippi State Fair, dressed in a bright, festive atmosphere of multicolored waving flags, fluttering pennants, and filled with the cries of carnival barkers hawking their games of chance, welcomed an opening day crowd of more than 5,000 on October 25, 1915. An enthusiastic description of the much anticipated opening day appeared in the following morning's *Daily Clarion-Ledger:* "The Twelfth Annual State Fair opened its gates to the public yesterday and the attendance was more than gratifying. One heard the din of the whistle man and his wares, boys and girls wanted balloons and whips, the Ferris wheel and flying ginnies were running full blast, and all in all, the place wore a carnival air. The eating stands were doing a tremendous business, and at these places many were buying the first 'hot dog' or hamburger they have enjoyed since the fair of 1914."

As with all state fairs there were hundreds of things to see, taste, and hear, but at the 1915 fair there was a particular event that captivated more people than the grandstands could seat. It was a race between a horse and an ostrich. Most people were unfamiliar with the strange, awkward-looking bird that is native only to Africa. Many, perhaps, were familiar with the fact that in centuries past people sometimes mistook the peculiar mournful cry of the large birds for that of a lion, as recorded in the Holy Scriptures (Micah 1:8). While it is likely that most knew that the ostrich could not fly, they probably had no idea how fast it could run. So, the curious onlookers jammed the stands at the fairground racetrack to find out. The race

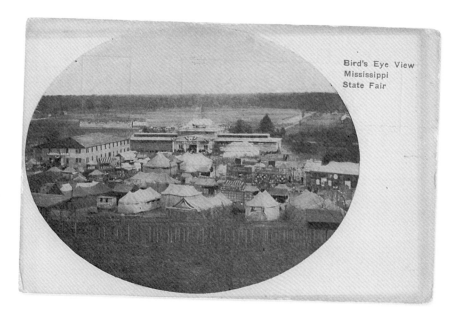

In this souvenir postcard view of the Mississippi State Fair of 1908, one can see (in the far background) the grandstand and racetrack where the celebrated 1915 race between a horse and an ostrich took place. The large building in the center, erected in 1906, is the "Coliseum." For its purpose as an exhibit hall at this fair, it is identified with a large banner reading "AGRICULTURE."

U.S. President William Howard Taft, who, unlike most men of his generation, was not fond of wearing a hat, is shown standing inside the elevated platform (first from left) at the Mississippi State Fair on November 1, 1909.

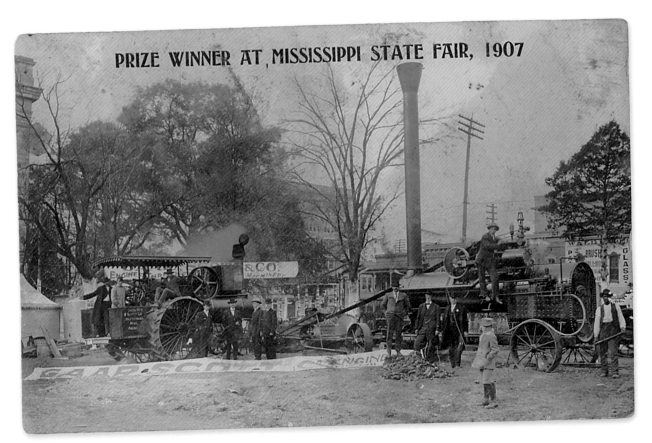

PRIZE WINNER AT MISSISSIPPI STATE FAIR, 1907

consisted of only one lap around the oval track, and in less than one minute it was over. The gangly ostrich won.

The Mississippi State Fair dates back to 1859, and although the State Fair Commission is promoting this year's extravaganza as the 148th fair, there were actually several years in which the now annual event was not held. For example, it is believed the fair was not held during the War Between the States or for several years afterwards. In fact, it was well into the Reconstruction Era before the fair was held again. Records on file in the Mississippi Department of Archives and History state that a stock company was formed in 1869 by private citizens, enabling several fairs to be held intermittently until the year 1880. In 1887 the Mississippi State Fair Association was formed, and held a fair for

In this real photo postcard view from the state fair of 1907, two large steam tractors, on loan from the Union Manufacturing and Supply Company of Hattiesburg, are pictured at work on the grounds of the Old Capitol. Note the northwest corner of the Capitol Building can be seen at the extreme upper left corner of this photo.

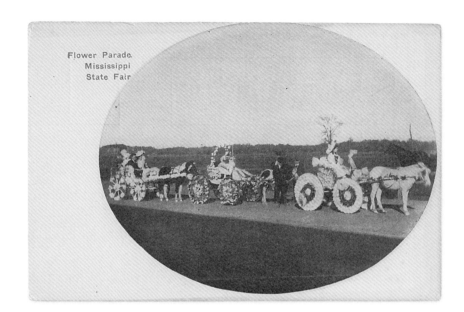

One of the most popular events of the 1907 fair was the flower parade, which began at the Edwards House (Hotel) on West Capitol Street and ended at the fairgrounds in front of the grandstand. Featured were locally sponsored floats and carriages decorated with thousands of multicolored blossoms.

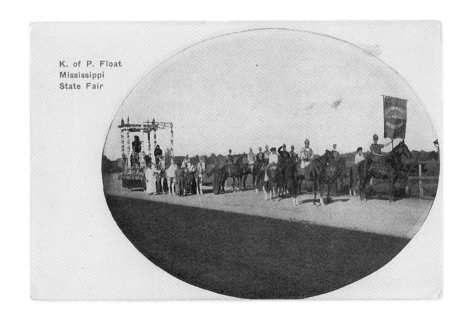

Costumed members of the Knights of Pythias, a fraternal order which originated in Washington, D.C., in 1864, accompany their popular float at the state fair in 1907.

the first time on the grounds behind the Old Capitol Building, but it was discontinued again in 1888. Finally, in 1904 the exhibition was restarted and was held inside the Old Capitol Building with some of the exhibits spilling out onto the Capitol grounds. With only one exception—during the year 1918 when the worldwide Spanish influenza epidemic made it advisable not to hold the fair—it has been an annual event.

For well over a century, state fair officials have met the challenge of making each year's event bigger and more exciting than the previous year. The formula of showcasing our state's agricultural and industrial products has proven to be the winning recipe for successful fairs and has changed very little over the decades. What has changed are the headliners. For example, the main attraction at the 1907 state fair was machinery. Two large steam tractors supplied by the Union Manufacturing and Supply Company of Hattiesburg won the prize for being the most popular exhibit.

The highlight of the 1909 fair was a visit by U.S. President William Howard Taft. In order to take advantage of the president's historic visit (Taft was the first sitting president to visit the city of Jackson) fair promoters delayed the opening of the fair by two weeks. When the president arrived on November 1, fair commissioners erected an elevated, covered speakers' platform with eight large U.S. flags, patriotic bunting, and a flagpole on top from which flew the nation's presidential flag.

Every year the Mississippi State Fair, with its mile-long midway, continues to provide merriment and memories for everyone, young and old alike. ■

brave and true

Mount Kosciusko is the tallest mountain in Australia. The 7,316-foot peak is found in the Snowy River Mountain Range near the southern edge of New South Wales, halfway between Sydney and Melbourne. In America the city of Warsaw is the county seat of Kosciusko County, Indiana.

In Mississippi, the only state in the U.S. in which there is a city bearing this same unusual name, is today perhaps the best known Kosciusko of all, as it is the hometown of television's Oprah Winfrey.

Like a bull's-eye, Kosciusko, Mississippi, is located in the very center of the state, and is surely remembered by those who visit as being one of the most picturesque, Tom Sawyer–like cities in the entire nation. Its heritage is rich with small town Southern charm and the beauty of its painted Victorian homes and turn of the century businesses is just about second to none anywhere. In fact, in a nationwide contest sponsored by *Better Homes and Gardens* and *Architectural Magazine* along with Rohm-Haas Paint Quality Institute in 1998, Kosciusko was selected as the second "Prettiest Painted Place" in America, second only to St. Louis, Missouri. There is certainly a uniqueness about this small city, but perhaps nothing is more unique than its name. Just who was Kosciusko anyway?

Tadeusz Andrzei Bonawentura Kosciuszko (Kosh-CHOOSH-ko) was born to a slightly impoverished gentry family on February 12, 1746, at Mereczowszczyzna in Byelorussia, which at the time was a provincial district of Polish Lithuania. His inherited natural leadership ability perhaps more than any other trait or circumstance

East Side Square, looking North
Kosciusko, Miss.

33638

opened doors for him to be educated at the Royal Military School in Warsaw. Afterwards he learned the military arts in the school of engineering and artillery at Mézières, France. He then completed his formal education in the fine arts and architecture at the Royal Academy in Paris. Upon graduation, he learned that his ambition to serve his country was not yet to be. The king

of Poland was reducing rather than building his army due to his country's lack of capital; his treasury was empty. So Kosciuszko found employment in Paris teaching mathematics to two daughters of a prominent European family. He soon fell in love with one of the girls against her father's wishes. The idea that his daughter could fall in love with, and perhaps one day marry,

This partial view of downtown Kosciusko is about how it looked when Oprah Winfrey was born in her grandmother's home, on January 29, 1954.

TADEUSZ KOSCIUSZKO.

"a poor military engineer" was apparently more than he could bear. Sensing this, young Tadeusz and his love tried to elope, only to be surprised by the angry father and his armed men. In the fight which followed, 28-year-old Kosciuszko was gravely wounded and left for dead. Months later, his wounds healed, the young officer turned his attention toward the news of the American rebellion against British authority. Details of the battles of Lexington, Concord and Bunker Hill were the talk of the day in Paris, and by March 1776, Kosciuszko, along with several other young Polish and other European officers, had sailed to join America's rebel army.

Immediately after arriving in Philadelphia, America's capital city at the time, Kosciuszko, who was fluent in both Polish and French, sought to become proficient in English. Over the next few years Americans, who have always had difficulty in pronouncing Polish names and words, helped him by Americanizing his name to Thaddeus Kosciusko (Kozzi-ees-ko). On October 18, 1776, after having helped lay out the defenses for Philadelphia, he was commissioned by Congress with the rank of lieutenant colonel of

SNOWY RIVER VALLEY FROM THE SUMMIT
MOUNT KOSCIUSKO

engineers with "pay of $60 a month." The following spring Kosciusko impressed General Horatio Gates, commander of America's Northern Army, as being "an able engineer, and one of the best and neatest draftsmen I ever saw." Before the trees budded in 1778, Colonel Kosciusko was placed in command of designing the defenses at West Point, New York.

History records that when he arrived at West Point it was a veritable uninhabited wilderness. When he left there two and a half years later, he had transformed the 40-acre plateau into an impregnable fortress which was referred to by various military leaders of the day as being the "American Gibraltar." So well- designed and fortified were the defenses built by

This circa 1936 postcard view pictures scenery from atop the 7,316 foot peak of Mount Kosciusko. Located in the Snowy Mountains, it is Australia's tallest mountain.

GENERAL KOSCIUSKO,

Commander in chief of the Polish Army.

Published as the Act directs, Nov.ʳ 1. 1791.

Kosciusko's corps of Scots and Irish, they were never tested. The British commanders thought it suicidal to attempt such an attack. Perhaps his most ingenious plan, though, was sealing off the Hudson River to British use. West Point is on the west side of the Hudson at a bend (a western point) where the river changes direction from east to north. The banks of the river at this location are of solid rock. Kosciusko ordered a steel chain to be stretched across the river, and anchored into the rock banks. The 60-ton chain was of no ordinary design—each link weighed 140 pounds. On both the west and east sides of the river the chain was guarded by three groups of strategically placed cannons. From 1778 until the war ended in 1783, the British were never able to use the Hudson to bring

Most likenesses of General Kosciusko picture him as being a tall, dapper figure when apparently he was a stocky, powerful man, with coarse red hair, who, with a will of iron, devoted his life to fighting for the freedom of the oppressed. This rare portrait by sculptor J. Chapman was "published as the Act [of Congress] directs, November 1, 1794," and probably is as true a likeness of him as there is. He was 48 years old when this portrait was registered. He lived to be 71.

in either supplies or troops from their staging areas in Canada. To help while away the time as he and his men waited for the assault attempt which never came, he designed a garden of trees and shrubs which is today considered one of the beauty spots of upstate New York.

Kosciusko's accomplishments during the war are now legendary. Besides his renowned achievement of designing the defenses at West Point, his selection and construction of the field fortifications at Saratoga contributed greatly to the American victory in that key battle. Later in the war, while serving under General Nathanael Greene, the commander of America's Southern Army, he distinguished himself again. As chief engineer, Kosciusko designed a fleet of flat-bottomed boats which could be easily moved by horses and wagons from one river to another. Greene's army used these boats to great success on the Catawba and Pedee rivers in the rugged western wilderness of North Carolina. This amphibious operation afforded them the mobility they needed to master hit-and-run tactics which they used successfully to stymie the British and their Indian allies time and time again. Greene once described the elusiveness of his smaller army with these words: "We fight, get beat, rise, fight again."

On November 14, 1782, Kosciusko again brought honor on himself and his men, not as an engineer, but as a cavalry commander. Commanding an advance guard near Charleston, South Carolina, he led a party of 50 to 60 men against a British infantry unit. The successful attack, which has been recorded in a 1975 *American Heritage* article titled "Kosciusko" as being "the last skirmish of the Revolutionary War," gave Kosciusko his closest encounter with death when his coat was pierced by four musket balls.

After the war a thankful U.S. Congress promoted him to brigadier general, gave him 500 acres of land near Columbus, Ohio, a considerable pension and, along with Major General LaFayette of France, honorary U.S. citizenship. Before leaving America, Kosciusko, a champion of liberty all of his life, named his friend Thomas Jefferson as executor of his will. He used his pension to buy as many slaves as he could so he could give them their freedom. Jefferson wrote of him, "He is as pure a son of Liberty as I have

ever known, and of that liberty which is to go to all, and not to a few or the rich alone."

In the 1790s General Kosciusko led Polish troops in a valiant effort to free his native homeland from the tyranny of Russia. Fighting against both Russian and Prussian forces, Kosciusko's army was destroyed on October 10, 1794, and he himself was severely wounded. He sustained three bayonet wounds in his back, and part of his left thigh was shot away by a cannon ball. The most critical of his wounds was a deep saber slash across his forehead. This ugly wound caused him to wear a sash, tied neatly across his forehead, for the remainder of his life. From 1794 until 1796 he was imprisoned in Russia by the order of Catherine the Great. Following her death, he was given his freedom and exiled after signing documents whereby he pledged never to fight against Russia again. In his retirement he traveled to both America and France, but made his home in Soleure, Switzerland. It was there that he died at the age of 71, on October 15, 1817, just 63 days before Mississippi became a state. His heart was buried beneath a monument in Soleure and his body was transported back to Cracow, Poland, where it rests in the great cathedral there, along with those of Poland's kings. Near Cracow a large earthen mound was raised in his honor by the men, women and children of Poland. They came bringing earth in their wheelbarrows, their pockets and even their caps from the Polish battlefields where he had fought. Today his heart is entombed in the Polish Museum in Rapperszwil, Switzerland. ■

the star
of creation

Churches, by their very nature, are about being the center of the community. Most are identified by a sign attached to the building or placed upon the lawn. However, even without a denominational sign, Mississippi's churches that were built prior to World War I, were, in most cases, easily identified by architectural enhancements in the form of symbols. To quote Andrew Young, owner and operator of Pearl River Glass Studio, Inc., in Jackson: "The Bible is a treasure trove of symbolism." It is this truth that for generations has prompted architects and religious leaders to utilize emblematic Christian symbols to encourage fellow believers in the faith.

Although there are quite a number of churches throughout the state that can be cited for their architectural symbolism, few employ as many different traditional Christian symbols as the First Baptist Church of Lexington once did. This simple house of worship, designed by an unknown architect in 1890, enhanced a mood of reverence for all who saw it for two generations. The east-facing façade was a veritable "sermon in wood and glass." The most striking feature (as depicted on a postcard made by the M. L. Zercher Postcard Company of Topeka, Kansas, in 1914) is the large, six-pointed star placed over the circular stained glass window. This design, when used on Christian churches, is a Trinitarian: the Christian symbol for a person who believes in the doctrine of the Trinity. This ancient symbol, which many believe predates the beginning of recorded history, is known as "the Star of Creation." The points recall the six days of creation, and it is based upon scripture found in Genesis 1:6: "And God said, 'Let there be a firmament in the midst of the

The east-facing facade of the First Baptist Church of Lexington was a veritable "sermon in wood and glass." The most striking of the many Christian symbols was (and still is) the large six-pointed "Star of Creation" affixed over the circular stained-glass window.

waters, and let it divide the waters from the waters.'" In Judaism, this symbol dates from the third century A.D. and is called "the Star of David," "the Shield of David," or "the Seal of Solomon." According to Jewish tradition, King David's shield was this shape. About thirty years ago, a senior Jewish rabbi from New York City visited Jackson's Temple Beth Israel, and shared his knowledge of traditional Hebrew writings about David's shield. He said

the warrior David and his soldiers used the uniquely designed shields. They were made of metal and were highly polished, almost to a mirror finish. In battle, the glistening shields were used to reflect the sun into their enemies' eyes. In addition, the ability to see one's opponent by looking between the six points as opposed to seeing over or around the edge of a round, oval, or rectangular shield gave David and his soldiers a decided advantage.

Just below the base of the open area of the bell tower are four four-leaf-clover–like designs facing east, and six more along the tower's south side. This design is known as a "quatrefoil," indicating that this is an evangelical church—meaning that this church emphasizes the authority of the Holy Scriptures rather than the authority of the church. The design in four equal parts represents Matthew, Mark, Luke, and John, the evangelicals who wrote the four Gospels where most of the teachings of Jesus are recorded.

The bell tower is significant because a steeple tops it. The upper portion is more correctly called a spire. The spire points upwards, as a reminder of things above, "Where Christ sitteth at the right hand of the Father." The other purpose of the tower is to house what is considered one of the most important architectural features of any Christian church, the bell. The church bell is a tool that for centuries has been used by

In this postcard view, the lines of the star in the "Creation Star" window on the Lexington Methodist Church are superimposed by a circle which signifies the eternity of the triune God.

Methodist Episcopal Church, South, Lexington, Miss.

The glorious "Star of Creation" window in the First Christian Church of Jackson once faced westward over the front lawn of the state's New Capitol Building. When, in 1950, the church was relocated three blocks away—to the northeast corner of North State Street and High Street—the window did not become a part of the new structure.

First Christian Church, Jackson, Miss.

The magnificent "Creation Star" window shown above the north entrance of the First Methodist Church of Itta Bena, in this circa 1912 view, is complemented by a host of other Christian symbols in stained glass.

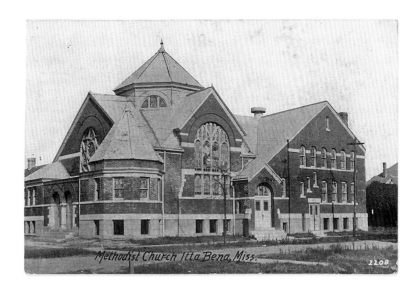

Methodist Church Itta Bena, Miss.

2208

Christians to ring out the news that "Jesus is Lord!" The pealing of the bell also serves as a reminder to believers of the priority of worship over work and play.

Six Romanesque arch windows are easily noticed, one on the bell tower, two near the peak of the church's roofline, and three under the "Creation Star" window. These windows are symbolic features of Gothic architecture, and they signify "an aspiration and a striving for growth in the spiritual life." Closer examination of the Zercher photograph shows the same arch-window design above both entrance doors and also as cutout designs under the banisters or handrails on both sides of each set of entrance doors. Although the two separate entrances are not Christian symbols, they are a carryover architectural feature of an earlier era in American Protestantism. Once, the sexes were separated during worship. According to *Religion in Mississippi* by Randy J. Sparks (2001), during the early days of the 19th century, female church members traditionally entered the sanctuary through the doorway on the left. The wider steps and wider doors on the left were built to accommodate fuller skirts and dresses, and women were seated in the pews to the left. Men entered through the right doorway and sat in the pews to the right.

The most important symbol is purposely placed as high on the church as possible. Located between and above the two arch windows near the peak of the roof are two timbers nailed together representing the "cross of Christ," the symbol of God's love for mankind: "And I, if I be lifted up from the earth, will draw all men unto me" (John 12:32). On all evangelical churches the empty cross symbolizes Christ's triumph over death and sin.

In 1929, the First Baptist Church of Lexington was enlarged and modernized. The bell tower was removed, and the entrance doors were replaced by a set of double doors that were moved to the center, and the entire building was veneered in an earth-tone-colored brick to match the newly constructed educational annex. Today the renewed outside appearance of Lexington's late nineteenth-century Baptist church urges all to look upon the "Star of Creation" symbol and know that inside is told the "story most precious, the sweetest that ever was heard. ■

famous
warrior friend

On St. Valentine's Day, February 14, 1836, Louisville, the county seat of Winston County, was incorporated and named in honor of the same man for whom the county was named, Colonel Louis Winston. The county was established just a little over two years earlier, on December 23, 1833, from land acquired from the Choctaw Nation through the Treaty of Dancing Rabbit Creek in 1830. Colonel Winston is a somewhat shadowy figure in the history of our state; however, there is enough recorded information about him to show that, like so many men during these early times of our nation, he clearly was a gifted man, who excelled in several professions. In reference to documents held in the Department of Archives and History in Jackson, Winston "was a scholarly young lawyer of Virginia, who first came to the Tennessee River country [now Huntsville, Alabama] and afterward to the western portion of the [then newly established] Territory of Mississippi."

As a famous warrior from the days of the American Revolution, Colonel Winston was not without friends of influence. And, apparently in addition to his military accomplishments, he, like George Washington, was also skilled as a surveyor. On March 7, 1809, Winston, who had been selected by the federal government to inspect the newly constructed Natchez Road (Trace) from Natchez to Nashville, began his trip from Washington, Mississippi Territory. It was his job to examine that part of the road reported to have been unsatisfactory to the U.S. Postmaster General so that the business of converting the Indian trail into a U.S. government–approved wagon road could be finalized.

Shortly after locating to the Natchez area he was in 1809 chosen as the Attorney General of the Mississippi Territory. Records show he served with distinction in this position for eight years. In 1817 he was named as Secretary of Mississippi's Constitutional Convention. Five years later he was elected to the judgeship of the Second Circuit Court and then later to the state Supreme Court.

At a state bar association meeting held August 21, 1824, at the courthouse in Natchez, word was received "that the Hon. Louis Winston has just departed this life." Upon hearing this sad news, his fellow bar members passed a resolution for the courthouse there in Natchez "to wear [black] crepe for thirty days."

The city of Louisville is proud to be named for Colonel Winston, and by the time the photo showing the courthouse (which accompanies this article) was made, around 1908, Louisville, with a population of just over 1,200, had become a hub for farmers and timbermen. The large building pictured near the center of the aforementioned photo, topped with a most unique cupola, is the county courthouse. Built in 1887 it served

the public for over 75 years. It was replaced by the present courthouse in 1964. The cotton-laden wagons all seem to be headed toward the covered artesian well in the center of the street. To the right of the well can be seen the Louisville Drug Company. It was here that both views shown, published as postcards by J. R. Holmes, could be purchased, and it was here, too, that no doubt some of those pictured had come to shop.

This store was one of the most popular destinations in town between the years 1905 and 1919, primarily because of the proprietor's method of advertising. This drugstore was the first business in town to issue trade tokens. These small brass coins, about the size of a modern dime, bore the wording, "Louisville Drug Co., Louisville, Miss." on one side and "Good For 5¢ in Trade" on the other. Known as brozenes or tokens, they were distributed all over town and when redeemed were usually given back to the customer along with their change to encourage them to return and make another purchase.

One of the newest structures, shown to the right in both pictures, is the Fair Company. This general

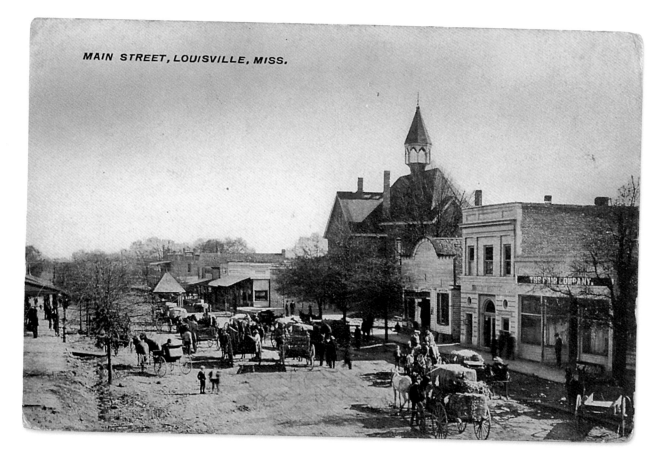

MAIN STREET, LOUISVILLE, MISS.

Louisville, circa 1908. The county seat of Winston County was by this time a bustling town of around 1,200 people.

mercantile store was built in 1905 by three brothers from neighboring Choctaw County, Davis Love Fair, Claude Fair and Frank Love Fair. So successful were the Fair brothers that it wasn't long before they expanded their business by building retail stores in the nearby towns of Noxapater, Weir, McCool, Calhoun City and Bruce. As the Fair Company prospered, so did

Louisville. On November 23, 1926, the status of Louisville was officially raised from town to city.

In 1927 W. A. Taylor, Sr., began to paint the town red. On the dirt floor of a mule barn in downtown Louisville, Taylor Machine Works was born from an idea and reared through seasons of hard work. It has even been said that during these early days "Mama" Taylor

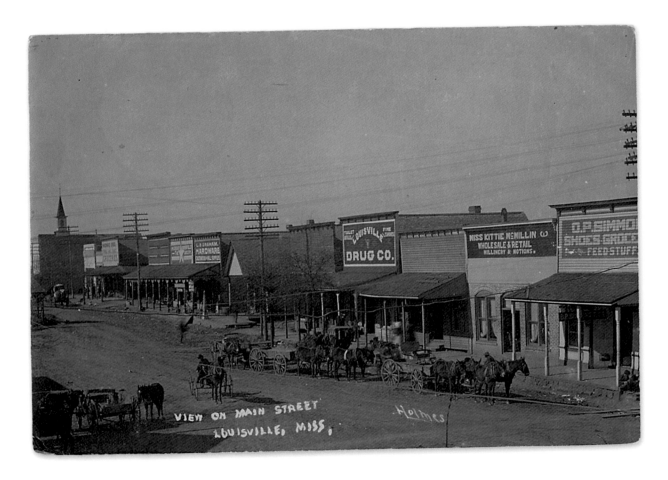

VIEW ON MAIN STREET
LOUISVILLE, MISS,

Holmes

did her part, too, by taking in boarders to help make ends meet. Mostly because of sheer determination to produce a superior product, Taylor's dependable, red machines began to attract a following. Then came the years of the Great Depression, and his little company struggled to exist. But his dream to succeed bore the same

resoluteness as did the dreams of Louis Winston and the other numerous pioneers who have walked in his footsteps. Finally, in 1937, Taylor and his small loyal group of workers hit pay dirt when they introduced the "Logger's Dream." This mechanical marvel, mounted onto the customer's existing truck, allowed a 1,500-foot

This photo, taken by Louisville photographer J. R. Holmes, clearly shows the popular Louisville Drug Company. Judging by the number of wagons parked out front, the proprietor's practice of issuing and redeeming trade tokens must have been a good investment.

cable to pull logs from any dense forest. Before 1937 this was a tedious job that had been done for more than 100 years by mules and oxen. The "Logger's Dream" revolutionized the logging industry and put Taylor's company (and Winston County's leading town) on the map. As the company grew, so did Louisville, and so did the size of Taylor's machines. Today the "Big Red" product line includes some of the largest lift trucks (fork lifts) made in the world. These user-friendly machines do the job not only in the logging industry, but are now prolific in the container handling business as well. The name "Taylor Machine Works" and the words "Louisville, Mississippi" are seen not only in the forests of this state, Oregon, Washington and others, but are equally prevalent in Brazil, Canada, Sweden and all other lumber producing countries around the globe.

Louisville, of course, is more than Taylor Machine Works. It is a city with a fierce heritage of winning, accomplishing, and succeeding, and is now home to 7,169 honest, hard-working, friendly people. Louis (which means "famous warrior") Winston (which means "friend")

would be proud of his namesake, and for what both the town and county mean to this state. ■

In 1868 a young Jewish boy named Leopold Marks left Germany with optimistic expectations of a better life. He was 17 when he reached New York City, spoke no English, and had only 18 cents in his pocket. Through the aid of a newfound friend, he became a peddler and began selling jewelry and kitchen items cross-country. A few years later he entered Mississippi at Friars Point, where he sold his wares from one plantation town to another.

He traveled, as most people did then, by riverboat, slowly and quietly through virtually pristine wilderness. Seated aboard a steamer churning its way through the rivers and bayous of the north-central Mississippi Delta, the young entrepreneur's eyes feasted on the beauty of the virgin hardwoods with their broad expanses of leafy shade, reaching well out into the river, often scrubbing the sides of the big, flat-bottomed boat as it pushed ever deeper into the most captivating woodlands he had ever seen. When he arrived in what would become Quitman County by way of the Coldwater River, he began to see more than adventure and mysterious beauty. As the giant trees became more plentiful he began to perceive a potential in the huge oak forests and fertile soil. When his boat docked at a new settlement which became known as Riverside, he stayed, opened a store and began to buy land as an investment for 40 cents an acre.

Ever the optimist, he saw opportunity around every bend. Historians have recorded the fact that it wasn't always smooth sailing for Marks, the man, who spoke with a heavy European accent, and who physically looked a little different from the

bulk of the people who were of English, Irish, Scottish, Welsh or African descent. However, because of his integrity and his work ethic (Marks and many other men of his era thought "work" was a verb), he was quickly accepted and respected.

Mississippi writer Elmo Howell has made an interesting observation in his book *Mississippi Scenes*: "With no ghettos in the South, Jews became more naturally a part of the life about them, settling first in the river towns, then inland settlements." Apparently a leader, Marks projected confidence and determination. Bearing in mind that leadership is a servant's role, the settlers, town folk and even the few old-timers realized before long that Leopold Marks was special. In 1877 Quitman County was formed from parts of Tunica, Coahoma, Panola and Tallahatchie counties and Mr. Marks was elected to serve the new county as their first representative to the state legislature.

In 1890 the Lake Cormorant-Tutwiler branch of the Yazoo and Mississippi Valley Railroad was completed through Quitman County, bringing with it new opportunities and more settlers. By 1900, the little village of Riverside, on the west bank of the Coldwater River at the confluence of Cassidy Bayou, consisted of only three stores: Marks's mercantile and two others. However, the new century seemed to be ushering in a renewed wave of optimism, much as spring is always filled with hope. During this decade and a half, before the Great War, the world's economics were strong and the demand for lumber and building materials was high. Loggers and logging companies appeared practically overnight in their eagerness to harvest Mississippi's ancient trees. Every few months Riverside added another merchant and another store. In 1907, with 22 businesses, the town was incorporated and renamed Marks in honor of the man who more than any other one person encouraged his fellow citizens to live their dreams. Four years later the county seat was moved from Belen to Marks, and today, during a resurgence of lumber, building materials and agricultural demands, the city boasts a population of more than 1,800 and growing.

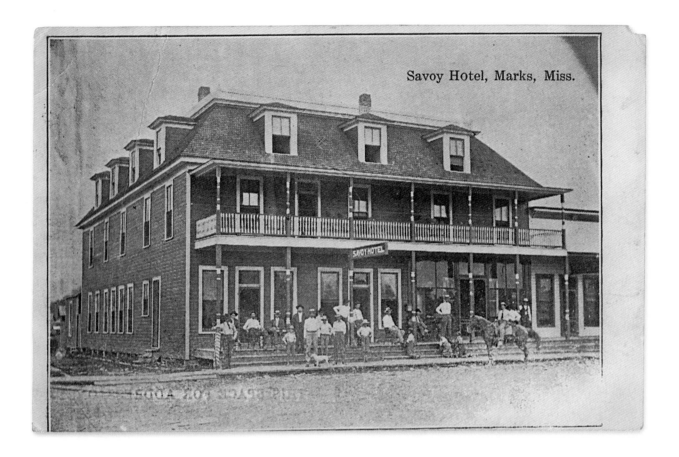

Savoy Hotel, Marks, Miss.

The photograph, made into a post-card, which accompanies this article was taken circa 1908 during what could be termed the beginning of the town's heyday. From a population of 200 in 1900 to 670 in 1920 and then to 1,750 by 1925 the rapid growth inspired merchants and local business leaders alike. Leopold Marks's positive attitude surely must have influenced those all around him, as is evidenced by the name chosen for the local hotel. The Savoy, appearing new and teeming with life, bears the same name as one of the world's finest hotel chains with branches in London, Paris and New York. Facing east at 106 Poplar Street, in the very heart of the business district, it was a grand place from which to observe the city. The large

The Savoy Hotel in Marks, circa 1908, shows an interesting cross section of people, from the barefoot youth in the front left to the proud horse owner on the right. Notice, however, there are no women—and everyone is wearing a hat.

windows afforded both natural light and comfort to the guests during this era before air-conditioning, and for perhaps that reason alone this hotel became the most popular in the city. Note the extra large, floor-to-ceiling glass windows at the bottom right corner of the building. Notice, too, the man pictured at the extreme left who is resting his arm on top of a presumably red-and-white-striped barber pole. Surely the front room to the right with the all-glass wall is the barbershop, and maybe the man leaning on the barber pole is the barber . . . and maybe not. This postcard was written and mailed on May 25, 1909. It was written in pencil by W.C. Pirtle to his brother W. P. Pirtle in Lyons, Indiana. His message was brief and to the point. It read: "Dear Bro.—This is whair [sic], my shop is. Good bye". Without knowing, we can have fun imagining that perhaps W. C. Pirtle was the barber and maybe, just maybe, his unorthodox spelling of the word "where" was his "barber talk" for saying this is a view of my barbershop. Then again maybe he wasn't a barber at all, just a poor speller to boot.

There are two social statements of the day in this photograph, one shown and the other perhaps more obvious because it isn't shown. The shown statement is really more of a fashion statement than a social one. It's the long-sleeve shirts. The photo was taken during the summer; the numerous open windows and the barefoot boy standing near the little white dog tell us this. But, why the long-sleeve shirts? The answer of course is that short-sleeve shirts had not been invented yet. Short-sleeve shirts didn't come on the scene until the mid-1930s. You might notice, too, that everyone is wearing a hat. There are not exceptions. The social state-ment, readily observed, is the absence of women in the picture. This is com-mon in photos of this period and is easily explained by the fact that it was not considered ladylike for women to be seen in town unless escorted by their spouses. Unmarried ladies stood even a greater risk of having their reputations stained should they be seen among a group of men.

As the city grew, so did its enviable record for being on the cutting edge of progress and advancement. For example, noted in James F. Brieger's monumental work, *Hometown Mis-sissippi*, is a positive reference to the

city's concern for the health care of
its citizens. The Marks Hospital, estab-
lished in 1919 by Dr. James Edward
Furr, "was the first in north Mississippi
to secure an oxygen tent." This was
during the time when tuberculosis
was such a real and ever-present
menace, and not just locally—it was a
deadly disease throughout the world.

This same optimism upon which
the town was founded still lives today
through the town's most famous
native, Frederick Wallace Smith, born
there on August 11, 1944, who has
carried on the town's tradition by
founding, in 1972, the Federal Express
Company. Leopold Marks would be
proud to know that both his town
and FedEx are alive and well. ■

almost a ghost town

McHenry is situated about a quarter of a mile west of Mississippi Highway 49 south, deep in the long straw pine area of Stone County. It is one of the many towns in the state that owe their existences to the vast stands of virgin pine timber that stood throughout most of Mississippi less than a century ago.

The opportunity for large profits from Mississippi's pine timber first brought the railroads and then hundreds of loggers, sawyers, and mill and turpentine workers into the state in the mid-1880s. Many of these settlers came from the Carolinas and Georgia; however, large numbers of timbermen came from the far north.

Like Lucedale, the county seat of George County, and the small town of Michigan City in Benton County, McHenry was founded by settlers from Michigan. In 1889 Dr. George A. McHenry led a group of fifty colonists from west-central Michigan into what was then Harrison County.

These "new" Americans of Scotch-Irish descent settled along the Gulf and Ship Island Railroad, which was then under construction in the midst of a great yellow pine forest. Situated atop a ridge that later was acclaimed to be the highest elevated point in south Mississippi, the new community became known as the Michigan Settlement. At first these families were fairly scattered because they were allowed to homestead only on odd-numbered sections; the even-numbered lots for three miles on each side of the railroad were reserved for the promoters of the railroad, which was under construction from Gulfport to Jackson for seventeen years (1883–1900).

133

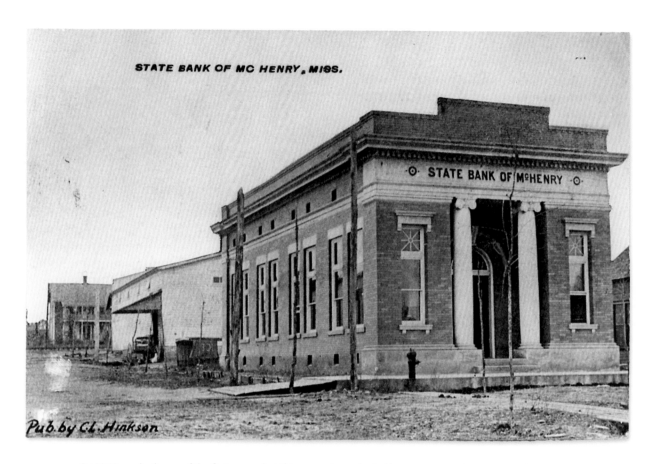

STATE BANK OF MC HENRY, MISS.

STATE BANK OF McHENRY

Pub. by C.L. Hinkson

Dr. McHenry built one of the first public buildings in the settlement, a general store where he also handled the mail. In an attempt to get the post office established, he requested that the government grant a post office under the name of Niles City, but this request was denied because there already was a post office known as Niles City in the state. The United States Post Office Department suggested that the town be named McHenry in honor of the new settlement's leader. The townspeople

The State Bank of McHenry, established in 1902 with a capital of $15,000, is shown as it appeared four years later when the town population numbered 1,200.

agreed, and the town acquired its official name. Within a few months the railroad constructed a depot at the site and the town began to grow.

In 1898, at the outbreak of the Spanish-American War, Dr. McHenry—physician, druggist, merchant, and local civic leader—answered the nation's call for volunteers. He entered the service as a surgeon with the rank of captain. During his tour of duty in Cuba, "his immunity to yellow fever enabled him to render a valuable contribution to the final conquest of the dread disease," writes Charles H. Sullivan in his book *The Mississippi Gulf Coast: Portrait of a People* (Windsor Publications, 1985). After almost five years in the military, Dr. McHenry returned to Mississippi to build and promote his town. By 1908 McHenry, with a population of about 1,500, rivaled Wiggins, its sister town to the north, as the leading trade center in the area.

Later Dr. McHenry became an emissary for the state, making several trips to Washington, D. C. During the time he spent in the Spanish-American War, he had become acquainted with General Leonard A. Wood. McHenry had also been a boyhood

friend of Thomas R. Marshall, vice president of the United States under President Woodrow Wilson. Through these friendships, Dr. McHenry, more than any other person, was responsible for the location of Camp Shelby near Hattiesburg.

The postcards accompanying this article show how a portion of the business section looked in 1909. One view, which looks south along the railroad tracks, shows the depot, which was faced by a group of the town's leading businesses. From left to right the business establishments pictured are the McHenry Trading Company, the McHenry Ice Company, four unknown businesses, and the E. J. Cooper Livery Stable at the end of the street. Next to the large barnlike structure is a two-story home.

McHenry, the town that lost by only a few votes (to Wiggins in 1912) the honor of becoming Stone County's seat of government, fell on hard times. First, on the night of September 24, 1903, a fire of unknown origin burned seventeen buildings. Four days later a second fire destroyed several more buildings. On April 3, 1930, during the Great Depression, a third fire destroyed almost the entire town,

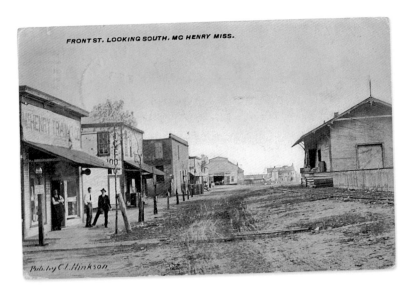

FRONT ST. LOOKING SOUTH. MC HENRY MISS.

Pub. by C.L. Hinkson

This scene of Front Street looking south along the railroad tracks shows McHenry's depot, faced by a group of the town's leading businesses. The sender of this postcard view, mailed on February 7, 1915, to Michigan, wrote this message: "Am stranded in this typical Miss. town with a broken auto."

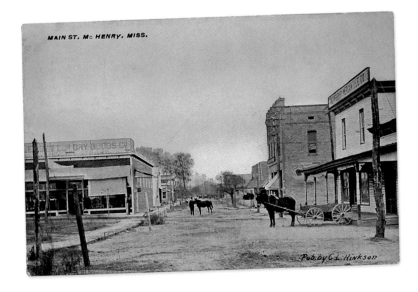

MAIN ST. Mc HENRY. MISS.

Pub. by C.L. Hinkson

In this view of Main Street a mule and wagon are shown backed up to the loading area of the McHenry Mercantile Company. This store and the others nearby were destroyed by a fire of unknown origin on June 29, 1939.

despite the efforts of the Wiggins and Gulfport fire departments. The general belief is that the fire was set by a robber of the James Brothers Mercantile Store to cover up his crime. Then finally on June 29, 1939, the fourth and final catastrophe struck. This fire of unknown origin destroyed the main business section, including the town's post office, drugstore, doctor's office, barbershop, meat market, and general merchandise store.

Today McHenry is a very small town, consisting basically of a post office, a small library, a Baptist church, and a service station out on the highway. However, the town, only twenty-five miles from the Gulf Coast, is a popular residential area. Many of the inhabitants have ties to the original settlers, including Delores McHenry Mauldin, the granddaughter of Dr. McHenry. Mrs. Mauldin still lives in the original McHenry home, a beautiful Victorian structure complete with peaked roof and ornamental weather vane.

The next time you drive to or from the Coast on Highway 49, take a few minutes to visit McHenry. Take this book with you, and using the old postcard view, try to locate the original town site. As you stand in the middle of what once was Front Street, you will have to use your imagination to relive the heritage of the flourishing settlement now almost a ghost town. ∎

The small Smith County town of Mize is situated along Mississippi Highway 28 midway between Magee and Taylorsville. The area was settled by the Scotch-Irish, many of whom bore the surname of Sullivan. Mize's heritage stretches back almost two full centuries, and so many stories have been told about the town and the sparsely populated area south of it known as Sullivan's Hollow that historians find it difficult to separate fact from fiction.

Records compiled during the 1930s by the Works Progress Administration and preserved by the state archives in Jackson note the early history of this so-called Piney Woods area. Though the facts of the early settlement of both Smith and Simpson counties are somewhat sketchy, historians have written that the first of the Scotch-Irish arrived by foot around the year 1800. The peaceful, nonwarlike manner of the Choctaws did little to discourage the whites, who came from the Carolinas and Georgia. Many of these pioneers had been on the move for most of their lives. They or their fathers had immigrated from Northern Ireland or Scotland to avoid the harsh living conditions caused mostly by the potato famine of the eighteenth century. Others had come in an effort to escape the heavy taxes imposed by the English.

Many of these early Piney Woods settlers bore arms with Washington's Colonial Army. However, almost before the sounds of musket fire had died away, the young American Congress began to enact taxes of their own in an effort to pay for the war and to build a nation. This action inflamed the hardy, individualistic Scotch-Irish living along the southeastern seaboard. So they packed their belongings in

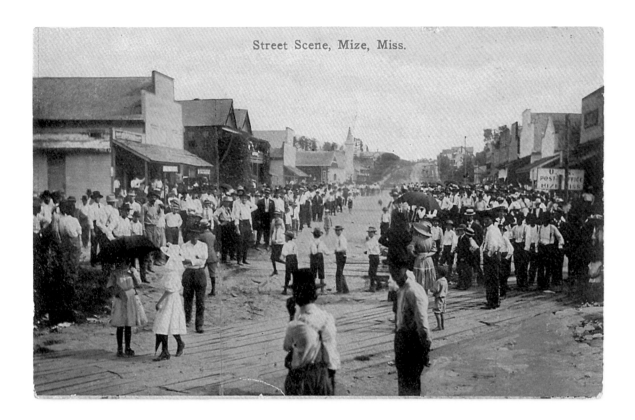
Street Scene, Mize, Miss.

This street scene photographed by Mrs. A. A. Ward about 1908 shows a crowd drawn for a special event in Mize. Notice in the foreground the thick wooden boards across the street. This was a type of bridge or covering over a small stream which still runs under the roadway into nearby Clear Creek.

wagons and carts and headed west into the hills of Tennessee and Alabama and then into the dense forests of Mississippi.

In 1814, Sam Hopkins, along with his family and seventeen others, settled on high ground close to St. Ealy Creek near the present boundaries of Smith and Simpson counties. Then came the Littles, the Sellers, the Campbells, the Bryants, the Sullivans, the Crafts, and others. As the

years came and went, more and more whites moved in as the Indians moved out, only to be followed by the Blue Coats, who pillaged and burned much of the Piney Woods. During these years of invasion, it was all that most Mississippians could do to protect and keep what they had, and even at that many fared poorly.

During the first two decades following the War Between the States, times were hard, money was less than

plentiful, and many people packed up and left for Texas and points beyond. Finally toward the end of the nineteenth century, the pendulum began to swing back as a worldwide demand for lumber developed.

The small communities of Hopkins, Waco, and McCollum's Mill soon gave way to one name—Mize. In the mid-1880s a man named Cecero Hopkins, who owned a large portion of the land where Mize is now, opened a post office. He named it Clear Creek for the nearby stream which still flows almost through the middle of town. It wasn't long before rumors began to circulate that a railroad was going to be built through the area. Men began to speculate and large and small tracts of land began to change hands. Soon the small post office was purchased by Smith County's popular sheriff, John Clay Mize, who served the county from 1878 to 1890. According to United States postal records, the name of the Clear Creek Post Office was changed to Mize in honor of the sheriff on August 22, 1887.

By 1890 there were 338 sawmills in the state, most of which were situated in south Mississippi. As more and more wood cutters, sawyers, and loggers

Sheriff John Clay Mize, for whom the town was named on August 22, 1887.

arrived, the number of mills grew. By 1899 there were 608 in the area. The railroad rumor through south Simpson and Smith counties became a reality as the first steam engine puffed into Mize on September 1, 1900. During the next ten to fifteen years, Mize grew like a seedling. In 1909 the number of sawmills in the state swelled to 1,761. Jobs, money, and good will in Mississippi were plentiful as the first two decades of this century, categorized as the state's golden era, witnessed a building boom that reached every county in the state.

The hand-colored photograph that accompanies this article is from a postcard dating from around 1908. Noticeable is the fact that almost every building in town was built of wood, including the Methodist church on the left just beyond the depot. Obvious are the thick wooden boards in the street covering a branch that still runs under the pavement into nearby Clear Creek. Today this little branch is still evident by the extra layer of asphalt that has been laid across the street at the very same angle.

Recently Al Meadows, the town's friendly and knowledgeable historian who owns and runs Al's Supermarket near the building shown in the extreme right foreground, noted that none of the buildings shown in this picture still exist. The church, now pastored by Reverend W. H. Wicker, has been replaced by a brick structure, as have most of the buildings. The old Lee Currie building, the first building on the left, was one of the last to go. It was torn down only a few years ago. Beyond it is the twin-roofed, two-story Mize Hotel. It fell into disrepair and was torn down in 1922. The depot is situated near the center of the photo. Now Highway 28 intersects North Oak Street, and the structure was sold for scrap lumber in the late 1940s.

In 1900 the population of Mize was 25. On June 19, 1905, Governor James K. Vardaman signed a proclamation changing the status of the little village to a town with an official population of 302. By 1910 the population was close to 1,000. When Robert Eubanks, one of Mize's oldest citizens, was shown this postcard view back in July of this year, his first question was, "Where did all those people come from?" They are apparently in town for a special occasion. Judging from the way they are looking down the street

and keeping the center open, they must be waiting to see a parade.

By the middle to late 1920s, the timber around Mize was gone. Stumps and pine tops littered the hills around for miles. Many citizens left to find employment; those who stayed turned to agriculture. When the Depression hit, the people of Mize turned to truck farming. Watermelons became a hot commodity, and within a few years, Mize stole the "Watermelon Capital of the World" title from Water Valley. During the 1930s, Dixie Queen watermelons, arguably Mississippi's best, were shipped all over America.

Today Mize is a town of fewer than 400 people. It still lays claim to being the watermelon capital and there is a sign just outside town that proudly proclaims it. But even those who still have their heart and soul firmly rooted in the town and its heritage admit prosperity is slipping. Wayne County now has more acreage in melons than does Smith. But to those citizens of Mize who have moved away, "The Hollow" is still home. Some are beginning to move back. Perhaps the pendulum will swing again. ■

the bell of st. mary's

The first Roman Catholic church in Natchez dates from 1788, during the period in which Spain controlled this westernmost area of what was then known as West Florida. The Spanish-built church was housed in a two-story frame building, the lower part of which was used as a dry-goods store, located on the east side of Commerce Street, between Main and Franklin streets. Initially the Spaniards named this mission church San Salvador of Natchez. However, apparently the designation of Saint Savior, or Holy Savior, was soon adopted and it was by this name that the chapel was called for the next four decades.

On March 30, 1798, Andrew Ellicott, Boundary Commissioner for the U.S. Government, along with members of a small military escort, was much relieved to see the Spanish garrison evacuate their fort in Natchez and proceed without protest or fanfare of any kind down Silver Street to their boats below, where they slipped away before the sun rose down the river to New Orleans. Almost immediately following their departure Ellicott unfurled the Stars and Stripes for the very first time over America's oldest city on the Mississippi River. Eight days later, on April 7, 1798, the Congress of the United States established the Territory of Mississippi.

Unfortunately for the Catholic community in the small town of Natchez, along with the departure of the Spanish officials went "the beloved clergy who had faithfully ministered to their little flock." The "church at Natchez" was left without a priest. Over the next 30 years it was only served intermittently either by priests traveling through the area or by French priests from nearby Louisiana parishes, including

not-so-near New Orleans. Now that the town and, of course, the entire area was under American control the population began to grow again. However, most of the new settlers were of English, Scottish, Welsh or Northern Ireland heritage and were therefore Protestant, not Catholic. The outlook for the little Roman Catholic church looked bleak during the early years of the nineteenth century. Indeed, the bleakest day in its history occurred on December 28, 1832, when the building, referred to by some as "the poor old Spanish Chapel," was destroyed by fire. According to local newspaper accounts of the period, the fire began from a candle left burning on a counter in nearby McDowel's tailor shop. Fortunately, all of the smaller church service articles were saved.

Unfortunately the organ, a gift to the chapel by Louis XVIII, which was said to have once belonged to King Louis XVI of France, was consumed in the fire. Although the members of this little church were distressed, they never counted themselves out. In fact,

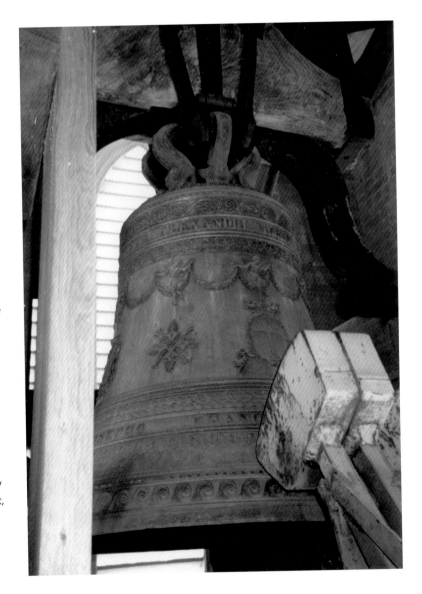

Maria Alexandrina bears religious symbols and magnificent decoration in relief around the bell's surface.

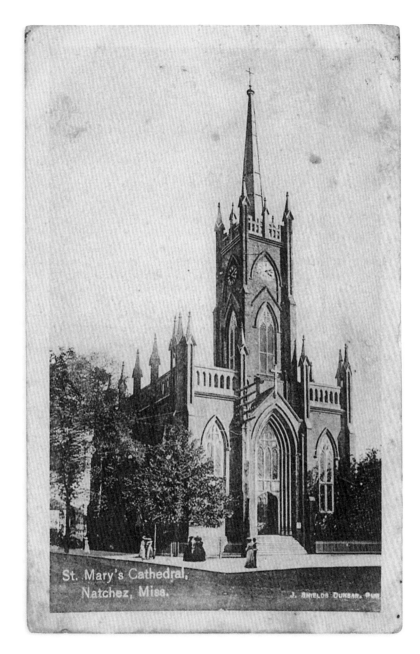

St. Mary's Cathedral,
Natchez, Miss.

J. SHIELDS DUNBAR, Pub.

The impressive exterior of St. Mary's Cathedral in Natchez circa 1904.

through their common adversity they became strong. Their strength and determination was surely the result of their faithfulness and prayers, many prayers. On July 28, 1837, after more than five years of being without a church building, their prayers were answered—perhaps in a bigger way than most of them ever hoped for—when Pope Gregory XVI located the Diocese for the Mississippi Territory at Natchez. This meant that "Natchez was to have a bishop who would reside here and from this city direct the affairs of the Church throughout the state."

Ten days before Christmas in 1840, Pope Gregory XVI named Dr. John Mary Joseph Chanche of Baltimore, Maryland, as bishop of Natchez. Bishop Chanche was a highly educated man from a family of considerable wealth who had numerous influential business connections throughout the United States and Europe. It was Dr. Chanche who, on the night of November 14, 1832, administered the last sacraments of the church to Charles Carroll of

Carrollton, the last surviving signer of the Declaration of Independence, as he lay upon his deathbed.

Under Bishop Chanche's direction, the Catholic community in Natchez set about to build their new church building. Chanche was accustomed to seeing the House of God dignified and impressive; therefore, a suitable cathedral along these lines seemed to hold the first place in his mind. At four o'clock on the afternoon of February 24, 1842, Bishop Chanche laid the cornerstone of the present Natchez Cathedral Church, dedicating it to God under the title of "the Transfixed Heart of the Ever Blessed and Immaculate Virgin Mary." The ceremony presided over by Bishop Chanche was the same ceremony which was performed by Augustine in England and by Patrick in Ireland, the same ceremony with which were laid the cornerstones of both Yorkminster Cathedral in York and Westminster Cathedral in London. In fact, it was the same ceremony witnessed by many of the Natchez congregation's forefathers when the Cross of Christ was planted on "the proud bluff of our own Natchez." Later, on Christmas Day in 1843, Bishop Chanche dedicated St. Mary's

The east face of the bell shows the coat of arms of Natchez Bishop Dr. John Mary Joseph Chanche.

The north face of the bell is made prominent with an illustration relief of the cross of Christ, the symbol of God's love for mankind.

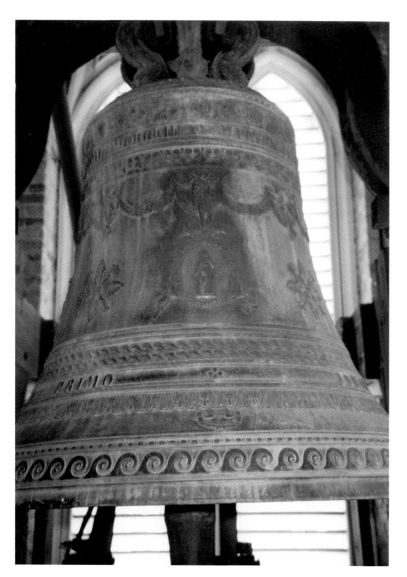

Cathedral to an overflow congregation of between 600 and 700, many of whom were visitors. On that day of the first mass, St. Mary's was not the beautiful adorned building that it is today. It consisted of "rough, unplastered walls, a shingle roof, a rough floor, and the most primitive furnishings." But it was not to be this way for long. Bishop Chanche set about to lead his congregation in supplying and acquiring the furnishings appropriate to a cathedral of this status.

Today, St. Mary's contains many church treasures and the beauty of the interior is second to none. Those readers who have seen the inside of St. Mary's will, I am sure, simply smile and agree with this statement. To those who have never been inside I can only say you are missing seeing one of the most beautiful treasures in all of the state of Mississippi. However, one of the most elaborately beautiful treasures housed inside St. Mary's can't be seen, because of its location high up in the belfry. It is the magnificent Maria Alexandrina Bell.

The south face of the bell showing in high relief a representation of the Blessed Virgin within a wreath supported by two cherubs.

This one-of-a-kind bell was described by Canon Raphael Bertinelli, the agent of the bishop in Rome in 1850, as being embellished with such architectural beauty "that neither in all the City of Rome nor in all America could you see its equal." This artistically molded bell was a gift to the Catholic congregation at Natchez from one of the most affluent families in Italy, the Torlonia family of Rome. In the fifteenth century Giovanni Torlonia established the Torlonia Museum, still one of the most prestigious museums in the Eternal City. The bell of St. Mary's is the generous gift of Prince Alexander Torlonia and his wife, Maria. The casting of the wonderfully decorated bell was the work of an eminent sculptor, Giovani Lucenti. This bronze masterpiece has a diameter at the base of 40 inches, and weighs upwards of 3,000 pounds.

In the book *Candle Days of St. Mary's at Natchez,* written by Most Rev. R. O. Gerow, Bishop of Natchez, and published in 1941, the story of the bell's casting is related by Bishop Chanche. The night the bell was cast, "about twelve o'clock the Prince left the company which he entertained, went with his wife and a few friends, to the foundry; the lady cast a gold ring in the glowing, melting mass, and all knelt down, reciting the Litany of the Blessed Virgin and other prayers during the fusion." The bell arrived in Natchez on Monday, May 12, 1850, on board the steamer *Natchez No. 3*. Two Sundays later, May 26, it was solemnly blessed by Bishop Chanche, and the next day, Monday, the huge bell was suspended in the bell tower at the base of the steeple. It was so highly polished that it shone like the sun itself. What a beautiful sight it must have been! Today the bell is as good as new, and it still chimes every hour, ringing out the reminder that "Jesus is Lord." But after 149 years, the gleaming brightness of the bell has aged into a soft green patina indicating its maturity. Its purpose is unchanged and its message today is the same as it was during its very first day of use.

Most church bells are plain and undecorated—after all, who can see them way up there in the bell tower? This bell can't be seen any better than any other church bell now, but it was seen by hundreds during its dedication. It would be good if someone were to film the bell now and the film shown to the church as well as to the

cathedral's visitors in order that the bell's historic beauty and symbolism be appreciated.

There are a number of inscriptions cast into the bell. In a band near the top is the wording "Munificentia Principis Alexandri Torlonia Romae Anno Dmi MDCCCIIL," and in a band near the bottom of the bell: "Joanni Josepho Chanche Episcopo Natchetensi Primo." (Surely this is the only place in Mississippi where Natchez is written in Latin.)

It is the ornamentation upon the sides of the bell that intrigued me the most, and gave me a real sense of discovery when I was privileged to see and photograph them on September 4, 1999. St. Mary's, which is located on Main Street at the corner of Union Street, faces west, towards the river. The bell, although it is round, has, because of its ornamentation, four sides. The western side (facing the front of the building) bears a relief showing the Torlonia coat of arms. The relief on the east side shows the coat of arms of Bishop Chanche. On the south side of the bell is a relief of the Blessed Virgin within a wreath supported by two cherubs, and on the north side is a simple cross, the symbol of Christ's love for man.

In 1977, the title of "Cathedral" was transferred from St. Mary's to St. Peter's in Jackson when the diocese became the Diocese of Jackson. On September 8, 1998, Pope John Paul II designated the church of St. Mary at Natchez a Minor Basilica, one of only a few in this nation.

Upon entering the Basilica of St. Mary, there is little doubt you are indeed standing on Holy Ground. Immediately you are reminded of Psalms 122:1: "I was glad when they said unto me, 'Let us go into the house of the Lord.'" ■

two counties

a town of

F
ew towns in Mississippi enjoy the type of unusual location that has given the Lee County town of Nettleton its personality, or rather has given the Monroe County town its personality. Nettleton is situated in both Lee and Monroe counties with Main Street being the dividing line between the two. This special characteristic has provided Nettleton with an extraordinary identity.

Like a number of towns throughout the state, Nettleton owes its very existence to the railroad. Back in 1886–1887 when the Kansas City, Memphis, and Birmingham Railroad was being constructed through the northeastern part of the state, a group of citizens from a now extinct village known as Eureka decided it was to their advantage to move to the railroad and establish a new town. Eureka was situated about three miles east of Nettleton.

Other citizens soon joined them, and the new town was named in honor of George H. Nettleton, vice president of the railroad. Now a town of some 2,500 citizens, Nettleton is situated about halfway between Tupelo and Amory where state Highway 6 intersects with state Highway 45.

The town center view of Nettleton accompanying this article is of Front Street looking south toward Main Street. It is believed to have been taken around 1910 by Charley Bourne of nearby Amory. The hand-tinted photograph is from a postcard that was mailed from Nettleton with the message: "this is how the town looked . . . when the folks walked home by lantern light." It is an interesting picture of

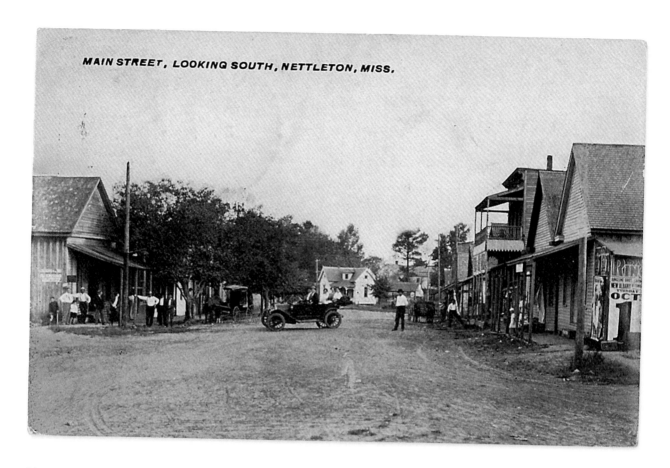

MAIN STREET, LOOKING SOUTH, NETTLETON, MISS.

Taken around 1910, this photograph offers a view of Nettleton's Front Street. All the stores shown on both the right- and left-hand side of the street are in Lee County while the white house at the end of the street is in Monroe County.

an interesting town. However, to really appreciate the picture, you must know a few interesting facts.

Front Street runs north and south and is now a part of state Highway 45. At the far end of the street, directly in front of the large white house, is Main Street, which is now a portion of state Highway 6. All the stores shown

in the photograph are in Lee County, while the white house as well as those behind it are in Monroe County. Unfortunately, none of the people in the picture are identified.

One item of interest is the tall building on the right—the two-story structure with the upstairs covered balcony. If you look closely, you will

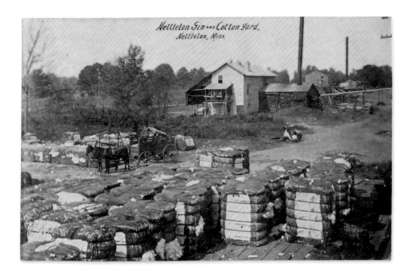

The rail line at Nettleton offered local farmers, in both Lee and Monroe counties, a closer shipping point for their crops, saving them both time and money. In this 1910 scene the cotton bales in the foreground have been placed on the depot loading dock ready for shipment.

Dozens of towns in Mississippi owe their existence to the railroad. Steam-driven trains required water for their boilers approximately every 10 miles. Therefore, the railroad made a practice of constructing depots and raised water tanks at 10-mile intervals. In this photo the water tank is just out of sight beyond the depot. Nettleton is located 10 miles northwest of Amory and 10 miles south of Tupelo.

see a large bell, much like a school or church bell, sitting on the floor of the upstairs balcony. This building was the Masonic Lodge, and the bell served as an alarm device for the town to report local fires and other emergencies.

Nettleton has grown from a 1906 population of 600 to 2,462 in 1990. The face of the town has, of course, changed with the growth. Almost all the stores shown in the front street photograph have been replaced with newer, more modern buildings. The white house on Main Street, which served the town for more than two decades as both a doctor and a dentist office, has been torn down. In its place is the relatively new Bank of Mississippi building. According to statistics housed in the Mississippi Department of Archives and History in Jackson, there was a total of 890 towns, including both urban and rural, in Mississippi in the year 1900. By 1930 this total had risen to 1,192; however, in 1960 the number had dropped to 882. According to the latest figures, the number of towns in the state now is 310.

Though Nettleton has two separate school districts plus the dichotomy of Lee County being wet and Monroe County being dry, it is in reality one town with one government. On March 1, 1973, the town made history by becoming the very first town in the state to have city delivery of mail service at selected street corner "cluster boxes." Perhaps Nettleton's most noteworthy trait is its ability to meld a single community out of two entities. Many attribute the town's progressive growth to a number of factors. However, most residents agree that the most important attribute of Nettleton is that it is just a good place to live. ■

fort henry

Congress passed a measure on March 3, 1885, that provided for the establishment of a Board of Fortifications and Coast Defenses. It was through this measure that the U. S. War Department began to organize the state national guards. Congress made an appropriation of $5,000 to each state having a sufficient waterfront upon which to build and equip a battery or fort, provided each eligible state would furnish the land to the government for that purpose. In early 1887, the citizens of Pass Christian raised sufficient money to buy land with 1,205 feet of frontage on the beach near Henderson Point. The seller, Elliott Henderson, then donated 50 acres adjoining this property to the north. This action raised the total land area to approximately 100 acres (part of the present Pass Christian Isles). Under the agreement, the state was required to encamp the guard (or state militia as it was then called) for at least three consecutive years or forfeit the title of the property.

The state adjutant general who was also chief of staff, Brigadier General William Henry of Jackson, was advised of purchase of the site. He contacted the War Department, and it sent Captain James Rockwell to superintend the construction of the earthen embankments and to place the big guns. The guns were two 10-inch Rodmans and four 10-inch mortars, taken from one of the forts on the lower Mississippi River. They were shipped to New Orleans by steamboat and were then transported to Pass Christian on the L. & N. Railroad. The task of hauling these heavy guns was contracted by John H. Lang of Pass Christian. This feat was accomplished with the use of two log carts coupled together. A crosstie was placed in the muzzle,

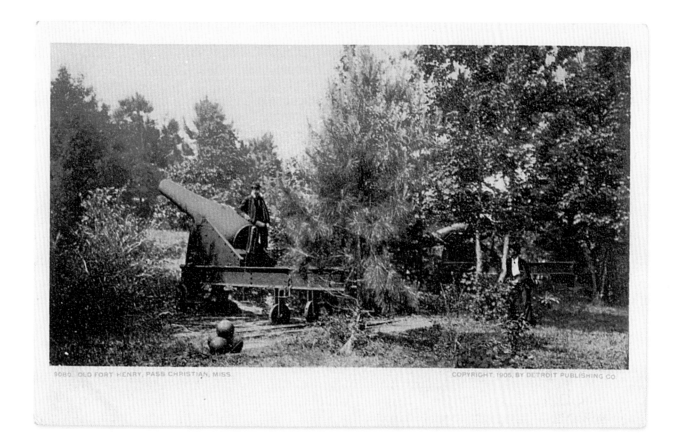

9080 OLD FORT HENRY, PASS CHRISTIAN, MISS.

COPYRIGHT, 1905, BY DETROIT PUBLISHING CO

In this photo copyrighted in 1905 by the Detroit Publishing Company, 18-year-old Fort Henry was referred to as "Old" Fort Henry because it had not been in use for about 15 years. Notice that the Gulf is no longer visible due to the stand of trees that has grown up between the big guns and the water's edge. Note also that the second cannon, shown on the right, is almost completely obscured by the foliage of several other trees that have begun to overtake the area.

and the gun was swung up under the two carts. Once these guns were in place at the new site, they were connected by an underground magazine, complete with a substantial amount of ammunition.

The first annual encampment of the Mississippi National Guard was held at Fort Henry on August 3, 1887. Attending this encampment were

three companies of the Mississippi National Guard (The Capitol Light Guards of Jackson, under Captain George S. Green, The Columbus Riflemen of Columbus, under Lieutenant R. R. Spiers, and The Natchez Rifles of Natchez, under Captain B. B. Davis) and four companies of Louisiana National Guardsmen. The Louisiana Guard was a battery of regulars from

New Orleans. These troops were to act as instructors.

It is recorded in the official adjutant general's report for the years 1886–1888 that this first outing of the Guard was successful in that the troops had ample practice in handling and firing the cannons and mortars and in target shooting with the rifle and Gatling gun. However, everything else seemed to go wrong from the start. No provision had been made for a sufficient water supply for so many men. Water had to be hauled to the camp in barrels, and through an oversight the state failed to provide the money for this expense. The railroads hauled the troops free, but all of them had to ride either through Alabama or Louisiana to get there. (The first north-south rail service to connect Jackson with the Gulf Coast area was the Gulf and Ship Island Railroad that began its operation in the summer of 1900.) To make things worse, the camp was hit by a tremendous rainstorm that was followed by a horde of mosquitoes.

Only three encampments were held, and after the turn of the century the guns were sold to a junk dealer who broke them up with dynamite and shipped the iron away.

Fort Henry now is only a memory. The only reminder of its existence is a street named Fort Henry in the city of Pass Christian. ■

the destruction of purvis

A s friends and relatives of the graduating class of 1908 filed out of Purvis's two-story brick schoolhouse on April 24, few paid much attention to the storm clouds that were lingering about one mile to the southwest of town. Such clouds were not an uncommon sight at that time of year, and most people thought the threatening clouds would soon blow away.

Just before 2 p.m., however, the clouds began to join forces, taking the shape of a funnel. Suddenly a deafening roar was heard, and panic struck as everyone realized that a tornado was headed toward Purvis. As the cloud came nearer, the sky became as dark as night, heavy rain fell, and men, women, children, and animals frantically ran for shelter. The world seemed to be coming to an end.

Two days later, the *Laurel Chronicle* gave a graphic description of the destruction. It was reported that "every house and store in Purvis with the exception of those on the extreme northwest end of the village had either been completely demolished or so badly damaged that they will have to be reconstructed."

The tornado, referred to by several of the writers of 1908 as a cyclone, was reported to be a full three-quarters of a mile wide. Certainly one of this state's most destructive storms, it originated in the Gulf of Mexico and swirled through portions of Louisiana and Mississippi, killing more than 300 people, 190 of them Mississippians. Twenty-three Mississippi towns and communities were struck by the tornado, but Purvis received the brunt of the storm. When the winds and the rain finally cleared, the unofficial casualty count in Purvis stood at 50 dead and 170 injured.

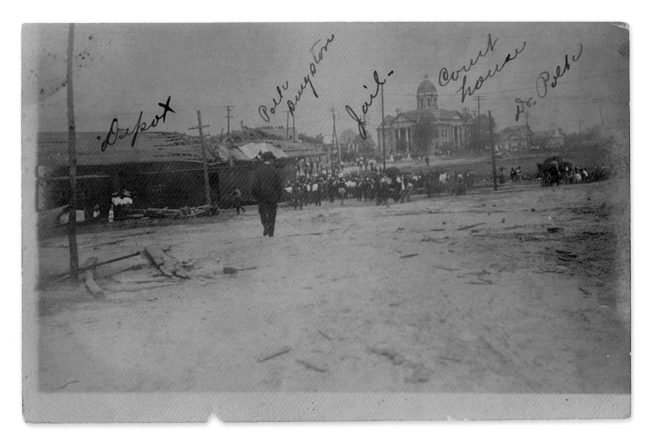

The New Orleans and North Eastern Railroad depot was one of the first buildings struck. It was thrown across the track and the boxcars standing in front were carried off the right-of-way. The famous old Poole Hotel was reduced to a pile of timbers and planking. The building, considered even then by town folk as a landmark, was fortunately unoccupied.

The office of the *Record,* the local newspaper published by J. R. Holcomb, was heavily damaged. Nothing remained but the side and rear walls; the roof and front were completely carried away. The roof was blown from the county jail, and later it was reported that none of the 27 prisoners was injured and none escaped during the incident. On the corner of Main Street, Dr. Polk's drugstore was only

This real photo view, apparently taken only a few minutes after the tornado struck, shows some of the destruction southwest of the courthouse. The wrecked railroad depot, shown on the left, was lifted completely off its foundation. The boxcars too were uplifted from the track and are shown sitting upright on the ground.

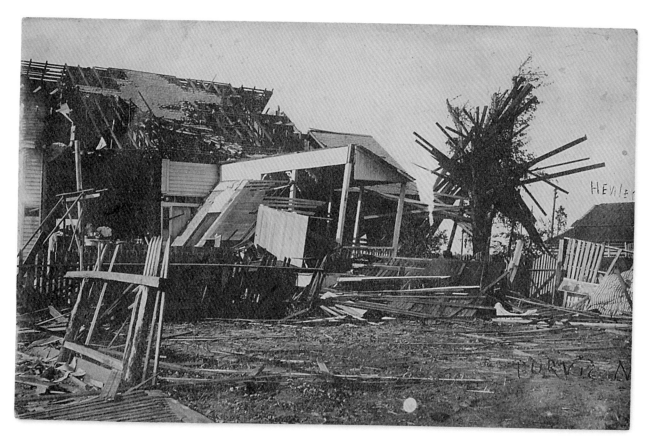

This photo, taken by Hattiesburg photographer D. B. Henley, helped to substantiate a report printed in the *Laurel Chronicle* which stated that "every house and store in Purvis with the exception of those on the extreme northwest end of the village had either been completely demolished or so badly damaged that they will have to be reconstructed." The house pictured was the W. H. Magee home on Ohio Avenue. Note the lumber-riddled tree in the side yard to the right.

slightly damaged, so it was there that the wounded and dying were carried during the day and night after the disaster.

Animals and plants suffered as well. Standing pine timber was twisted into kindling wood, and the small saplings that were left standing were stripped of bark and foliage and spattered with mud from top to bottom.

In the wake of the tornado, tales of tragedy circulated. Nineteen-year-old Lettie Clark was standing near the Methodist Church when the dark funnel clouds were first sighted. Frightened, she started running toward home. Within two or three steps of her front door, she was felled by a heavy piece of timber. She remained unconscious for several hours, and when she was examined by a physician, it was

found that both legs were broken. It was necessary to amputate one, and although it was reported that she underwent the operation with rare courage and fortitude, she lived for only a few hours. Later, an examination of the spot where the girl was picked up brought to light a piece of bloody timber, recognizable by the paint as being part of the church building from which she had run when the storm struck.

It was fortunate for those attending the graduation exercises that the tornado did not strike an hour or two sooner, because the top story of the school was completely blown away and the bottom portion severely wrecked. The school was later rebuilt and continued in service until 1937, when it was torn down and a new building was erected.

The pride and joy of Purvis, the Lamar County Courthouse, which was barely three years old, survived the storm fairly well, receiving only minor structural damage with the exception that every pane of glass in the building was blown away. The most obvious damage was to its big clock. The hands were stopped at 2:13 p.m., and since the clock was never repaired, it remained a reminder of the terrible storm until late in the 1930s when the courthouse burned.

Within minutes after the tornado had passed, efforts were made to contact Hattiesburg for help. Leonard L. Slade, Jr., in the book *Lamar County Heritage*, states that all means of communication were destroyed, so G. W. Holleman and W. B. Alsworth saddled horses and started across country for Richburg, 10 miles from Hattiesburg. "Pushing their horses for all they were worth," Slade wrote, "Alsworth made the trip in less than fifty minutes and wired direct to Hattiesburg of the disaster."

By 5:30 p.m. the first of many freight trains left Hattiesburg with doctors, nurses, food, clothing, bedding, and medical supplies. For days and in some cases for several weeks, many things were in short supply.

With much pain and perseverance, the citizens of Purvis rebuilt their town. As always, time is the great healer, and today, with the exception of the tombstones, Purvis bears none of the scars of the tornado of April 24, 1908. ■

where families gathered

I have my grandfather's favorite arrowhead. It is the one that he found while plowing cotton. I like it because I know it meant so much to him. I also have my dad's favorite pocket knife and my first football helmet he bought me in 1957.

Most of us have kept some small family memento from our past. It is our link with a happy moment. I cherish my small collection of Cracker Jack toys that I collected one at a time from my family's grocery trips from Florence to Jackson in the early 1950s. These bring back memories of the seemingly long drives and visions of Daddy driving "with no hands." Isn't it funny how we remember the little things?

The late Wyatt Cooper, a native of Quitman in Clarke County, gained fame as an actor and lecturer. He is perhaps best remembered as being the husband of New York's Gloria Vanderbilt and for his sober look at himself and his family in his best-selling book, *Families*. In this book, which is difficult to find now, Cooper began the first chapter, which he entitled "Of Sons and Immortality," with a quotation from Ecclesiastes 1:4: "One generation passeth away, and another generation cometh: but the earth endureth forever."

In one of the pre-1910 postcard photographs accompanying this article, several families are shown, dressed in their best, at one of Forrest County's favorite meeting spots, Rawls Springs. This area, which was discovered by the Choctaws many, many years ago, is situated two or three miles north of Hattiesburg and was named for a pioneer settler, Benjamin Rawls, who moved there with his family in 1841.

Around the turn of the 20th century, the spring water was found to possess certain minerals which were said to be helpful in the treatment of kidney and

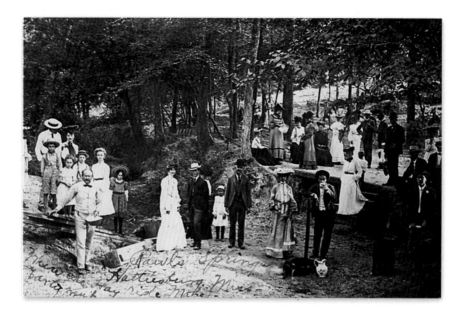

Families visited at Rawls Springs in Forrest County in the early 1900s for recreation and to take advantage of the curative water.

blood disorders. Consequently, Rawls Springs was recommended to health seekers by several doctors. A frame hotel was built near the springs and visitors came from as far away as Jackson and the Gulf Coast seeking the curative powers of the water.

Several years ago, from a telephone conversation with Mrs. Rose McInnis of Jackson, I learned that her father, J. W. Lewis, moved from Tylertown around 1905 because her mother was in bad health. They moved first to Mammoth Springs, which was about one mile

east of Rawls Springs. Lewis bought the Mammoth Springs Hotel, and the family lived there in the summer and at Rawls Springs in the winter.

As time passed, her father sold the hotel to a Dr. Brumfield and opened a store which he operated along with the post office at Rawls Springs. As a child, Mrs. McInnis remembered large groups of people, mostly families, coming to the springs, especially in the summer. She recalled dinners on the ground followed by games. Horseshoes and washers entertained the

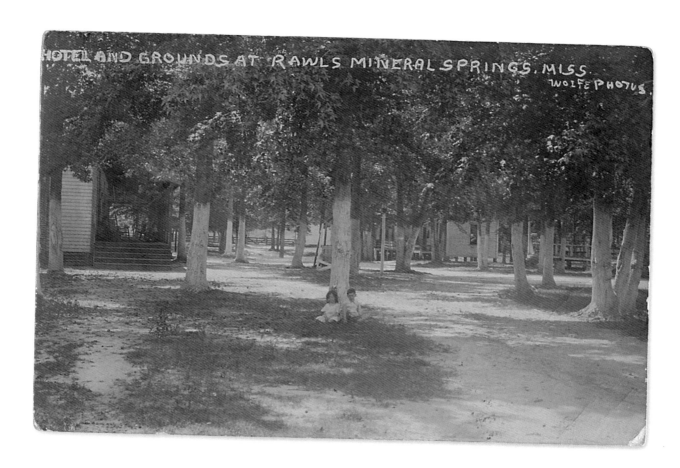

In this 1907 view a portion of Rawls Mineral Springs Hotel, showing a chair-filled porch and the grounds, has been captured in time by Laurel photographer Wolfe. Notice that the tree trunks have been painted white, up to about head high, to make them more easily seen "so you wouldn't run into them" and "so your horse wouldn't run into them either."

adults, and hide-and-seek kept the children occupied. The one game both grownups and children played was baseball. Trees served as bases. Mrs. McInnis particularly remembered the trees; she said they were all painted white, up to about head high, so they could be more easily seen at night, "so you wouldn't run into them," she said, "and so your horse wouldn't run into them, either."

Today the community of Rawls Springs is a sleepy suburb of Hattiesburg. However, the springs are gone. Back in the 1960s a local landowner had a bulldozer level the hilly area behind his house, covering up the springs. ■

sardis, prince of joy

A few years back, eighteen to be exact, a book was published by the University Press of Mississippi which showed how Mississippi differs from all the other states of the union. The book was the result of a symposium held at the University of Southern Mississippi at Hattiesburg on October 5–6, 1978. At this historic meeting, twenty-four of the state's gifted writers, including Willie Morris, Will D. Campbell, and Patti Carr Black, presented their papers which shared their personal views about Mississippi's rich cultural heritage. Their collection of essays is bound together under the title *Sense of Place: Mississippi*.

Mississippi, for the most part, was founded by people who put first things first. These people, our forefathers, were Judeo-Christians who put God first in their lives and were not ashamed of it.

This fact is easily seen when you consider that it was no accident that when a town was established the very first public building constructed was a church—not a bank, not a government building, not even a school. Nowhere in Mississippi is this better illustrated than in the Wilkerson County town of Woodville. Incorporated as a town in 1811, it is one of the state's oldest settlements. From the beginning its citizens put God first. The Woodville Baptist Church, founded in 1798, occupies the oldest church building (built in 1809) of any denomination in Mississippi. St. Paul's Episcopal Church, built in 1823, is the oldest Episcopal church outside the original thirteen colonies, and the Woodville Methodist Church is the oldest church of its denomination in the state. St. Joseph's Catholic Church is more than 130 years old

MAIN STREET, SARDIS, MISS.

Sardis (Prince of Joy) in Panola County bears the same name as the ancient capital city of Lydia mentioned in the Book of Revelation.

1412 STREET SCENE, PHILADELPHIA, MISS.

Philadelphia (love of a brother) is the thriving county seat of Neshoba County.

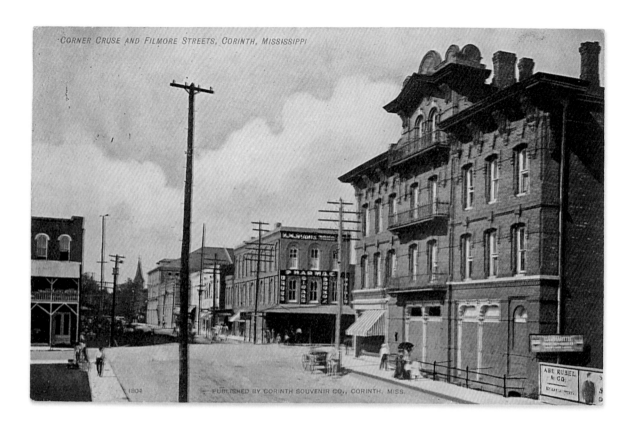

CORNER CRUSE AND FILMORE STREETS, CORINTH, MISSISSIPPI

1804 PUBLISHED BY CORINTH SOUVENIR CO., CORINTH, MISS.

and although the town no longer has a Jewish synagogue it had two.

Place names found in the Holy Bible abound in Mississippi. It is not difficult to see what our forefathers had on their minds when they began to search for a name for their town or community. There are more than fifty places in the state which are named for Biblical sites. The most popular name seems to have been Salem (perfect peace), the city of Melchizedek (Genesis 14:18), as there are five communities by this name located in the following counties: Benton, Covington, Hinds, Leake, and Walthall. Another popular name is Antioch (speedy as a chariot). This was the Syrian city where the followers of Jesus were first called Christians (Acts 11:19–26). There are four Antiochs, one in the county of Attala, one in Jones, one in Tate, and one in Warren. The third most popular name is Palestine

Corinth (ornament), the county seat of Alcorn County, is named for the famed Greek crossroads city where the Apostle Paul established one of his strongest churches (Acts 18:1).

(which is covered), the somewhat ill-defined region between the Jordan River and the Dead Sea on the east and the Mediterranean on the west (Genesis 15:18). The communities of Palestine are found in Clay, Hinds, Pearl River, and Yalobusha counties.

In Jefferson Davis County there is a small community named Tyre (rock). You might remember that it was the King of Tyre who furnished the building materials to build King David's palace (II Samuel 5:11). Ebenezer (stone of help) was the name of the stone Samuel erected to commemorate God's victory over the Philistines (I Samuel 7:12). The small Holmes County town of Ebenezer is perhaps best remembered as being the hometown of PFC Milton L. Olive, a Congressional Medal of Honor winner, who, during the war in Vietnam, helped save the lives of four of his fellow soldiers by throwing himself upon a live enemy grenade. His sacrifice enabled four others to live.

The prophet Isaiah's name for the Promised Land after the Babylonian captivity was Beulah (married). This information is found in Isaiah 62:4. If you look up the word Beulah in today's dictionary you will see that it now

means "Israel." The small community of Beulah is found in Attala County and the well-known Delta town of Beulah is located in Bolivar County.

Mississippians take great pride in being hospitable and for this reason it is good that there are at least three communities with a name that bears this out. The Hebrew city of Hebron (friendship) is located in the hills of Judah about 20 miles south of Jerusalem, and is mentioned several times in the Bible (Genesis 13:18; Numbers 13:22). There is a small community named Hebron in Jones County, and also one in Jefferson Davis County. The much larger town of New Hebron is located in Lawrence County.

The original name of Palestine, the land given by God to Abraham and his descendants (Exodus 6:4), is Canaan (purple). A community by this name is located in northeast Benton County.

Up in Alcorn County the historic city of Corinth (ornament) is named for the famed Greek crossroads city where the Apostle Paul established one of his strongest churches (Acts 18:1). This ancient city of trade is located about 40 miles west of Athens and is mentioned many times in the New Testament.

There are a dozen or so other localities in the state that were named for towns or villages visited by Jesus, but in all of Mississippi there is only one community that bears what is perhaps the most symbolic Christian name of all. This small settlement of rural homes is found in the southeast corner of Marshall County and is named for the birthplace of Jesus (Matthew 2:5), who said in John 6:35, "I am the bread of life. He who comes to me will never go hungry. . . ." This remote community is named Bethlehem, which in Hebrew means "house of bread."

The Book of Revelation, filled with prophecy, mystery, and, most of all, promise, is the book from which at least four towns in the state selected their names. In the first few chapters of this great book are John's letter of urging and warnings to the seven early Christian churches of Asia Minor. Some of the names of the churches or cities remain with us today. One is the northern county seat of Panola County, Sardis (Prince of Joy). In ancient times Sardis was the capital city of Lydia and is mentioned in Revelation 1:11 and 3:1–6. The old city was conquered and destroyed by the Arabs in A.D. 716. Today a small village renamed Sart stands among the ruins.

Another mentioned was at Thyatira (sacrifice of labor), which was a city located near ancient Sardis (Revelation 2:18–19). It exists today as the Turkish city of Akhisar, and with its population of 50,000 it is much larger than is Thyatira in Tate County. Another of these churches, examples to us all, is Philadelphia (love of a brother). John praised the church at Philadelphia for their patience (Revelation 3:7–13). When Jesus was asked which of the commandments was the greatest he answered, "Love the Lord your God . . . ," but without being asked he added that the second greatest is to "love your neighbor [brother] as yourself" (Matthew 22:36–40). This second commandment is the literal meaning of the word "Philadelphia."

Philadelphia in Neshoba County is a thriving little city. Back in what was Asia Minor the ancient city of Philadelphia no longer exists. The Turks have built another city where Philadelphia once stood, but they, like our forefathers, put first things first. They have named their new city Alasehir (city of God). ■

the heart of Oktibbeha

Early historians have written that the site of present-day Starkville was originally called "Hic-a-sha-ba-ha," reportedly meaning in the language of the Choctaw "sweet gum thicket." Apparently this area was a favored campground of numerous Indian tribes for hundreds of years prior to the arrival of the Spanish in 1540. The Indians often gave names to places based on simple logic, and this northeast Mississippi town is no exception. Today, the still plentiful groves of sweet gum trees are just as eagerly sought for their shade as they were in pre–De Soto days.

Geographically, Starkville is centered near the heart of the 459-square-mile Oktibbeha County. Named for Tibbee Creek, which traverses near the extreme northeast corner of the county, Oktibbeha is a word that vividly describes the ancient history of this much fought over soil. Translated into English, Oktibbeha means "bloody water" and refers to the many battles fought between the descendants of two brothers, Chata and Chicsa, who parted ways more than two thousand years ago according to ancient stories. Tibbee Creek formed one of the natural boundaries between the two tribes with the Chickasaw Nation to the north and the Choctaws to the south. Legend has it that civil wars between them were both fierce and often.

On September 27, 1830, the Choctaws, led by Chiefs Greenwood Leflore and Mashulatubbee, signed the Treaty of Dancing Rabbit Creek whereby they ceded possession of the last of their Mississippi lands, some 10,000,000-plus acres (16,286 square miles), to the United States government. State of Mississippi officials

Looking East on Main Street, Starkville, Miss.

wasted little time in carving this vast wilderness into seventeen counties. A large number of the new counties were given Choctaw names, such as: Choctaw (separation), Noxubee (stinking water), Neshoba (wolf), and Leflore (named for Chief Greenwood Leflore, who, along with several hundred other Choctaws, never left the state at all), to name a few. Almost the same number of the new counties were named for popular Revolutionary War heroes, including Washington (General George Washington), Carroll (Charles Carroll of Maryland, the last living signer of the Declaration of Independence), and Montgomery (General Richard Montgomery, who was killed during the assault on Quebec in 1776). And there are others. The War for American Independence was still fresh in people's minds during

The sender of this circa 1912 postcard picturing downtown Starkville noted that this scene depicted "the heart of the city." He also proudly wrote that this town (his town) "is where the Agricultural College of Mississippi is located."

GENERAL STARK.

Born in Londonderry, N. H., Aug. 28, 1728. He grew up in the wilds of New Hampshire, was captured by the Indians and adopted into the St. Francis tribe. Served as captain in the French-English war of 1758-59, raised recruits at the beginning of the Revolution and fought at Bunker Hill, Trenton, Princeton and distinguished himself at Bennington. He died May 8, 1822.

this time; therefore the larger-than-life American heroes who helped to change the course of history were the names that were most eagerly sought. Some of the counties given Choctaw names chose, for the names of their county seats, the names of prominent Continental soldiers. The citizens of Attala, named for the fictitious Choctaw Princess, Atala, selected the name of General Thaddeus Koscuisko for their seat of government; Noxubee chose the name of the intrepid North Carolina Revolutionary War soldier, Nathaniel Macon, who after the war became an outspoken senator from that state; and in 1835 Oktibbeha opted for New Hampshire's favored son, General John Stark.

John Stark was indeed a true American hero. He was a soldier almost all of his life. He was independent, smart, and bluntly honest. He did not mince his words; one always *knew* where he stood. And he cherished the cause of liberty.

Stark was also steadfastly loyal to his home state. After successfully

Tradition says that General John Stark was the man for whom Starkville, Oktibbeha's seat of government, was named.

leading his troops at the Battle of Bunker Hill on June 17, 1775, he took part in the New Jersey campaign where he commanded the right wing of George Washington's troops at Trenton. Following these engagements he took some time off to see to the needs of his family. During this recess in the war he was pressed by the Exeter Legislature to accept a commission as brigadier general of the New Hampshire militia. On the condition that he be "answerable" only to New Hampshire, he agreed.

Stark was born in Nutfield (now Londonderry), New Hampshire, on August 28, 1728. He was a farmer, trapper, sawmill operator, soldier, and the father of eleven children. Between 1754 and 1759 he served first as a lieutenant and then as a captain in the French and Indian Wars. When the American Revolution began he entered the conflict as a colonel.

In August of 1877, Brigadier General Stark led his force of 1,500 officers and men from New Hampshire and Vermont against two detachments of British General John Burgoyne's army near Bennington, Vermont. Emphasizing his determination to defeat the British invaders and Hessian mercenaries, General Stark is reported to have said, "Now, men, over there are the Hessians. They were bought for seven pounds, ten pence a man. Tonight the American flag flies over yonder hill or Molly Stark [his wife] sleeps a widow!" Stark's men carried the day, and the Battle of Bennington is often referred to by historians as the turning point of the war, for it led directly to the Battle of Saratoga where Burgoyne was defeated.

When Oktibbeha County was formally organized on December 23, 1833, Stark's popularity as a genuine Revolutionary War leader was still at its peak. It is reasonable to imagine the community leaders of Boardtown, the original name of Starkville, discussing with some degree of excitement the possibility of their village being named the county seat. Obviously Boardtown, a name which was given the young community more or less unofficially, was not the sort of name the town fathers wished for their new role as the county government site. The community, which started to form there in 1831, did so around a sawmill. As the sawmill grew, so did the town, with apparently all the other buildings in the area, stores, houses, barns,

Mississippi Agricultural and Mechanical College as it appeared in 1907, when all first- and second-year students were required to receive military training. The large twin-towered building to the right housed the school of engineering. Visible with the aid of a good magnifying glass is a banner stretched between the towers which reads, "Textile."

etc., being constructed from the local rough-cut boards. It is said there were no brick houses and only a few log homes in the vicinity. Taking advantage of the new town's not-so-affluent plight, nearby outsiders played on the term "Boardtown," deriding the new settlement for being "poor." The

clapboard houses, built using boards placed vertically to form the walls with a narrow plank (clapboard) nailed over the cracks—an inexpensive way to build structures—encouraged citizens from the wealthier towns and settlements to poke fun at the struggling new Oktibbeha community. Surely,

the town fathers must have reasoned, if we change the name of our town to honor General John Stark we will steer a new course in a positive direction not only for our town but for our county as well.

Throughout the middle of the nineteenth century, Starkville and its surrounding area prospered to a degree, based chiefly on farming. Just as it looked like the town was about to grow in earnest, the War Between the States almost dealt it a deathblow. During this period, women, old men, and children struggled to maintain a meager existence. Following the vain attempt by the South to win its independence, hard times lingered until 1876 when marshal law was finally lifted and thousands of federal troops were withdrawn from Mississippi soil.

A healthy and favorable economy did not really plant its feet in Starkville until the coming of the railroads. A branch of the Mobile and Ohio Railroad first reached Starkville from Artesia in Lowndes County in 1874. Nine years later the CA&M, which became the Illinois Central Railroad, built a line through the town from Aberdeen down to Durant. These railroads introduced numerous business opportunities, which in turn led to a lasting economic foundation. For the first time in the history of the town, business leaders had a substantial base on which to build for the future. The future, as they envisioned it, lay in the field of education. Working in unison, Starkville's political, business, and religious leaders proposed a plan, which has impacted not only their town, but the entire state. The hard work of these visionaries came to fruition in 1878 when Starkville was selected by the state legislature as the site of Mississippi's first land grant college, Mississippi A&M. The school's first session began in the fall of 1880, with former Confederate General Stephen D. Lee as president. And, with few exceptions, the student and faculty population has grown every year since. In 1932 A&M was renamed Mississippi State College. Twenty-six years later, in 1958, the school became Mississippi State University. Today, with a student enrollment of over 16,000, MSU is the largest institution of higher learning in Mississippi. Still working together as one, Starkville is MSU and MSU is Starkville.

Starkville's progressive atmosphere continues to grow today, and that

progress may very well have begun with the changing of its name more than a century and a half ago in honor of an American hero. In 1809 the idealistic namesake of Starkville was invited to attend the thirty-second reunion of veterans who fought at the Battle of Bennington. Because of ill health, the eighty-one-year-old general was unable to attend. In his written response to the invitation he thanked his former comrades, who had once upon a time "taught the enemies of liberty that undisciplined freemen are superior to veteran slaves," and he assured them that he would never forget their respect. He closed his letter with a toast, honoring them with eleven well-chosen words, which have become one of the most famous phrases in American history: "Live free or die—death is not the worst of evils."

On May 8, 1822, at the age of ninety-four, Major General John Stark died at his home in Manchester, New Hampshire, the last living general of the American Revolution. ■

molders of men

The Tupelo Military Institute once gave its namesake city a sense of spirit. The very presence of the private academy, with the motto "Send us a boy and we will return him a man," gave Lee Countians a sense of pride and a feeling of purpose. The disciplined and polite manly bearing of the young cadets, dressed in their tailored "butternut" grey uniforms and looking very much like the "boys in grey" of an earlier era, influenced practically everyone to reach above and beyond.

No history of this once prestigious school can be separated from the personality of its founding father and champion, George Washington Chapman. A native of Chapmanville, Virginia, and a graduate of Northern Illinois College (now University) with a Doctor of Philosophy degree, he began his lifelong work as a schoolteacher and administrator in the state of Kentucky. In the book *Tupelo Military Institute: A Forgotten Chapter in Our History*, published in 2004, authors Bill Carroll and Bill Lyle stressed that Chapman "believed that schools should prepare students for citizenship and the realities of the world...." This statement could be considered his creed, having been developed from his convictions as a Bible student and teacher. At the age of 51, Chapman felt encouraged, perhaps by an intuition or by a visit made to him by a group of concerned Tupelo businessmen led by Asa W. Allen (or maybe both), to relocate one more time in his life to start a school where he could fulfill his dream of molding boys into men.

Following more than six months of traveling back and forth from Paris, Kentucky, to Tupelo, Chapman turned T.M.I. into reality with "thirty-six day students

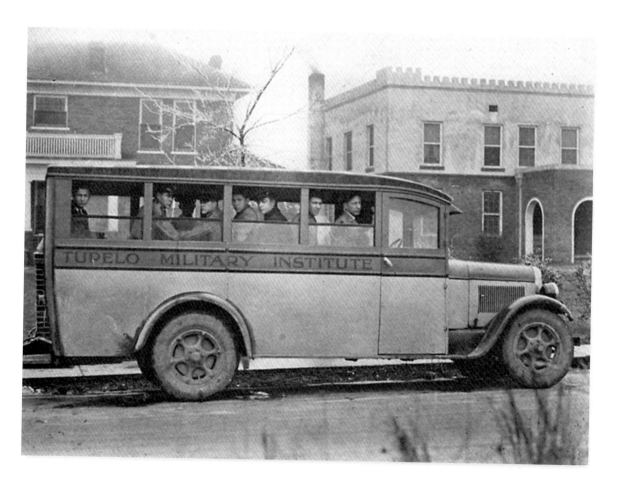

"T.M.I. on its way to victory," read the caption for this photograph in the school's 1931 catalog. Along with military, religious, and academic training, athletics played an important role in most cadets' daily schedules, as institute leaders believed sports required "the practice of many virtues which make for success in life, including self-control, alertness, and fairness."

and five boarding students" on Tuesday, September 9, 1913. The objective of this institution, as stated in an early advertisement in the *Tupelo Journal,* was to be "a boy's training school," and as such it was "designed to prepare boys for entrance to any college or university, as well as for the duties and responsibilities of

life." All of this was in keeping with the institution's published motto, which over time was condensed to four powerful words: "We build the man."

First-year tuition rates varied from $60 for a "sub-freshman" (boys from 11 to 14 years of age) to $100 for a senior. The total cost per year per student

including tuition, board, room, fuel, and lights was $350.

T.M.I. was a success from the beginning, with enrollment reaching its highest following the end of World War I. The 1920s have been hailed as the "boom years," when the dormitories were filled and the school received full accreditation by the Southern Association of Schools and Colleges. In 1928, it became a member of the United States Association of Military Schools and was recognized for its outstanding curriculum. Skilled instructors offered three different tracks of study—classical, scientific, and commercial—to all cadets, using classrooms and laboratories equipped with modern amenities.

As may be expected, Chapman and his assistants required every student to study daily. Written examinations, which accounted for 60 percent of their total grades, were given at the end of each month. The other 40 percent came from daily recitations. It was believed that with this grading system it was "impossible for any cadet to idle away his time until a few days before the final examination and then by the cramming process make a passing mark." The courses offered included English, history, civics, economics, mathematics (arithmetic, algebra, and geometry), Latin, Spanish, science, chemistry, geography, physics, music, and physiology.

In addition, a strong emphasis was placed on moral and religious instruction. As a private nonsectarian institution, T.M.I. was steadfast in its belief "that the worst asset any school can turn out is an individual whose intellect is highly developed and whose moral nature is undeveloped."

Highlighted in italics in the 1931–1932 school catalog under the heading "Right Influence" are these words: "It is written, 'man shall not live by bread alone,' yet almost every influence with which the boy comes in contact magnifies material things: financial discussions in his home; the courses of study in schools and colleges; the efforts he sees made to provide for the body with but little thought of the intellect—only as it will prepare to make money—and no thought at all of the spirit, of what it means to BE REAL MEN. And thus this materialistic age, in which we now live, has been ushered in. We must get back to sensible things—to the greatest truth that TO BE is greater than TO DO; that

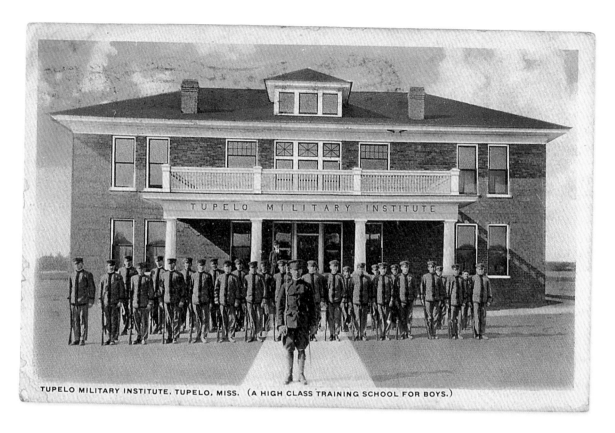

TUPELO MILITARY INSTITUTE. TUPELO. MISS. (A HIGH CLASS TRAINING SCHOOL FOR BOYS.)

This view of T.M.I., showing a company of cadets at attention in front of the 16-acre campus's main building, is from a postcard which bears a Tupelo postmark of November 4, 1915. The man pictured in the background, standing on the front porch, is believed to be the institute's founder and owner, George W. Chapman.

to be good is greater than to have wealth, etc. T.M.I. lines her students up in this direction and leads and guides them toward manhood, character, and service. The only true goal in life." Therefore, all cadets were required to "assemble in the study hall each Sunday morning and study the chapter in the Bible containing the International Sunday School Lesson." Jewish and Catholic cadets were excused if their parents so desired.

In addition to daily military drills, athletics played an important role in T.M.I.'s desire to "build the man." All the major sports were offered, including football, baseball, basketball, track, tennis, swimming, boxing, and wrestling. Throughout the 1920s, the school's football teams were legendary. The 1925 team's schedule included games against junior colleges, senior colleges, and the Old Miss freshmen— and only the Ole Miss team managed

to cross the T.M.I. goal line. In 1926–27, the T.M.I. Black and Red Tigers won twelve and lost only two, both to college teams. The 1926 track team won both the state championship and the Southern Prep School Track and Field Championship.

During this decade, perhaps the school's most famous athlete was Guy Terrell Bush, a native of Aberdeen. Bush pitched the baseball team to success and himself to stardome in 1921 and 1922. In 1923, he was signed by the Chicago Cubs and won a game for them in the 1929 World Series, though the team lost the championship to the Philadelphia Athletics. In the 1932 season, Bush was a 19-game winner. In 1934, he was traded to the Pittsburgh Pirates, and on May 25, 1935, against the Boston Braves, he gave up two home runs to the immortal Babe Ruth en route to a Pirates victory. They were the last home runs, numbers 713 and 714, of Ruth's career. Bush went on to pitch the next year for Boston, then in 1938 played for the St. Louis Cardinals. He ended his major league career with the Cincinnati Reds in 1945. In 1973, T.M.I. sensation Guy Bush was inducted into the Mississippi Sports Hall of Fame.

On September 25, 1927, tragedy struck the T.M.I. campus when fire, believed to have been caused by defective wiring in the attic, destroyed the school's main dormitory. Not a single one of the 60 cadets housed in the dorm was injured, but the $40,000 building was only insured for less than half that amount. Nevertheless, a new dorm, utilizing much of the ground-floor structure of the original building, was completed by Christmas. The next year was business as usual, onward and upward.

The school year of 1929, however, was another story. The stock market crash on October 29—known as "Black Tuesday"—brought America and T.M.I. to its knees. In an effort to keep the school open, the trustees amended their constitution to become a junior college. It was rationalized that, with no other community college within 10 counties, the move to combine a junior college with the Military Institute would be a win-win situation. The theory was that the junior college, which would allow female students as well as males, would draw about 300 students, along with a projected total of 100 military school cadets. But when the school opened

Guy Bush, shown here on a 1933 Goudey Gum Company baseball card, was a textbook fastball pitcher, beginning his days on the mound at T.M.I. In 1935, while playing for the Pittsburgh Pirates, he gave up two home runs to Babe Ruth—the last two home runs of Ruth's career.

in September 1934, there were only a few more than 150 students registered in the junior college and just 44 cadets enrolled in the Military Institute.

The situation failed to improve, and in early 1936, after a visit with local banking officials and surely many prayers, Chapman made the decision to sell the 16-acre T.M.I. campus and buildings to the city of Tupelo to be used as a state-supported junior college. The date was set to meet with county supervisors on April 6, 1936. The day before the meeting, however, Tupelo and T.M.I.'s history was changed forever. On Sunday, April 5, just after 9 p.m., Tupelo (which in Choctaw and Chickasaw means "to make a noise") was wrecked by one of the most destructive tornados in state history. One eyewitness wrote that the storm sounded like "a cavalcade of heavily laden freight trains approaching." In less than three minutes, the storm was gone, but in its wake lay more than 200 dead and many more hundreds injured. Some 300 homes were flattened, and much of the downtown business area lay in ruins. T.M.I.'s buildings and all 70-plus cadets and instructors were spared, but all hope of Chapman's dream, already crippled by the economic plight of the era, was forever blown away with the wind.

T.M.I. is no more. The cadets are long gone. But there are some visible signs of the once-active campus in west Tupelo on Clayton Avenue, bordered on the south by Blair Street and on the north by West Jackson Street. In the few buildings that do remain are housed the Inspirational Community Baptist Church and some apartments.

Nothing really looks the same as it was, because it isn't the same. However, the memory of the esteemed T.M.I. headmaster, who was forever saying to his boys, "You've got to be more than just a fellow wearing pants, a pair of shoes, and a shirt, to be a man," is still very much alive at Tupelo's First Methodist Church. On December 20, 1942, the second Sunday following "the grand old man's" death at the age of 81, his young men's Bible class voted unanimously to change its name in honor of their longtime teacher to the "Chapman men's Bible class." This class still meets every Sunday morning at 9:40 a.m., and as in his day all are not only welcome but are eagerly encouraged to come and "Bring your Bible, men!" ■

washington: the most honorable name

Outside of New England, Virginia, Georgia, and the Carolinas, Mississippi may just be America's most British state. Among the first to acquire statehood following our nation winning her independence from King George III in 1783, Mississippi on December 10, 1817, became the seventh state to be formed after the nationalization of the thirteen original colonies. Today, many of Mississippi's citizens can trace their lineage back to England, Ireland, Scotland, or Wales. Many are also justifiably conscious of both our American and British heritage. In fact, it is from this courageous pedigree that we have inherited our spiritual values, much of our self-confidence, and, therefore, a great deal of our happiness. This legacy left to us by our paternal and maternal ancestors is our greatest wealth. It is to these descendants from the British Isles that we owe our deepest gratitude, for it was they who built our towns, established our schools, and organized our churches.

Of the 82 counties that make up Mississippi, possibly the most vivid example of our Britishness is found in the riverside county of Washington. Covered cloud-like with green forests, fertile with deep arable soil, and watered by uncounted streams, this county—like our state—is noticeably blessed. Named for U.S. President George Washington, whose parents were natives of Northamptonshire in the English Midlands, it has the enviable distinction of bearing the most honorable name of all of our state's counties.

In addition to the British surnames that to this day proliferate throughout the county, a short listing of the city, town, and community names helps to illustrate

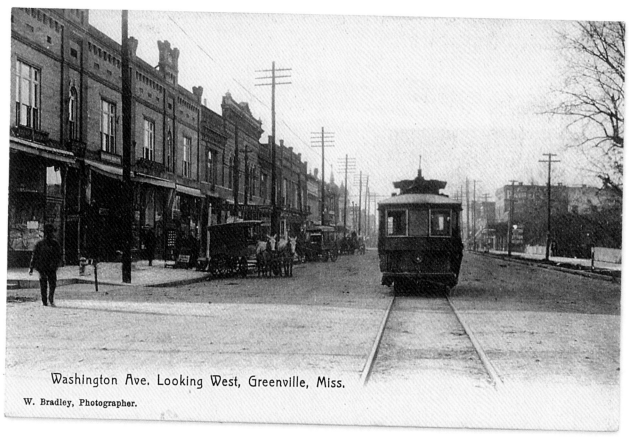

Washington Ave. Looking West, Greenville, Miss.

W. Bradley, Photographer.

Washington Avenue, the first street in Greenville to be paved, is shown in this postcard view, circa 1906, as looking much like the English towns of the same era in the vicinity of Sulgrave Manor, Northamptonshire, the ancestral home of George Washington.

their Britishness. Greenville (pop. 45,226), the county seat, was named in honor of Major General Nathanael Greene, who was both a good friend and a trusted officer of General Washington during the Revolution. Greene, who could easily trace his

ancestry back to England, most likely found that the original spelling of his name was "Grene"—the most commonly used word to describe the motherland. Leland (pop. 6,366) was named for Ms. Lela McCutcheon, whose ancestors hailed from Scotland.

Hollandale (pop. 3,576) gained its name from Dr. David Holland, a prominent landowner, who gave the Southern Railroad the right-of-way in 1882. For his generosity, the railroad reciprocated by painting his surname on the depot and adding the old English suffix "dale," meaning "valley." The community of Chatham, located at the head of Lake Washington, was originally a plantation named for Lord Chatham. The old English word "chatham" means "homestead in the wood." Avon, which also originated as a plantation, is of Celtic origin, meaning simply "river." As an illustration that the people who established this plantation were well-versed in their language, they named their school "Riverside." The pre–Civil War community of Glen Allan was settled by the Spencer family, who descended from Scotland. This old name is of pre-Celtic origin, and, roughly translated, it means "a clean clearing (no weeds or undergrowth) owned by a man named Allan." And lastly, the community of Elizabeth, located two miles north of Leland, is a name the British people took from the Holy Bible and made their own.

Washington County is embraced along its entire western boundary by the mightiest of American rivers, and enveloped within this land of loess are three of the most productive fishing lakes to be found in all of the Mississippi Delta—Lake Ferguson, Lake Lee, and Lake Washington. Of these, Lake Washington is believed to have been formed when the ever-moving Mississippi shifted its course farther westward about 700 years ago. It is the largest of the oxbows at 5,000 acres. Each of these lakes teems with some 15 different species of sport fish, but it is deep Washington, with its abundance of largemouth bass, bream, crappie, and channel catfish, that is the fisherman's favorite. Maybe also being home to numerous schools of shad, silversides, and minnows would not be a drawing card for today's fisherman, but it would surely have been of interest to George Washington. In writer John McPhee's new book *The Founding Fish* (2002), he reviews the legend that "shad saved the starving American troops at Valley Forge." Although he only touches on this subject, he does state that "George Washington was a commercial shad fisherman who in one season netted

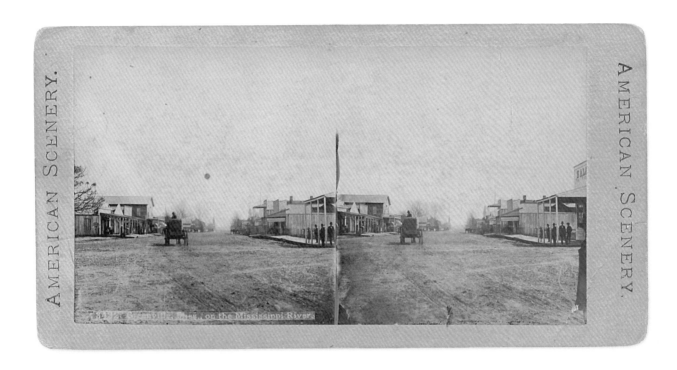

AMERICAN SCENERY.

AMERICAN SCENERY.

This real photo stereoscope card depicts Main Street in Greenville, circa 1890. Greenville, the county seat of Washington County, is named for Major General Nathanael Greene, who, among American's officers during the Revolutionary War, was second only to George Washington.

nearly 8,000 shad before turning to revolution."

As the "founding father" of our nation, Washington, like Abraham, was a devout believer in the one and only true God. It is thought by many Christians and non-Christians alike that George Washington was both guided and protected by the hand of Providence all the days of his life. In the monumental tome *America's God*

and Country (1994), edited by William J. Federer, much is written about Washington's relationship with the Lord. In letters written by his own hand and documented by close friends, the general gave an insightful account of his military service during the early days of our nation, when we were still an English colony. As a young officer fighting with the English against the French and their Indian coalition, he

became aware, perhaps for the first time, of Heavenly protection. During the Battle of the Monongahela, fought on July 9, 1755, 23-year-old George Washington fought with an allied force commanded by British General Edward Braddock. They won the day, but at great cost, as every single officer on horseback, including General Braddock, was killed. On July 18, Washington wrote his brother John, "But by the all-powerful dispensations of Providence, I have been protected beyond all human probability or expectations; for I had four bullets through my coat, and two horses shot under me, yet escaped unhurt, although death was leveling my companions on every side of me!" Fifteen years later, Washington was approached by an old Indian chief who addressed him as "a particular favorite of Heaven." This Indian warrior, through an interpreter, said, "Washington was never born to be killed by a bullet! I had seventeen fair fires at him with my rifle, and after all could not bring him to the ground!"

On July 4, 1775, from his general orders as Commander-in-Chief of the Continental Army, General Washington issued the following order at Cambridge, Massachusetts: "The General most earnestly requires and expects a due observance of those articles of war established for the government of the Army which forbade profane cursing, swearing, and drunkenness. And in like manner he requires and expects of all officers and soldiers not engaged in actual duty, a punctual attendance of Devine services, to implore the blessings of Heaven upon the means used for our safety and defense."

It is recorded that during his day, no man was a better horseman than George Washington. Evelyn Brogan wrote in her book *Famous Horses of American History* (1923) that Washington was devoted to his favorite warhorse, Nelson, a dapple-gray Arabian stallion. "Often during the terrible winter at Valley Forge, Nelson was seen by the starving soldiers to stand beside the kneeling form of General Washington shielding him from the bitter wind that swept across the snowy waste, while Washington knelt often and long in the deep snow, beseeching God for help in his bitter need."

Besides being a man of principle who was constantly scrutinized by the public in general and his enemies in particular, Washington was as

MUSEUM OF FINE ARTS, BOSTON AFTER PAINTING BY GILBERT STUART

70942 GEORGE WASHINGTON COPR DETROIT PUBLISHING CO

George Washington, the "Father of our Country," was a man of high ideals, immense courage, and a devoted faith in the Lord. It is for this man that Washington County, Mississippi, is named.

comfortable with the pen as he was the sword. He was able to express himself sometimes in an eloquent way, but always in a manner which left little doubt as to how he stood, or as to his intent. Like him, Mississippi's Washingtonians have an affinity for the written word. No other county in our state, a state which is known throughout the world for its authors, can claim as many award-winning writers. Greenville native son Shelby Foote has written about the Civil War perhaps better than any other writer. William Alexander Percy's *Lanterns on the Levee* received much critical acclaim. Ellen Douglas, who won the Houghton-Mifflin Award for her very first novel, is now, several novels later, considered one of America's most distinguished writers. Other authors of note are Hodding Carter, David Cohn, Walker Percy, Bern Keating, Charles Bell, Louise Crump, Jessie Rosenberg, and Ben Wasson. This listing is admittedly incomplete but is given as a measure of the literary giants who live or have lived within the boundaries of Mississippi's most literary county.

George Washington's name has withstood the test of time and has come down to us through history not because of his horsemanship and not because of his bravery. His name has endured for more than 200 years because of his unwillingness to compromise his Christian faith. Most 21st-century Washington Countians will quickly tell you that if we hope to leave our descendants a similar legacy we can do no less. ■

When Colonel James Madison Wesson, the founder of the city of Wesson, read the words "Wine is a mocker, strong drink is raging; and whosoever is deceived thereby is not wise," he believed them. His understanding of this proverb apparently encouraged him to also adopt as his motto the old adage that "whiskey and manufacturing do not mix." Never one to compromise his principles, Wesson, like a great many Southerners of the Victorian era, was an idealist who placed high values on both character and respect. A recent study of his life has revealed that yes, one person really can make a difference. Visible proof of this statement can be seen simply by looking at a modern state highway map of Mississippi.

Of all the sometimes irregularly shaped boundary lines separating the 82 counties in our state, perhaps none of them has a more unique history than does the dividing line between Copiah and Lincoln counties. Here is the story.

The surveyed horizontal line that runs east and west between the two counties is, for the most part, as straight as an arrow, with the exception of a one-square-mile area of Copiah County that extends south into Lincoln County. This area, still webbed with streets and occupied by Copiah-Lincoln Community College and homes reminiscent of the old South, is the original town of Wesson. Almost a year before the surrender of Mississippi to federal forces on May 20, 1865, the Confederate state legislature of Mississippi incorporated the then-proposed village of Wesson to include a sizeable tract of land that lay both north and south of the old Choctaw boundary line as determined by the Treaty of Mount Dexter in 1805.

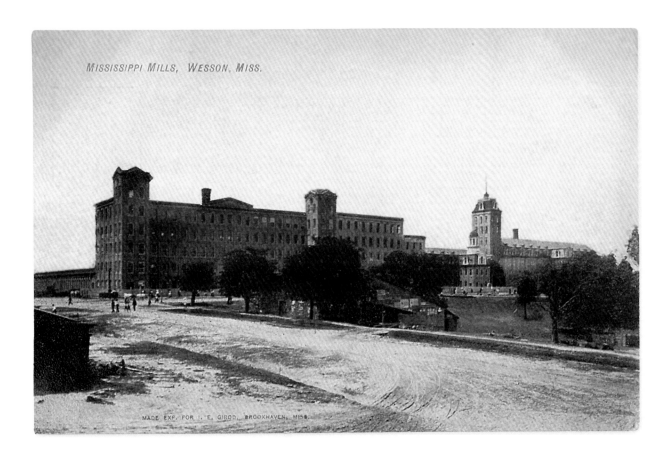

MISSISSIPPI MILLS, WESSON, MISS.

MADE EXP. FOR I. E. GIROD, BROOKHAVEN, MISS.

For more than two decades, the Mississippi Mills at Wesson was the "largest cotton and woolen mill in the South." This view, circa 1905, was taken shortly after the heyday of the mill when, with a town population of around 4,000, Wesson was the state's 14th largest city.

Later, when Lincoln County was being organized, Colonel Wesson became concerned that the new county might one day enact laws that would permit the sale of spirits. Determined that the sale of liquor would not become an issue in the town where his family and his new textile mill were located, Wesson made a special trip to the capitol building in Jackson. There, he told state officials of his desire to keep his town dry. The legislators approved his request, and the Wesson city boundary line reflects their decision to this day.

Twenty-two years before this survey was made, Colonel Wesson incorporated the Mississippi Manufacturing Company, the first textile mill in the state, at what became the town of

Bankston in Choctaw County. Former Governor J. P. Coleman, in his book *Choctaw County Chronicles* (1973), wrote, "When the Civil War came in 1861, the Bankston Mill was operating 1,000 cotton spindles, 500 woolen spindles, 20 looms, a wool carding machine, a grist mill and a large flour mill." Unfortunately for Colonel Wesson and the South, just after midnight on December 30, 1864, a detachment of Grierson's Raiders burned the mill and the outbuildings to the ground.

Bankston dated from 1850 and was named for a Mr. Banks from Columbus, Georgia, who was a financial backer of Colonel Wesson. A description of this early industrial settlement furnished by the colonel in *Debow's Southern and Western Review,* October 1850, contained this sentence: "We have but one grog-shop within seven miles of us, and that will probably not last long."

It is ironic that the colonel, a North Carolina native who became the father of textile mills in Mississippi, used the naval term "grog" for liquor. Because of its association with a certain type of cloth, it could just as well be labeled as a derivative of a textile word. During the 18th and early 19th centuries, alcohol was a staple onboard the ships of the British navy. According to *The Wordsworth Dictionary of Phrase and Fable,* British Admiral Edward Vernon was nicknamed by his sailors "Old Grog" for his habit of "walking the deck in rough weather wearing a 'grogram,' a heavy fabric coat woven from silk and wool and stiffened with gum." He initiated the practice of diluting the ship's rum with water, resulting in a beverage his men named "grog." The feeling experienced the next morning by sailors who drank too much grog the night before is the origin of the word "groggy." It is this "groggy" unsteadiness on one's feet which Colonel Wesson and, later, Wesson Mill manager Captain William Oliver sought to avoid.

Little is known as to exactly when Colonel Wesson decided to invest in building a new mill in the piney woods section of the state. However, he apparently had entertained the idea of relocating from north Mississippi perhaps since the Battle of Shiloh, which was fought frightfully close to Bankston in the spring of 1862. Before this invasion, many thought the war would not reach the Deep South. Reevaluating his situation,

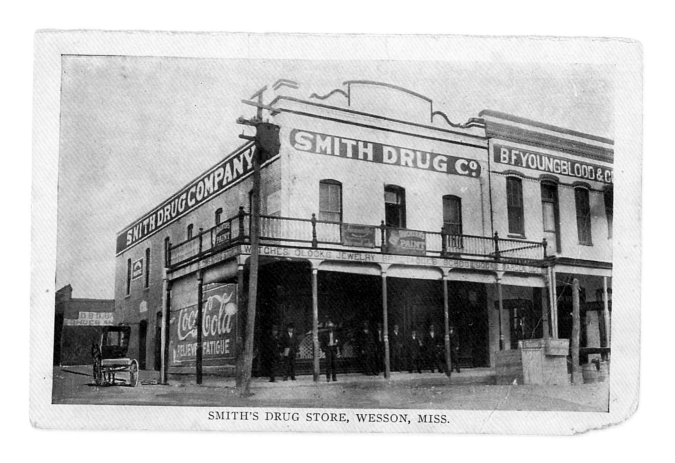

SMITH'S DRUG STORE, WESSON, MISS.

Pretty much dated by the large 1906 "Coca-Cola RELIEVES FATIGUE" sign, the Smith Drug Company, located on Main Street in Wesson, apparently sold far more than just medicine. It seems to have been the place to go for "house paint, candy, watches, clocks, jewelry, spectacles, school books, garden seeds" and of course Coca-Cola, presumably served "ice cold."

Wesson laid the groundwork by arranging for the state to incorporate his new mill town site on March 31, 1864. By 1866, he and his associates had built their homes in the new Copiah County location. The first mill built in Wesson was a sawmill used to produce lumber for the construction of homes, churches, and businesses, and it wasn't long before settlers

began to arrive. Being located on a ridge with a high elevation along a one-mile stretch of the New Orleans, Jackson & Great Northern Railroad—which later grew to become the Illinois Central—was a definite plus. With the Civil War over and with many looking for work, it didn't take long for the new town to develop. It was first officially placed on the map when the

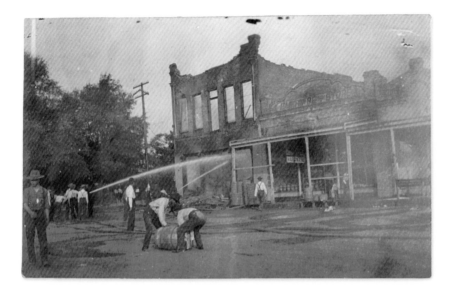

This rare photo postcard was mailed from Wesson on June 17, 1907, to the *Democrat Star* newspaper at Scranton (now Pascagoula). The message tells of a fire that destroyed the Becker Lyelle McGrath Company Store June 9. "They didn't save a thing but have reopened in the old mill building and are going ahead with biz," the sender writes.

post office was established on June 19, 1867. The new mill site began to grow like a proverbial mushroom. By 1870, the population had reached 500, with more growth to come.

In 1871, 56-year-old James Wesson sold his mill to two New Orleans businessmen, Captain William Oliver and John T. Hardy. According to *Wesson: Industrial City of the South* (1994), written by Copiah-Lincoln Community College professors Durr Walker and David W. Higgs, Oliver "incorporated the company on April 13, 1871, with 300 employees." Two years later, the mill, which had expanded to become the Mississippi Manufacturing Company, was destroyed by fire. That year, Hardy, who was the chief stockholder, sold out to Oliver and to a man named Colonel Edmund Richardson, regarded as "the largest cotton producer in the world." With the almost unlimited financial backing of Richardson, combined with Oliver's managerial skills, the mills were rebuilt on a grand scale and renamed Mississippi Mills. By 1880, the company consisted of three mills, each lighted by electricity—quite a feat when you consider

that Thomas Edison invented the light bulb only one year earlier. Wesson was aglow before even New York City invested in Edison's miracle, and the town became a destination for the curious, as hundreds came to see the "white city," the term used for places on the cutting edge with the new electric illumination.

The mills were large, impressive brick structures. The weaving room alone, unique for its innovative glass roof, covered five acres. "Mill Number 1 was 350 feet long and 50 feet wide," Walker and Higgs noted. "It was three stories high. Mill Number 2 was 216 feet long and 80 feet wide and was four stories high." At the south end of this mill, there was an eight-story tower, the top of which housed water tanks that supplied the water for the in-house 5,000-gallon sprinkler system. "Mill Number 3 was built in 1876 and was 216 feet long, 50 feet wide, and 4 stories high. Mill Number 4 was built in 1891 and was 114 feet long, 75 feet wide, and 2 stories high." Alongside this mill was another weaving shed, this one 340 by 175 feet, which included a basement for storage.

The mills were operated totally by steam engines, which were fueled by firewood at the rate of 50 cords per day. The water supply for the engines and other equipment came from Spring Creek, about one and a half miles from the city. This spring-fed creek was reported in 1890 to have an inexhaustible supply of crystal clear water. The water was pumped to the mill, where it was stored in a 115,000-gallon cistern. In *Biographical and Historical Memoirs of Mississippi,* published in 1891, the biggest reason for the success of the mills was said to be the great variety of products created there, things such as "cassioneres, jeans, doeskins, tweeds, linseys, flannels, wool and cotton knitting yarn," "ticking for feathers and mattresses, sewing thread, sewing twine for bags, and awnings, wrapping twine, honey comb towels, balmoral skirts," and more. A cotton fabric woven there was so extraordinarily fine that it was known throughout the world as "Mississippi silk."

The success of the mills, which were visited by a delegation sent by Henry Ford, numerous foreign manufacturers, and even President William McKinley, began to unravel shortly after a tornado hit in 1883. That same year, financier Edmund Richardson

passed away. Eight years later, during the same year mill Number 4 was constructed, Captain William Oliver, described as "the spark who drove the mill," died. For 20 years, Oliver, who also founded the town's Presbyterian church, had emulated Colonel Wesson in everything he did. And in 1899, Colonel Wesson, the man who built the town that became—if only for a short time—the diamond of the United States cotton and wool textile industry, closed his own eyes in death.

In the waning decades of the 19th century, as Mississippi struggled to regain its economic position among her sister states, America's Immigration Service was being overwhelmed with an influx of Europeans. Immigrants brought with them their own customs, religions, and trade unions. The growing number of unions and laborer unrest, combined with the Gold Reserve Panic of 1893, set the mills at Wesson on course for a financial disaster that came to a head when the Mexican boll weevil entered the cotton picture in 1908. In 1910, Mississippi Mills fell into the hands of receivers, and operations ceased almost overnight. In the years following the end of World War I, the buildings were sold and dismantled brick by brick. All the furnishings were sold as well. Even the big brass steam whistle with its distinctive "locomotive" sound that called the different shifts to work was auctioned away. Only the old mill warehouse, which stands on the east side of Main Street, remains as a testament to the city's heritage.

Today, if the colonel and the captain were to come back and walk the streets of Wesson, they would be disappointed to discover their mills gone. However, they would also see that all their efforts were not in vain. The steeple of the Presbyterian church stands just as tall as ever, and although no longer a manufacturing center, Wesson is what most places strive to be—a safe residential town where everyone is a welcomed neighbor, where educational advantages abound, and where 1,500 residents are proud to call Wesson home. ■

christmas in wiggins

Christmas Day, December 25, has been celebrated by followers of Jesus since the 7th century A.D. In England, for hundreds of years after this date, each civil, ecclesiastical, and legal year began on Christmas Day. For some reason, the Anglican Church dropped the custom in the 14th century and began the year on March 25, and the new dating procedure remained in force until the reformation of the calendar in 1752. Nevertheless, December 25 has remained a holy day for almost 2,000 years.

We, too, have traditions that have been handed down to us. In more modern times, it is the Germans who have been given credit for initiating the custom of the Christmas tree as we know it. *The Wordsworth Dictionary of Phrase and Fable* notes, "The custom of having a Christmas tree decorated with candles and hung with presents came to England with the craze for German things that followed Queen Victoria's marriage to Prince Albert of Saxe-Coburg-Gotha in 1840."

But church historians are adamant that the custom of the tree is much older. They point out that "believers" are the "righteous branch," and therefore a tree has been used to symbolize this truth since the days of Isaiah the prophet. They cite the custom based on Isaiah 60:13: "The glory of Lebanon shall come unto thee; the fir tree, the pine tree, and the box together, to beautify the place of my sanctuary." The "glory of Lebanon" refers, of course, to the great cedar trees that once grew in abundance there. The imagery of this verse, not to be taken out of context, is that the barren hills which surround Mount Zion (Jerusalem) will, in the new state of things (when Jesus comes back), be forested with tall, beautiful trees not unlike it

was in the beginning in the Garden of Eden.

Christmas, the day that has traditionally been set aside by Christians to celebrate the birth of Jesus, is the most revered of all holidays on the American calendar. This has been the case as long as the United States of America has been a nation, and it was not different 100 years ago when farmers, loggers, and others traveled over dirt roads to shop for their loved ones at the big Kew Mercantile Company store in Wiggins. This commissary served dozens of communities in south Mississippi for more than 20 years. The history of this store, with its seemingly unending variety of tools, Queens ware (china dishes), shoes, hats, bolts of cloth, books, coffee, tobacco, candy, and much more, is an interesting one.

In 1907, from 1,036 miles north of Wiggins, at Des Moines, Iowa, two millionaire businessmen, brothers W. O. and E. C. Finkbine, saw in the most northern section of Harrison County—that area which in 1916 became Stone County—considerable mineral wealth in the form of brick clay; ochre and paint pigments; building, moulding, and glass sands;

timber; gravel; and building stones. This list of "milk and honey" was enticing to the two entrepreneurs, who already owned the Green Bay Lumber Company, with lumberyards scattered all over the state of Iowa, in addition to a 17,000-acre wheat farm in Canada. But the selling point that was of most interest to them was the vast acreage of virgin yellow pine timber.

The two men knew a good opportunity when they saw it, and before the year was out, they purchased the John H. Gary sawmill in Wiggins and built a large mercantile commissary to enhance their business. The commissary was operated under the name of the Kew Mercantile Company and served Finkbine Lumber Company employees and the community at large.

For most of the mill workers, the big store was a godsend, for it basically assured them that they would have food and clothing for themselves and their families. During this era, most blue-collar workers had never been trained in the handling of money. Many were tempted by the world and its ways to separate them from their pay. It was common knowledge that large percentages

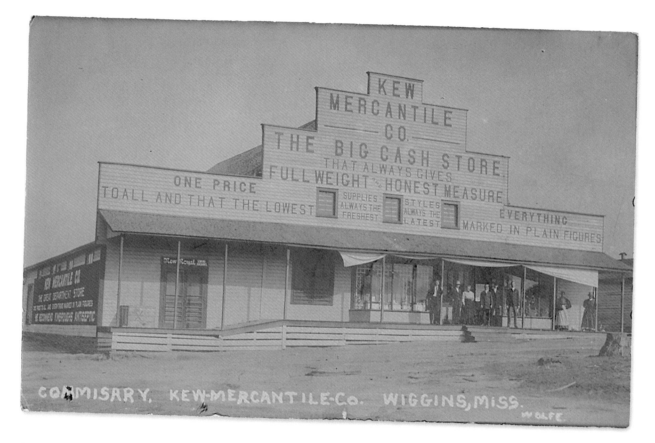

The big Kew Mercantile Company store at Wiggins, shown in this photo postcard mailed to Century, Florida, on December 18, 1908, was a virtual wonderland to the citizens of that era.

of these hard-working people were broke every week, well before the next pay period. Knowing this, lumber company owners (and not just the Finkbine Lumber Company) essentially protected their workers by paying them three times a week in checks or tokens that could be used solely in trade at the commissary store. Only on Saturday night were most workers paid in cash. As strange as this may sound to us today, this was a widely accepted practice, especially in the lumber industry, during the early decades of the 20th century.

There were other mercantile stores in Wiggins, but none was larger than Kew, and in the days before billboards were as popular as they are now, the storekeepers made good use of the exterior walls and front of the Kew building to advertise not only

their products but their way of doing business. Their slogan, "The Big Cash Store That Always Gives Full Weight and Honest Measure," was painted in extra-large lettering on the front of the building. Also painted in easy-to-read letters were "One Price To All And That The Lowest," "Supplies Always The Freshest—Styles Always the Latest," and "Everything Marked in Plain Figures."

The Kew owners realized from day one that they were more than just the new kids on the block—they were also from north of the Mason-Dixon line. So they took extra steps to assure customers that they were not there to take advantage of anyone and that the store was there to serve the public by always giving them their money's worth whether they were buying fresh produce for resale or selling the latest household or clothing items. Consequently, as the lumber business grew, so did their stock and their store. In fact, they operated a branch

The Kew Mercantile Company's 1924 Christmas catalog highlighted some of the most modern innovations available to consumers, including "electrical gifts" like ruffled-shaded lamps and self-heating teapots.

store at D'Lo in Simpson County from 1916 until 1930 and another branch at Stillmore, a nearby lumber camp in Stone County, during the years 1926 and 1927.

By the 1920s, the name of Kew Mercantile Company was so well-established that it was virtually an institution. Shoppers came from as far away as Gulfport and Hattiesburg by train and automobile to shop for the latest items. It was not uncommon to see soldier boys who had gained a few hours leave from Camp Shelby there looking for something to send their mothers or sweethearts back home.

From a little Christmas sale catalog entitled *The Guide Post,* published by the Kew Mercantile Company in 1924, a number of interesting facts are discovered. On the first page of the 32-page catalog, the store owners referred to their establishment as "The Store of the Christmas Spirit." In page after illustrated page, they offered everything from Christmas decorations to a precooked Christmas meal of turkey or chicken with all the trimmings to electrical lamps and appliances advertised with the words, "An Electrical Christmas Is a Happy Christmas." One page presented an array of items for ladies such as "Scarfs, Hand Bags, Beaded Bags, Gloves, Ivory Toilet Sets, Silk Umbrellas, Sweaters . . . ," with the headline reading, "Every Man Knows That Every Woman Likes Silk Underthings!" They offered furniture, curtains, blankets, linens, rugs, and other items too numerous to mention. For men, there were two complete pages of items from tools to neckties and from knit sweaters to leather boots. One advertisement showed a sketch of a smartly dressed man wearing a stylish hat under the wording, "Give Him A Stetson." Men were also encouraged to come and buy their gasoline for the low "Kew price" of 17 cents a gallon.

For the children, "Our Store Abounds in Christmas Gifts," read one full-page ad, along with the words, "Santa Claus has emptied his pack at the Kew—his own store—and invites everyone to meet him here." A list of some of the many toys in their toyland included "automobiles, velocipedes, iron wagons, metal banks, doll beds, wheel barrows, garden sets, mechanical toys, coaster wagons, doll buggies, toy pianos, ten-pin sets, rocker toys, block sets, mechanical trains, horse and carts, dart games, baseball

gloves, marbles, tin spelling boards, toy drums, ring tossing sets, cedar chests, doll furniture, doll tea sets, friction toys, rocking chairs, tool chests, map puzzles, pedal bikes, fire engines, trumpets, dolls—all sizes, pop guns, musical instruments, and books . . . Assembled in our Christmas book display are hundreds of books that boys and girls enjoy reading."

On October 29, 1929, the stock market fell in New York, bringing to an end the hopes and dreams of millions of Americans. The demand for goods and services plummeted literally overnight, and early in 1930, the Finkbine brothers—with no market for their lumber—were forced to close their mills and both of their beloved Kew Mercantile stores. It was the end of an era.

For years afterwards, untold numbers of Mississippians enjoyed reliving the moments when they walked through the doorways of the big Kew stores into the nicest wonderlands they would ever know. Today, the city of Wiggins is becoming one of the most thriving residential cities in the state. Few people a century ago could have visualized the Wiggins of today, and who knows but that the Wiggins of tomorrow may be "Kew Bigger" than even we can dream. Merry Christmas! ■

steeped in history

The historic town of Woodville, the seat of Wilkinson County, is located atop what is reported to be the second highest elevation in Mississippi. The elevation here is 460 feet above sea level.

Incorporated as a town in 1811, Woodville is one of the oldest settlements in the state, and consequently has played a leading role in providing Mississippi with a number of distinguished politicians and business leaders. It is home to the oldest business institution in continuous operation in the state, the local newspaper. *The Woodville Republican* first began publishing on Saturday, December 2, 1823.

In 1831, the Mississippi legislature chartered the West Feliciana Railroad, which was headquartered in Woodville. It ran from Woodville to St. Francisville, Louisiana, a distance of approximately 35 miles, and when it actually made its first run in 1842 it became the first interstate railroad in America. It also held the distinction of being the first standard gauge railroad in the United States, the first railroad to issue and print freight tariff bills, and the first to adopt cattle guards and pits. The original railroad office and banking house building to serve this historic company was built in 1837. It is nationally recognized as America's oldest railroad office building, and as such was placed on the National Register of Historic Places on October 28, 1977. Today, it serves the town as the Woodville Museum of Southern Decorative Arts.

Many Mississippians will readily recall that Woodville was the boyhood town of Jefferson Davis. Actually his boyhood home, Rosemont, is situated just one mile east of town. Built around 1810, it is the only Davis-built home which still survives.

COURT HOUSE, WOODVILLE, MISS. *The yard is much prettier than in the picture. I will write soon — with love Your devoted Sister M. C.*

JOS. SARPHIE PUB.

Open to the public Monday through Saturday, Rosemont offers the visitor a firsthand glimpse into the life of Jefferson Finis Davis—one of this state's most famous personalities. Davis was actually born near Fairview, Kentucky, on June 3, 1808. The house in which he was born no longer stands; however, on the spot where it once stood is the Bethel Baptist Church of Fairview.

Davis, who was of Welsh stock, moved with his family to Mississippi just prior to the War of 1812. Three of his older brothers left Woodville to fight in that war against the British. Throughout his life he fondly remembered Rosemont as being "where my memories began. . . ." During his early political years Davis was one of America's foremost leaders. He served as a U.S. senator

In this 1906 postcard, published for jeweler Joseph Sarphie of Woodville, the then three-year-old Wilkinson County Courthouse is shown with what surely must have been one of the first automobiles in town. According to records maintained by the Mississippi Department of Transportation there were only 20 automobiles registered with the state in 1900.

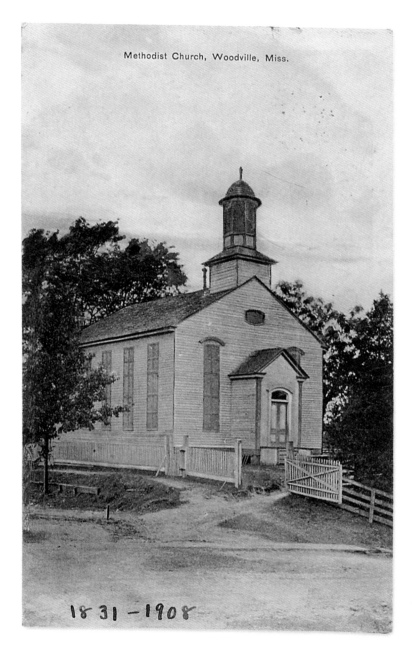

Methodist Church, Woodville, Miss.

1831 — 1908

from 1848–1853. From 1853–1857 he served his nation as U.S. Secretary of War, and from 1857–1861 he again represented Mississippi in the U.S. Senate. Of course, he is best known for being the first and only president of the Confederate States of America. He was renowned as a great leader all of his life.

Perhaps it would be good to remember him from his words spoken during his last speech: "...The past is dead; let it bury its dead, its hopes and its aspirations; before you lies the future—a future full of golden promise; a future of expanding national glory, before which all the world shall stand amazed. Let me beseech you to lay aside all rancor, all bitter sectional feeling, and to make your places in the ranks of those who will bring about a consummation devoutly to be wished—a reunited country."

Just a few miles southwest of Woodville, near the once-prosperous town of Pickneyville, lies the grave of one of early America's most supportive benefactors. It is the grave of

The Woodville Methodist Church, shown in this circa 1908 view, is the oldest church building of its denomination in the state.

Oliver Pollock, the largest individual contributor to General George Washington's Continental Army during our War of Independence. Pollock was a businessman who bought and sold goods on the international market. Wealthy Mr. Pollock also held the distinction of being the man who invented or initiated the dollar sign. As important a figure as he must have been during his lifetime, he was only one of many who lived in the Woodville–Wilkinson County area. As a matter of fact, the county itself was named for General James Wilkinson, who lived for a time in nearby Natchez and who, from 1796 to 1805, held the position of general of the U.S. Army.

The town of Woodville is blessed with an abundance of historical superlatives. The downtown area is liberally sprinkled with historic homes, sites, and public buildings. Perhaps the town's greatest claim to fame is its Judeo-Christian heritage.

Located on the corner of First South Street and Church Street, St. Paul's Episcopal Church (dating from 1823–24) is the oldest Episcopal church outside the original thirteen colonies. Even the organ inside is almost of that date, having been imported from England to Woodville in 1827.

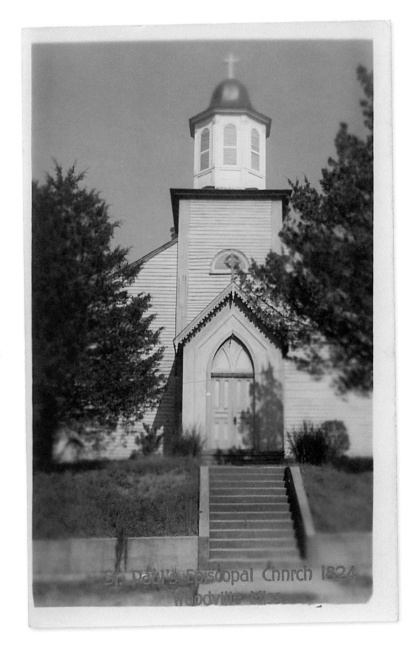

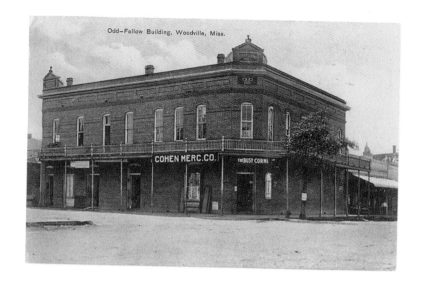

Odd-Fellow Building, Woodville, Miss.

COHEN MERC.CO. THE BUSY CORNE

The Odd Fellow Building housed the Abe Cohen Mercantile Company and was known locally as "The Busy Corner." It was built in 1901 and was destroyed by a fire in 1932.

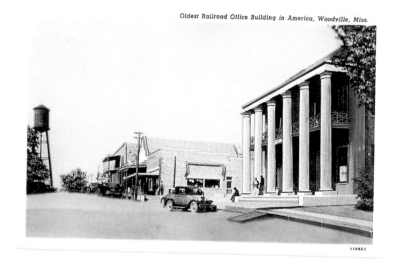

Oldest Railroad Office Building in America, Woodville, Miss.

The West Feliciana Railroad Office and Banking House, the oldest railroad office building in America, is shown in the right foreground of this circa 1935 postcard view. As one of Woodville's most noteworthy architectural gems, this stately, colonial columned structure has been listed on the National Register of Historic Places since October 28, 1977.

The Woodville Baptist Church, founded in 1798, occupies the oldest church building (built in 1809) of any denomination in Mississippi. St. Paul's Episcopal Church, built in 1823, is the oldest Episcopal church outside the original 13 colonies, and the Woodville Methodist Church is the oldest church of its denomination in the state. St. Joseph's Catholic Church is more than 120 years old and, although the town no longer has a Jewish synagogue, it once had two; in its early, more prosperous years, Woodville had a large, active Jewish community. Historians Leo and Evelyn Turitz have written in their book, *Jews in Early Mississippi,* that during the middle-to-latter part of the 19th century the town "was even called, affectionately, 'Little Jerusalem.'"

In the sepia photo accompanying this article, which dates from 1907, the Odd Fellow Building is shown at the corner of Main Street on the northwest side of the courthouse square. Known locally as "The Busy Corner," it housed the Abe Cohen Mercantile Company.

Much of Woodville was entered on the National Register of Historic Places on May 21, 1982. This unique small town, population 1,400, abounds in historical heritage. If historical heritage is wealth, then Woodville is truly one of Mississippi's richest towns. ∎

yazoo
toys and trolleys

When the city council voted 6 to 2 to accept the bid from construction engineers Harry K. Johnson and W. A. Pollock of Greenwood on December 5, 1908, history was made in Yazoo City. The bid was for the installation of an electric streetcar system, and the "Queen City of the Delta" became the second city in the United States to own and operate a municipal electric street railway. The first was Monroe, Louisiana.

There were several cities in the state in which electric streetcars or trolleys operated earlier than Yazoo City. They included Jackson and Vicksburg (1899), Meridian and Greenville (1901), Natchez (1902), Pascagoula (1903), Gulfport and Biloxi (1905), and Columbus (1906). But they were all independently owned and operated. Later, other Mississippi cities added streetcars. They were McComb and Summit (1910), Laurel (1912), and Ellisville and Hattiesburg (1913).

Yazoo City's local newspaper, the *Saturday Evening News,* kept the public well informed on the construction of the trolley line. On November 21, 1908, a column ran with the subtitle "Everything About in Readiness for the Buzz of the Trolley." On December 12, 1908, the *News* announced, "Yazoo City now owns and operates her electric street car system, the only city in the state that can say as much."

The same front-page article stated that at the end of the first week of operation, "the four cars have earned on the average of $50 per day, which is something above actual running expenses." The trolley line continued to make a profit as, nine months later, on September 4, 1909, the *News* ran another front-page story with the headline "Street Cars Paying." The article said that August 28 was the streetcar line's

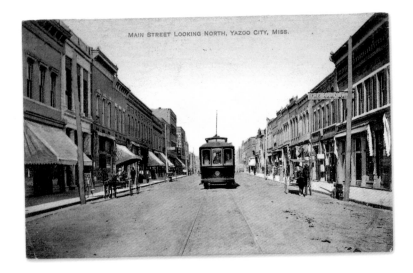

MAIN STREET LOOKING NORTH, YAZOO CITY, MISS.

Yazoo City was the second city in the United States to own and operate an electric trolley system.

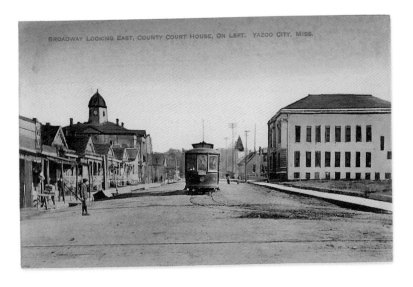

BROADWAY LOOKING EAST, COUNTY COURT HOUSE, ON LEFT, YAZOO CITY, MISS.

Trolley car number one is shown traveling up Broadway past the big, domed Yazoo County Courthouse. During the Great Fire of 1904 prisoners armed with "yard hoses from nearby homes" were placed on the roof of the courthouse in a successful effort to keep the building from catching fire.

HEGMAN'S TOY & MUSIC HOUSE, YAZOO CITY, MISS.

biggest day since Confederate Day on July 8, when a total of 1,238 people rode the trolleys.

Yazoo City was founded in 1824 and was first named Hannan's Bluff in honor of a United States government surveyor. Then six years later, in 1830, it was incorporated as Manchester, for Manchester, England, the hometown of the man who platted the town. The present name was chosen in 1839 for the river near which it is situated.

Like a great many Mississippi towns, Yazoo City has had more than its share of ups and downs. In 1853 and 1878 the town was hit hard by yellow fever epidemics. Then during the Civil War, a number of the town's important public buildings, including the court-house, were burned. Aside from the great flood of 1927, an earlier flood in 1882 covered Main Street, and draymen had to use boats instead of wagons.

On May 25, 1904, Yazoo City's most devastating calamity struck. A great

Inside the W. T. Hegman and Son's Toy and Music Store, located at 201 South Main Street, could be found everything from peppermint sticks to pocket knives and from needlecraft to newspapers. Note the sign outside the main entrance which states: "Memphis Press Scimitar on sale here."

YAZOO CITY, MISS. ,,Queen City of The Delta" situated on the Yazoo River, one hundred and ninety miles south of Memphis, Tenn., on Y. & M. V. R. R.; visited by a great conflagration on May 25th, 1904, three hundred and twenty four buildings being destroyed including the entire business portion, which has been entirely rebuilt with modern two and three story buildings of brick, stone and marble.

Public School Building, Yazoo City, Miss.

fire began in the business district. No one knows exactly where or how it started, but three days later, the fire had demolished 324 buildings, including the entire business district. Witnesses said the fire jumped a block at a time. Even the city of Jackson sent two pumpers in by train, but to no avail.

In the book *Yazoo: Its Legends and Legacies*, by Harriet DeCell and JoAnne Prichard, Yazooian Nelson Gary told about a man playing "There Will Be a Hot Time in the Old Town Tonight" on a burning piano in the middle of Main Street. In the same book, Emma Lee Stubblefield recalled that her father, who was the sheriff at the time, released all the prisoners from the jail on their word that they would return after

In 1908 Yazooians were particularly proud of their new brick school. The large state-of-the-art building instantly became another in a long list of reasons proud citizens of "the zoo" proclaimed their town to be the "Queen City of the Delta."

the fire was put out. A number of the prisoners were placed on top of the courthouse, and using yard hoses from nearby homes, they were able to keep the valued structure from catching on fire. When the fire was finally extinguished, all the prisoners returned to the jail.

Within a year of the great fire, the downtown area was completely rebuilt with brick, stone, and marble. The city council outlawed wooden buildings of any nature inside the business district. Main Street was widened by six feet and the trolley car tracks were laid over what had been a plank road.

Yazoo City's golden era (1905–1920) was documented by picture postcards, and at least 75 different scenes still exist. All of these were produced and sold by W. T. Hegman and Son's Toy and Music Store at 201 South Main Street. Since Yazoo City was the most modern city in Mississippi at that time, it was a shopping mecca. The toy store, one of only a few in the entire state, drew visitors from all over.

Longtime city resident Mrs. Ian Ingram recalls that one of her favorite dolls, a china-head doll with a kidskin body, came from Hegman's, as did a doll-sized chocolate pot. She can remember being enchanted by the store's varied offerings of firecrackers and books with colored pictures.

Hegman Corner, as the shop was locally known, offered jars of candy lined up in rows—jawbreakers, lemon drops, cinnamon red hots, peppermint sticks, and more. There were spinning tops and marbles, tin soldiers, baseballs, bats and mitts, and pocket knives. The latest ladies' magazines and newspapers were also available.

It wasn't long before the automobile became the rage. The streetcars were run out of business. In 1918 Yazoo City's trolleys were sold to Helena, Arkansas, and refurbished for a second life. Shortly after, Hegman's sold out and a drugstore moved in. Today the Hegman building is still there, looking much the same as it did in the early part of this century. Mrs. Helen Nicholas owns and operates Cindi's Gifts of Distinction there.

Her shop invites you to look around, relax, and enjoy yourself. At Cindi's you can take time to smell the paint on a brand new toy or look at a fine piece of china and dream it is yours, even if you can't afford it. W. T. Hegman and Son's Toy and Music Store must have been like that. ■

flowers
a lesson in

Here in Mississippi the list is long of plantations, communities, towns, and cities that bear the names of blossoming plants, shrubs, and trees. Magnolia, Pike County's seat of government town, was named in the 1820s for the numerous *Magnolia grandiflora* trees, which profusely inhabit both the hills and lowlands of all eighty-two counties in our state. Named by pioneer settler Mrs. Mary Sinnot, Magnolia is a grand example of man's love for beauty.

The small town of Sunflower, which was first called Sunflower City, is thought to have been named for the little yellow flowers that grow in abundance along the nearby banks of the Sunflower River. During the first ten years of the town's existence, growth was slow because of limited access by its citizens to the county courthouse in Indianola, due to the fact that there was no bridge across the river. Local merchant A. Sidney Robinson, whose large mercantile store serves as a backdrop for the scene pictured here, established a ferry to assist with this transportation problem. One of the highlights in the history of the town came on September 28, 1915, when a new all-steel drawbridge was opened for use. As part of the dedication, planter R. C. (Dick) Fox, Jr., who owned the 1800-acre plantation called Fox Bend, had his workers haul across the first loads of cotton in parade fashion. Following the taking of this photograph, Indianola newspaper *The Sunflower Tocsin* recorded that "an immense crowd enjoyed the finest barbecue ever given in the county."

The small town of Myrtle is located near the northwest corner of Union County, eight miles northwest of New Albany. Over the years Myrtle has not only had a few

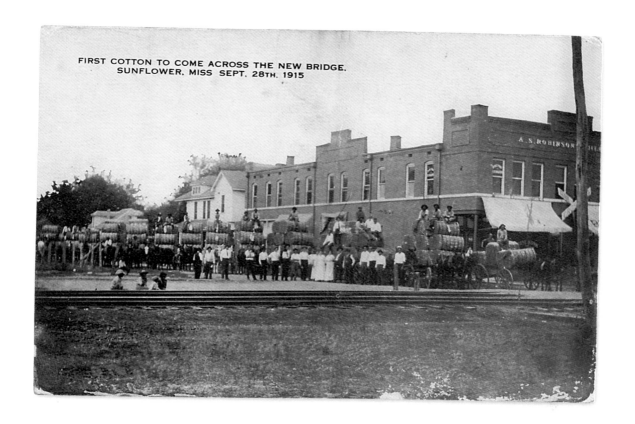

FIRST COTTON TO COME ACROSS THE NEW BRIDGE.
SUNFLOWER, MISS. SEPT. 28TH. 1915

This historic scene captured on film during the opening of the new all-steel bridge across the Sunflower River on September 28, 1915, depicts a group of men and women filled with town pride in this accomplishment.

name changes, but also has physically moved from one spot to another. In its earliest days, when it was a struggling community before the invasion by federal forces, it was called Candy Hill and was only a one-store settlement run by a man named Moses Parker. However, Candy Hill was evidently not the kind of name that most folks wanted for their village. So, it wasn't long before the name was changed to Myrtle for the large number of crape

myrtle trees that were planted by the settlers who continued to move into the area. In 1886 the Kansas City, Memphis, and Birmingham Railroad was built through the county, and the little village of Myrtle moved two miles north to be near the rail line. Ironically, in the picture of the business section, which was taken around 1918, none of the trees in the photo are crape myrtles. The tree in the center appears to be a sycamore

while the others look as if they are in the oak family. In the 1930s when U.S. Highway 78 was built just south of town, the business section slowly moved to it. Today not one of the stores pictured exists.

Rosedale, established as an early riverboat landing on the Mississippi River, is one of the two county seats of government in Bolivar County. The name Rosedale came from one of the earliest residences built in the area, that of Colonel Lafayette Jones, who named his home and plantation Rosedale after his family estate back in Virginia. At first, the settlement around the landing bloomed rather quickly as other planters moved in to take advantage of the rich delta soil. However, Rosedale, like a number of small towns throughout northern Mississippi, suffered greatly during the War Between the States. Because of this setback it was not until 1882 that the town received its incorporation. In the view of Court Street looking east, the seven new cars shown attest to the prosperity of the period. The old courthouse at the end of the street, built in 1889 and damaged by a tornado in 1893, was replaced by a newer structure in 1921. Concrete streets

were poured in 1926 and six years later the town adopted the slogan "Rosedale, The City of Roses."

In middle Mississippi Irish settlers gave Jasper County's Rose Hill its name for the hardy wild roses that grew in the area. The roses still thrive in large numbers in that locality. In Forrest County, Petal, a sister city of Hattiesburg, was given its name at the suggestion of Mrs. R. A. McLemore who happened upon the name while plucking petals from a rose. Up in Tallahatchie County, the picturesque community of Rosebloom, located thirteen miles southeast of Charleston, acquired its name from the resolute Cherokee roses that continue to flourish there.

Over the years a number of hopeful individuals focused a great deal of attention on nature when naming their communities; however, not all of these sites have survived. Cotton Plant, one of the first settlements established in Tippah County, is a case in point. Named for the plant which has made many men wealthy and at the same time has provided a livelihood for literally millions of others, the historic town may have initially derived its name from the striking

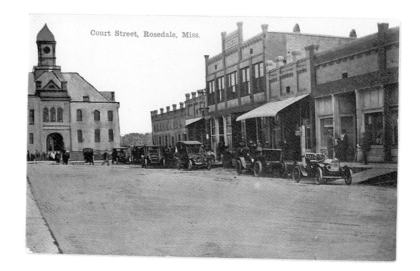

Court Street, Rosedale, Miss.

This Court Street scene of Rosedale, the western county seat of Bolivar County, is enhanced by seven automobiles, indicating an enviable degree of prosperity in 1912.

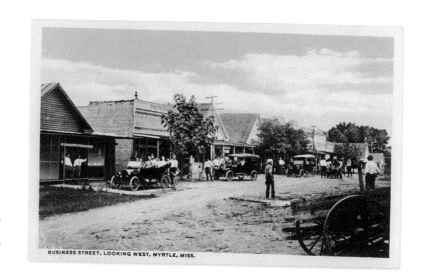

BUSINESS STREET, LOOKING WEST, MYRTLE, MISS.

Although the Union County town of Myrtle was named for the area's once abundant crape myrtle trees, not a single one is visible in this circa 1918 snapshot. What is visible are thirty-one Myrtletonians, the majority of whom are eagerly posing for the camera.

beauty of the plant's bloom. Prior to forming the bole that produces the treasured fruit, the crisp green leaves are complemented by large white blossoms with reddish-purple centers. These blooms give the sometimes-tall cotton plants the appearance of having been purposefully decorated for a special occasion. Although a vibrant village for decades, today Cotton Plant is no longer noted on the map.

Down in Jefferson County, prior to the War Between the States, there was a farming community known as Violet. A pretty name, but the town barely survived a violent period in our nation's history only to become extinct by 1919. In northwest Kemper County the once thriving community of Bloomfield was named for an uncommonly large stand of dogwood trees that treated the eye to a cascading blanket of white cross-shaped blossoms each Easter. When the government introduced rural free delivery (RFD) of mail in 1904, Bloomfield lost both its post office and its identity. Lauderdale County's Buttercup, which was located about six miles north of Meridian, met the same fate in 1906. Lee County's Flowerdale, a community that grew up around the greenhouse

and grounds of the Tupelo Floral Company in 1915, retained its identity for only a few years before being swallowed up by the ever-growing city of Tupelo. Way up in Coahoma County, Roseacres was at one time the largest rose garden in the South. Originally a plantation owned by former Governor James L. Alcorn, the property was sold around the turn of the twentieth century to the United States Nursery Company. In 1903 this nursery had 750 acres of field-grown roses under cultivation. In its heyday Roseacres had its own post office from which thousands of rose bushes were shipped to every state in America. All of this lasted but a season. In the early 1920s the manager of the enterprise passed away. By 1922 the property and all the plants, which made Coahoma Mississippi's most wonderfully fragrant county, were sold, and Roseacres was no more.

Still on the map or not, Mississippi's many floral-named communities bear witness to our state's lovely landscape. The citizens who chose these names must have valued the natural scenery and wanted it to be evident to visitors and residents alike for many years to come. ■

named in her honor

On May 10, 1908, Rev. Harry C. Howard preached a Mother's Day service at the request of a longtime friend and member of his congregation, Miss Anna Jarvis. This special sermon was preached in Andrews Methodist Episcopal Church in Grafton, West Virginia, in honor of Mrs. Anna Reeves Jarvis, Miss Anna's mother. Throughout his sermon Mrs. Jarvis was recognized and remembered for her service as a teacher in the primary department of over twenty years. Four years later a delegate representing this church at the General Conference, held in Minneapolis, Minnesota, introduced a resolution recognizing Miss Anna M. Jarvis as the founder of Mother's Day and also requesting that the second Sunday in May be set aside as Mother's Day in the church. This gesture of love was quickly seized upon by other congregations, organizations, and even states. Most likely it came as a surprise to no one when in 1914 Congress authorized President Woodrow Wilson to designate the second Sunday of each May as the national holiday, Mother's Day.

In honor of the upcoming Mother's Day I thought it might be nice to take a look at some of the women who have played a part in our state's history by leaving their legacy behind through their name.

Here in Mississippi there are, according to James Brieger's book *Hometown Mississippi*, more than fifty communities, towns, and/or cities that have been named for women. Many of these localities were named for daughters, and an almost equal number of places were named for wives. Two communities were named for

businesswomen, two for Indian princesses, and one community, Rosella, located five miles north of Monticello, was named in a lady's honor. Apparently, Mrs. Rosella Evans, an African-American woman in the area, had so gained the respect of the community that when the railroad came through and a depot was constructed it was named in her honor.

The two localities named for Indian princesses are both located in the very heart of the state. Attala County, of which Kosciusko is the seat of government, was organized two days before Christmas in 1833 and was named for

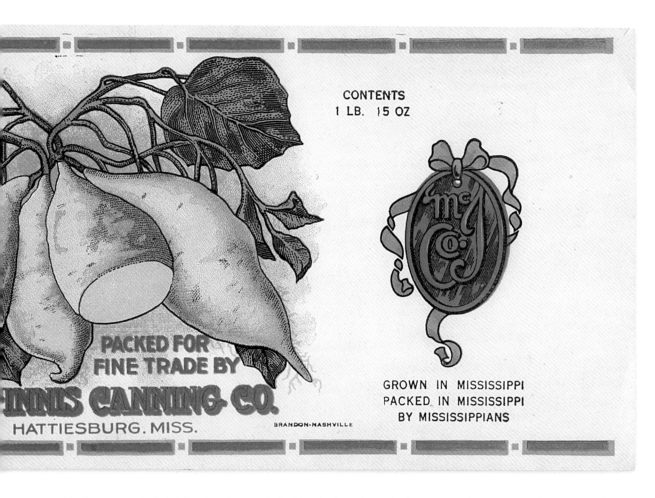

CONTENTS
1 LB. 15 OZ

PACKED FOR
FINE TRADE BY
INNIS CANNING CO.
HATTIESBURG. MISS.

BRANDON-NASHVILLE

GROWN IN MISSISSIPPI
PACKED IN MISSISSIPPI
BY MISSISSIPPIANS

Mrs. Hattie Lott Hardy, the lady for whom the city of Hattiesburg is named, was respected and admired by thousands of people, the great majority of whom she never met. As can be seen from the McInnis Canning Company product label, circa 1912, "Miss Hattie's" popularity was indeed special.

the fictitious Indian princess Atala, who was the heroine of French writer François-René de Chateaubriand's 1798 novel by the same name. Following the 1818 release in the United States of Chateaubriand's lavishly illustrated book about the romance of a primitive Indian couple in the pristine wilderness

of America's South, it remained for more than two decades one of the most popular novels in the country.

Carroll County, Attala's sister county to her northwest, is a forested, scenic, rural land of rolling hills and numerous natural springs. One particularly picturesque setting of springs

was in ancient days named for a local Indian princess whose name when translated into English means "Little Panther." The town, which has grown up around the springs and dates from 1840, now has a population of 1,529, all of whom prefer to use the original Choctaw name of Coila. At least two of our cities, including Leland in Washington County and Yazoo County's Bentonia, were named for sweethearts. Miss Lela McCutcheon of Vicksburg was the apple of Charles E. Armstrong's eye. As an auditor with the Yazoo and Mississippi Valley Railroad, Armstrong was given permission to name a proposed rail stop for his then fiance. Once a depot was constructed in 1886, the town of Leland sprang to life, and today it is home to 7,000 people. Charles and Lela married and bought a plantation just north of the city.

One hundred and forty years ago the intersection of the Yazoo, Vicksburg, and Satartia roads in southeast Yazoo County known as Pritchett's Crossing offered promising business opportunities. Because of the war, however, it failed to grow and was never much more than a stagecoach stop with a blacksmith shop.

Beginning in the 1880s a degree of prosperity returned to the area with the coming of the railroads. In 1884 the struggling community received the shot in the arm it needed with the establishment of a post office and the building of a depot, both of which were named for Miss Bentonia Johnson, the sweetheart of Jackson attorney Hal Green, who presumably was an attorney for the railroad.

Hattiesburg, with a population of 50,000 citizens, is the largest city in the state named for a woman. Founded in 1884 by Captain William H. Hardy, vice president of the New Orleans and Northeastern Railroad, Hattiesburg was named by him for his partner in life, Hattie Lott Hardy. Hattie Lott projected a polished, cultured image that publicly gained for her not only respect, but admiration. Through her conscientious involvement in church activities and social organizations she developed a loyal following of admirers, and her popularity with both business leaders and the common people was a source of inspiration for her throughout her life. Even though Hattie was well-deserving of this honor, a disc jockey from Laurel once questioned the city's name. He posed the

This postcard view of the business section including the Yazoo and Mississippi Valley Railroad depot (top left) of Leland shows how the city, named for Miss Lela McCutcheon, looked in 1908.

question to his listeners: "What if Hattiesburg had not been named for Hattie Lott Hardy, but instead had been named for her husband?" If that had happened, he said, the airport serving the sister cities of Laurel and Hattiesburg would be known today as the Laurel and Hardy Airport . . . It would have been a marketing bonanza!

My hometown of Florence, Rankin County's oldest municipality, was founded in 1823 and for the first seventy-eight years of its life it was known as Steen's Creek. The name came from the Steen family, Welsh Baptists, who were among the first to settle in the area following the signing of the treaty with the Choctaws in 1820. Located at the crossroads of two ancient Indian trails, it is today a city, which is enjoying new growth at the rate of one new family per day.

The name change, from Steen's Creek to Florence, occurred exactly one hundred years ago this year. On July 5, 1901, the railroad was completed through the town linking it to Gulfport in the south and to Jackson in the north. At the time William Cofield Ellis owned approximately 2,000 acres of land in and around the town. Ever the astute businessman, Ellis quickly and willingly gave to the railroad the right-of-way through his property, which in turn brought the services of the Gulf and Ship Island Railroad to within a few blocks of his large mercantile store. For his generosity in making it so easy for the railroad to traverse his property, an official with the G. & S. I. reciprocated by naming the depot for Ellis's wife, Florence. Known as "Fonnie" to her closest friends, Florence was the daughter of Judge Thomas Nowell, a plantation owner from nearby Richland. As a graduate of Whitworth College in Brookhaven, she complemented her business-minded husband and together they provided leadership to the community in both civic and business matters.

Towns, counties, and communities named for women of all ages are sprinkled across the state like a spring shower. In Webster County, a settlement that was established as Early Grove, was incorporated in 1888 and renamed for Mrs. Eupora Corkern Eudy. Down near the southwestern corner of the state, in Amite County, store owner W. J. Seals secured a post office, which he named for his wife, Eunice. Up in Lee County, Guntown, which is located about twenty miles northeast of Tupelo, has had a long colorful history. There are several stories as to how the town got its name; however, the most accepted version is that it was named for Miss Rhoda Gunn, the granddaughter of William Colbert, who was one of the last chiefs of the Chickasaws in Mississippi. The Sunflower town of Rome, located about three miles northeast of Parchman, was reportedly named for Miss Roma Page, the first white child born in the community. In Lincoln County, a man by the name of Smith Felder bought a large tract of land, built a store, and secured a post office that he named for his youngest daughter, Ruth. Almost all letters of the alphabet have been used in place names, even including the letter "Z." The old Zada community of Kemper County was named for Miss Sallie Zada

B7427 Dunn Street from North, Eupora, Miss.

When the Webster County community of Early Grove was incorporated in 1888 it was renamed Eupora in honor of a much-loved resident, Mrs. Eupora Corkern Eudy. In this circa 1914 view, looking south down the main thoroughfare, Dunn Street, it appears from the number of glass insulators on the electrical poles that every business in town has a telephone.

McWilliams. In 1916 the Ayres Community of Attala County was renamed Zama for Miss Zama Franklin, and only a few miles away from there is the Zemuly community. Zemulians were proud of their post office, which was named in honor of their postmaster's wife, Zemuly Morgan.

Noticeably quite a number of communities and towns have been named for wives. In Marshall County in 1875, the founders of a particular community were two men, not one as is normally the case. Martin Greene and Sam Mimms established large farms near one another about twelve miles southwest of Holly Springs. As the community grew they sought for a name, and apparently after some discussion they decided to name it for

both of their wives, Mary Mimms and Anna Greene. To this day the community is still known as Marianna.

My favorite account of a woman-named city is about a town located near the geographical center of the state. In the difficult years following the War Between the States, Daniel Mann moved with his young family into the farming area of Madison County. There in the rich soil between the Big Black and Pearl rivers, Mann became a successful farmer. Soon other families settled close by and before long the community of inter-locking farms became known as Mannsdale. Daniel Mann's pride was not his farm, however, but his family—his wife and their daughter, Flora Banks Mann, who married nearby landowner William B. Jones. The benevolent Jones, who would soon serve as the new town's first postmaster, proved his mettle when in 1882 the Illinois Central Railroad began laying rails through the area. Seizing the initiative, he approached the I.C. officials and voluntarily gave them the land on which to build their depot. Shortly after the gift of the property had been finalized and attorneys for the railroad had signed and filed the paperwork,

an executive with the railroad company, J. C. Clarke, arrived and sought out Jones in order to thank him for his kindness. Apparently Clarke had spent some time in the area, and he must have inquired about the people of the community who provided leadership. Clarke's words to Jones have been recorded in the book entitled *The Land Between Two Rivers: A History of Madison County,* by Carol Lynn Mead: "I have heard of the beautiful Christian character of your wife—as an honor to her we will call this station Flora." ∎

SYSTEMS & CONTROL ENCYCLOPEDIA
ENCYCLOPEDIA
Theory, Technology, Applications

EDITORIAL ADVISORY BOARD

CHAIRMAN

John F Coales FRS
University of Cambridge
Cambridge, UK

A Bensoussan
Institut National de Recherche
en Informatique et en Automatique
Le Chesnay, France

P Eykhoff
University of Technology
Eindhoven, The Netherlands

C S Holling
University of British Columbia
Vancouver, British Columbia, Canada

L R Klein
University of Pennsylvania
Philadelphia, Pennsylvania, USA

G J Klir
State University of New York at Binghamton
Binghamton, New York, USA

M Mansour
Eidgenössische Technische Hochschule Zürich
Zürich, Switzerland

M G Singh
University of Manchester Institute
of Science and Technology
Manchester, UK

M Thoma
Universität Hannover
Institut für Regelungstechnik
Hannover, FRG

T Vámos
Hungarian Academy of Sciences
Budapest, Hungary